Zodiaco

Libro para

colorear

Este libro para colorear pertenece a

.........................

ARIES

TAURO

GEMINI

CÁNCER

LEO

VIRGO

LIBRA

ESCORPIO

SAGITARIO

CAPRICORNIO

AQUARIUS

PISCES

PICTURING
LAS
VEGAS

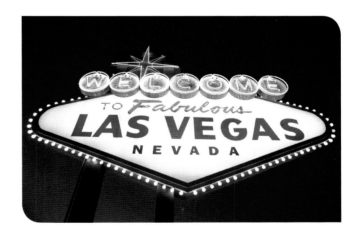

PICTURING LAS VEGAS

Linda Chase

GIBBS SMITH
TO ENRICH AND INSPIRE HUMANKIND
Salt Lake City | Charleston | Santa Fe | Santa Barbara

First Edition
13 12 11 10 09 5 4 3 2 1

Text © 2009 Linda Chase

Published by
Gibbs Smith
P.O. Box 667
Layton, Utah 84041

Orders: 1.800.835.4993
www.gibbs-smith.com

Designed and produced by Kurt Wahlner
Printed and bound in China
Gibbs Smith books are printed on either recycled, 100% post-
consumer waste, FSC-certified papers or on paper produced
from a 100% certified sustainable forest/controlled wood source.

Library of Congress Cataloging-in-Publication Data

Chase, Linda.
 Picturing Las Vegas / Linda Chase. — 1st ed.
 p. cm.
 ISBN-13: 978-1-4236-0488-4
 ISBN-10: 1-4236-0488-1
 1. Las Vegas (Nev.)—History. I. Title.
 F849.L35C476 2009
 979.3'13503—dc22

 2008050427

To my parents, Howard and Mary Katherine
Chase, who proved that culture and education
could thrive in the desert.

CONTENTS

ACKNOWLEDGMENTS

I would like to acknowledge the following individuals for their help in making this book possible:

Susan Strayer, who spent countless hours combing the far reaches of the earth (and the Internet) for the best photography of Las Vegas; Mary Pat Koos, who watched over my grammar and syntax like a casino eye in the sky; Jared Smith, my editor, and Gibbs Smith, for having faith in this book; Philip and Jean Allen, two "Vegas hands" who generously shared their memories and experiences of the Nevada Test Site and Las Vegas; Dr. Claytee White and the staff of the Special Collections Department at UNLV Libraries, who provided invaluable assistance in my research about all things Vegas; Sid Stebel, my writing mentor, and the invariably generous and supportive members of the Chautauqua Writers' Group.

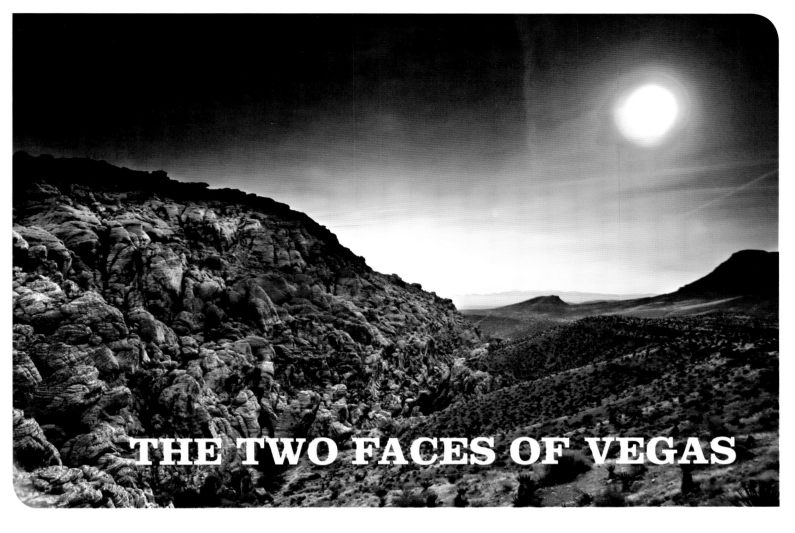

THE TWO FACES OF VEGAS

For the first century of our nation's existence, there was no Las Vegas, so we had to invent one. Repressed Puritans that we were, we needed a place where, for a few nights a year, we could abandon our corseted notions of right and wrong and succumb, without guilt or remorse, to the pleasures of the flesh. It needed to be somewhere godforsaken, far removed from the centers of civilization. And if, perchance, it simulated the burning heat of hellfire and damnation, so much the better: after all, sin does have its price.

Two events gave life to this dream: the construction of Hoover Dam, which provided a source of power, and the legalization of casino-style gambling by the Nevada legislature in 1933. As the freshman legislator who introduced the bill remarked, "The damn state was broke and we needed the money." The success of this simple syllogism—take an activity that is illegal everywhere else, legalize it, and tax it—proved extraordinarily successful, so much so that Nevada to this day has no state income tax. The tax is vice; the penalty is the dens of iniquity that line the streets of every city, town, and hamlet in the state.

But raising a shining city out of the hard caliche of the Mojave took more than electricity or a law on the books; it took the Spanish rider who came upon this desolate valley and dared to call it the Meadows, and it took men with names like Bugsy and Benny, who like that Spanish rider were in the grip of hallucination. These were men shrewd enough to give that

hallucination the legitimacy of a dream. It also took people like my father, who never gambled except that one time, when he moved his family West to build a music school in the desert: let a thousand eighth notes bloom!

Together they fashioned this extraordinary place that has been variously described as "a disease, a nightmare, a paradise for the misbegotten" (Nick Tosches), "everyman's cut-rate Babylon" (Alistair Cooke), and "deliciously deranged" (columnist Maureen Dowd). This is the Vegas of neon signs and showgirls, of green felt and hard luck. There is also the other Vegas, the one where ordinary people live and work. "It was as though there were two Vegases," one native observed, "the one where you lived, and the other, you were a little ashamed of."

I know the feeling well. Having grown up there in the 1950s and '60s, I find it difficult, even impossible, to picture Las Vegas in a way that doesn't make me blush. Even long after I have moved away, distanced myself geographically and in every other way, I can't shake the dust of Vegas from my mind. Standing in my front yard, I have seen the explosion of the atomic bomb. I have ridden my bike into the teeth of a north wind sweeping off the Great Basin, the cold cutting through the pleather of my new car coat. I have breathed in the casino's

heady mix of cheap booze and cigarette smoke, the olfactory top notes of Vegas. I have seen women in faded stretch pants put coins into slot machines at the supermarket. I have taken communion in the sanctuary of First Presbyterian Church and afterward eaten my fill at the chuck-wagon at the Last Frontier. I have sung, lungs welling with pride, the Nevada State Song and the words to the Petula Clark song:

> The money you earn's
> Ready to burn
> Everyone knows
> That's how it goes
> In Las Vegas

In writing this book, I have attempted to square these memories—some just blurred, vague impressions, others vivid and intact—with the reality of Las Vegas, both then and now. What I discovered about my hometown is not always a pretty picture, but it is, in many ways, the picture of America: a story of the frontier, of manifest destiny, of corruption and greed, of larger-than-life personalities and ordinary people pursuing their dreams, of beauty and loss and ineffable hope.

Creating a Cut-Rate Babylon

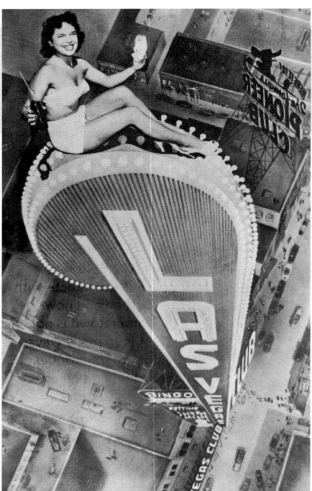

A vintage postcard of Fremont Street.

In the 1940s, Herb McDonald, the entertainment director for the El Rancho Vegas, received a call from Billy Wilkerson, owner of the *Hollywood Reporter.* "I'm coming up with a man named Benjamin Siegel, and he's thinking about building a new hotel further out on the Strip," he said.

McDonald provided bungalows for the visitors and won $28 from Siegel in a card game. The next day, while he was behind the front desk checking the mail, he felt a nudge in his ribs.

"Hey, kid, when do I get my $28 back?" It was Siegel.

"Anytime, buster, you think you can get your money back, just come at me," McDonald retorted, the usual gambler's trash talk.

Siegel laughed and walked away. "I'll get to you," he said.

A dealer came up to McDonald. "Do you know who you were talking to?" the dealer asked.

Neon sign, Flamingo Hotel.

"Yeah, Ben Siegel."

"That isn't Ben Siegel, that's Bugsy Siegel, president of Murder, Incorporated."

"Hell," McDonald replied, "had I known that, I would have dumped."

Bugsy Siegel. We can call him that now, with impunity, and he has become interwoven in the fabric of Las Vegas lore, but Benjamin Siegel despised that nickname, and few had the nerve to call him that to his face. A skeptic turned fanatic, he set out, with the zealotry of the recently converted, to build "the goddamn biggest fanciest gaming casino hotel you bastards ever seen in your whole lives." He spent lavishly and indulged every excess and ended up with a bullet through the eye. But in a kind of inverted logic, it was this very excess, this giddy extravagance, that would become the cornerstone upon which Vegas would build its success.

Bugsy Siegel was not the first to build a hotel on what was then a dusty stretch of US 91, the two-lane highway that connected Los Angeles with Las Vegas. Thomas Hull, a Los Angles hotel builder, had the foresight to realize that the automobile, not the train, was the transportation wave of the future. So rather than building downtown near the train depot, as convention would dictate, he built on a thirty-three-acre tract of land just outside the city limits.

The El Rancho Vegas, which opened in 1941, became the city's first resort, a lavish setting with lush gardens, a large swimming pool, and a showroom in which scantily clad chorus girls performed nightly. There were plenty of

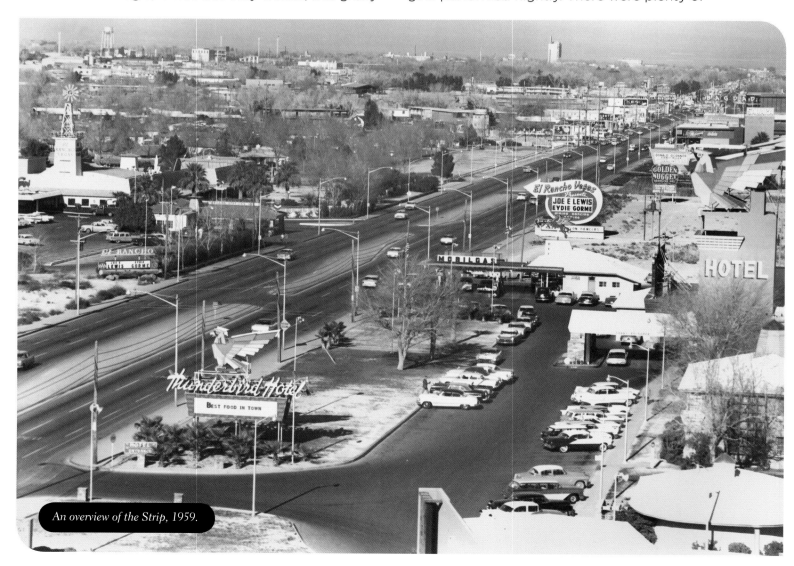

An overview of the Strip, 1959.

customers from the Las Vegas Gunnery School, an Army Air Corps training base, and the Basic Magnesium plant in nearby Henderson. Out-of-town visitors also poured into the city—especially couples looking for a quickie wedding or divorce. Hull added another sixty guest rooms to his hotel, and within a year, another new resort, the Last Frontier, opened down the road. Residing just outside the reach of city tax collectors, these hotels basked in the unincorporated township of Paradise. The stretch of highway on which they resided needed its own identity, something less prosaic than US 91; they decided to call it "the Strip," after the Sunset Strip in Los Angeles.

The Flamingo Hotel, a project begun by Billy Wilkerson, existed in splendid isolation out in

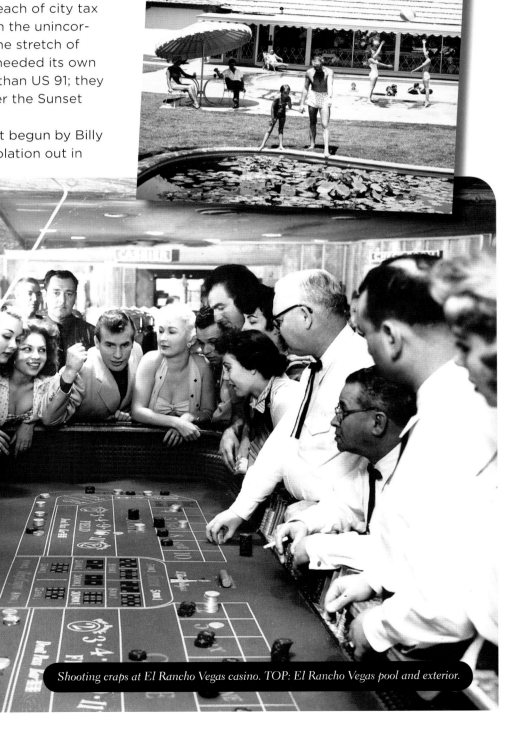

Shooting craps at El Rancho Vegas casino. TOP: El Rancho Vegas pool and exterior.

the middle of the desert—a "lonely giant," as one reporter described it, that many saw doomed to failure. When Wilkerson ran out of money, Bugsy Siegel acquired a two-thirds interest in the project and proceeded to pour $1 million of mobster Meyer Lansky's money into it. His spending was extravagant: he ordered rare marble and stonework and imported exotic palms from the Middle East. Evidently, Siegel was to palm trees as Ronald Reagan was to redwoods: you've seen one, you've seen 'em all. He would sign for a delivery in the morning; the next day, the same trees were brought around from the back, and he would sign for them again. And what would the Flamingo Hotel be without flamingos? Siegel ordered a hundred birds, but after the first two to arrive perished in the heat, the order was canceled.

Siegel brooked no governmental resistance to his vision. "We don't run for office," he once pointed out, "we own the politicians." He bribed government officials and falsified records. When a Mormon commissioner proved recalcitrant in granting him a gaming license, Siegel built him a steam bath. The Mormon connection was to prove fruitful: among the lenders who bankrolled the Flamingo, which was now well over its $1 million budget, was what the FBI later identified as a "Utah corporation."

Though the hotel wasn't completed, the grand opening was held as scheduled on December 26, 1946. It was to have been a lavish affair, with

Exterior of the Flamingo at night, 1953.

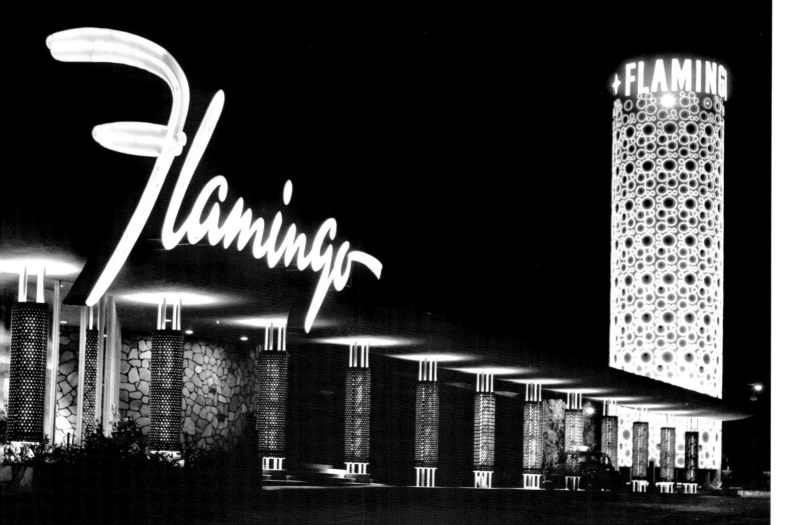

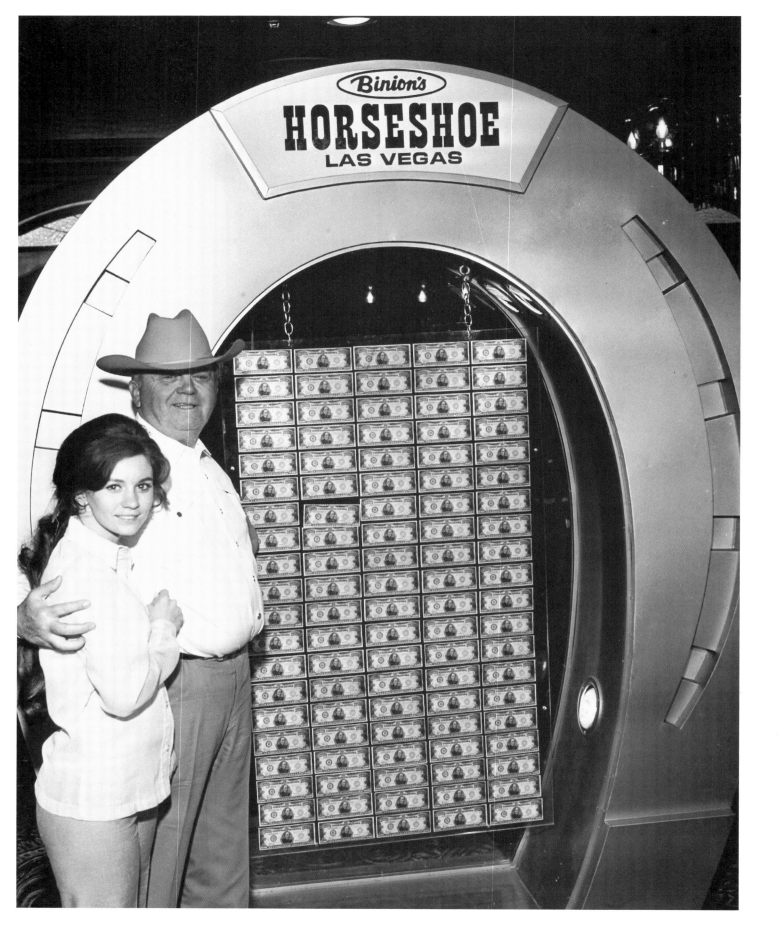

Siegel, dressed in a cutaway coat and white tie, welcoming guests to his temple of hedonism, comedian George Jessel acting as master of ceremonies, and Xavier Cugat's orchestra rhumbaing into the night. Planes were chartered to fly in celebrities from Los Angeles. But bad omens abounded: a storm grounded the planes, and the few guests who did turn up went on a hot streak; within two weeks, the casino had lost $300,000. It appeared as though Siegel's gamble had failed—the hotel closed in late January. Like the gambler who thinks his salvation lies in the next hand or roll of the dice, Siegel scrambled for more loans and reopened in March; by May, the natural laws of gambling had prevailed, and the house was winning.

Siegel, however, had played out his hand: three months later, in Beverly Hills, a hit man put a bullet through his eye (a scene famously reenacted in the film *The Godfather*). This ignominious end—a corpse with a toe tag in a Los Angeles morgue—was perhaps the penalty for hubris, a cold-hearted reprisal for reaching too high. Yet Bugsy Siegel left an indelible mark on Las Vegas.

Benny Binion was a character straight out of a dime western: he wore a white ten-gallon hat and a buffalo-hide coat, snap shirts with gold buttons, and alligator boots. A convicted bootlegger and numbers runner from Texas whose formal education had ended in the second grade, he arrived in Las Vegas in 1942 in a Cadillac with his wife and five kids and a suitcase full of money. Within five years, he was the proprietor of one of the most successful casinos on Fremont Street. He looked into the hearts of his clientele, both present and future, and reduced their wants and desires to a simple catechism—"good food, good whiskey cheap, and a good gamble."

Benny Binion's Horseshoe Club, on the corner of Fremont and Second, was the first of the so-called "carpet joints"—a casino with carpets on the floor rather than sawdust. The giant seven-foot horseshoe outside, filled with a hundred $10,000 bills, stopped tourists in their tracks. It stood on what had come to be known as "The Brightest Corner in the World"—so bright, in fact, that you could take a picture at night without benefit of a flash. It seems, by contemporary Vegas standards, a modest enough gimmick, but it was, in its day, a dazzling display.

Benny Binion with his daughter Beck standing next to the display in front of the Horseshoe Club, c. 1969.

But that was the limit to the excess—there were no fountains, no splashy floor shows, no fancy restaurants. If you were hungry, you could have a bowl of chili in the restaurant, made from a Dallas jailhouse recipe. The Horseshoe was the first to serve free drinks to customers, and the first to raise the limit on craps from $50 to $500; eventually it went up to $100,000. The Horseshoe's slots were the most liberal in town.

Binion was a throwback cut from rough frontier cloth, out of step with the sleek, modern midcentury. He was a reprobate, a scofflaw, a bigot. In 1952, he pled guilty to tax evasion charges, hoping to bribe the judge, but his attempt was foiled, and he ended up serving forty-two months in Leavenworth. However, he continued to run the Horseshoe while Nevada authorities looked the other way. Upon his return, he continued his ruthless practices—bribing judges and senators, killing off rivals, having suspected cheaters dragged out into the alley and beaten. An unabashed racist, he once threw a paralyzed veteran in a wheelchair out of his club because he was black.

Binion's public persona remained that of a colorful figure, rough around the edges but a good ol' boy nonetheless. He held forth in the Sombrero Room at the Horseshoe Club and told

stories becoming the grand old man of Glitter Gulch. People even named offspring after him: there is at least one person living in Oklahoma who has had to live down the name "Binion."

In the 1950s, the Strip unrolled like a rug to Damascus: the Sahara, the Sands, the Desert Inn, the Riviera, the Dunes, the Stardust, the Tropicana. Each hotel provided its own theme

was the Las Vegas ode to that great North African desert. There were plaster camels out front and inside a Casbah Lounge and Ray Bolger headlining in the Congo Showroom (the geography was a bit off, but no one was quibbling). A few weeks later, the Sands made its debut. Emulating the low-rise architecture and lavish landscaping of the other hotels, the Sands added its own embellishment: a glass-enclosed coffee shop with a view of the pool, which had

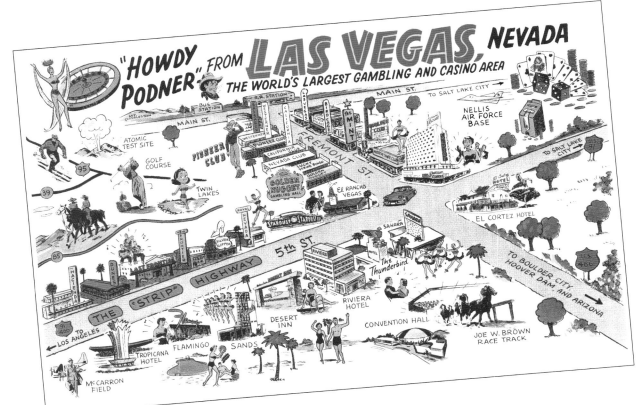

RIGHT: Alighting in front of the Sahara, 1954.

LEFT: A vintage map of the Strip.

and variations on Siegel's basic formula: a distinctive architectural motif, a big swimming pool and lush landscaping, top-name entertainment, cheap rooms and food—what British historian Alistair Cooke referred to as a "cut-rate Babylon." The guiding principle for all: keep the gamblers well lubricated with free drinks in an air-conditioned casino. Make sure they keep coming back, and make sure they keep losing.

Dell Webb's Sahara, which opened in 1952,

its own floating craps game. Danny Thomas performed on opening night in the Copa Room, later the stage for the antics of Frank Sinatra and the Rat Pack.

The Strip's first high-rise, the $10 million, eleven-story Riviera, opened in 1955, disproving the theory that the hard-packed caliche soil could not support a skyscraper. The Dunes—the self-proclaimed "miracle of the desert" that opened kitty-corner from the Flamingo in

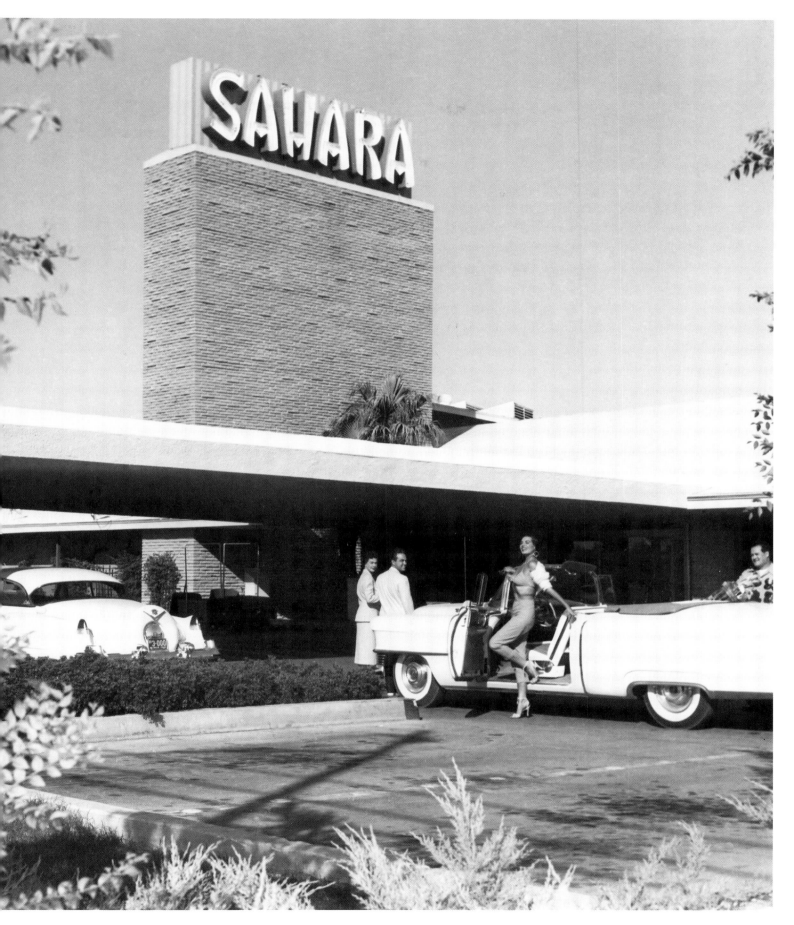

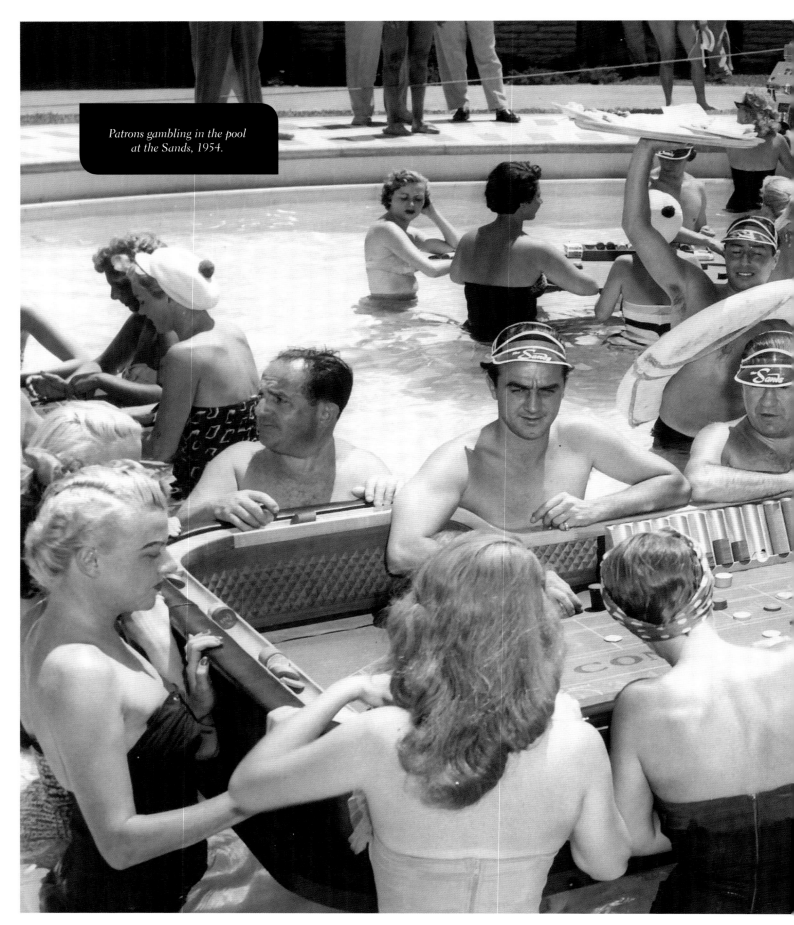

Patrons gambling in the pool at the Sands, 1954.

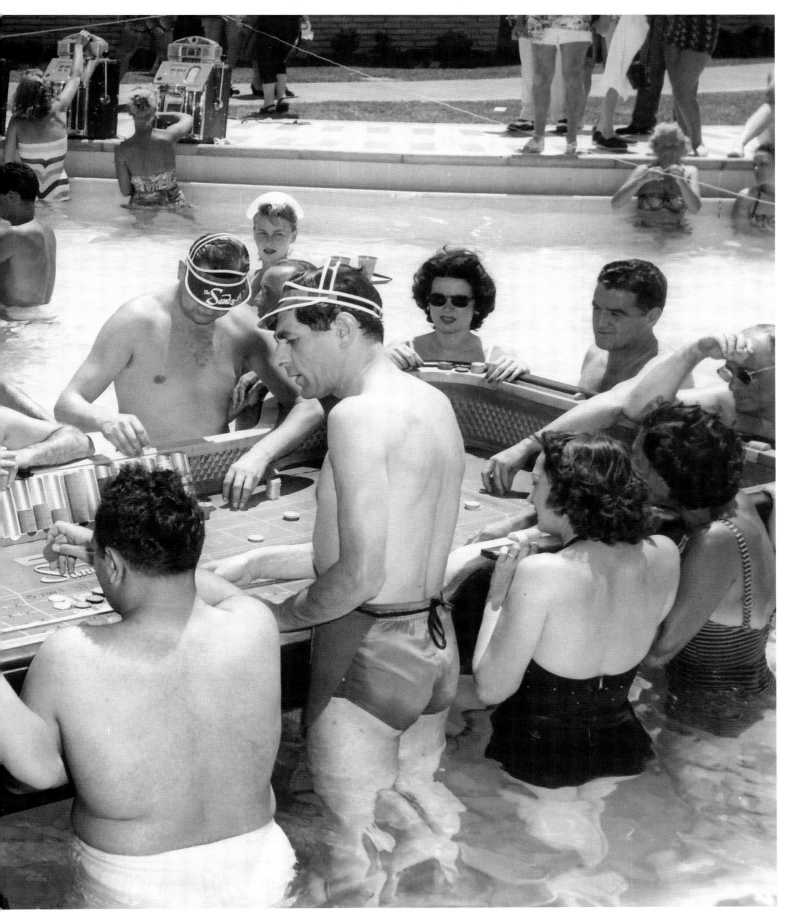

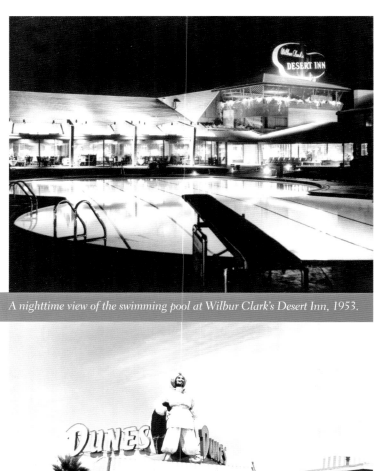

A nighttime view of the swimming pool at Wilbur Clark's Desert Inn, 1953.

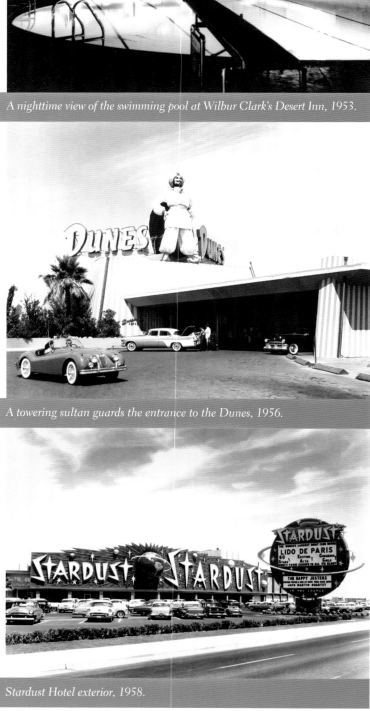

A towering sultan guards the entrance to the Dunes, 1956.

Stardust Hotel exterior, 1958.

1955—put Bugsy Siegel's notion of excess to shame with its towering thirty-foot sultan, arms akimbo, guarding the entrance, and guests disporting themselves in a ninety-foot-long swimming pool.

The Stardust almost remained just that—cosmic dust that never materialized. The project was three-quarters complete when its financier, Tony Carnero, died of a heart attack while playing the tables at the Desert Inn. Wanting to own a piece of the action, John Factor, brother of cosmetics magnate Max Factor, poured $10 million into the sprawling thirty-two-acre hotel, which, with its 1,000 low-rise bungalow–style rooms and 16,500-square-foot casino, was billed as the "largest motel in the world." The pool at the Dunes was cast out of first place by the Stardust's 105-foot-long pool.

The construction of the Stardust delayed the completion of yet another Strip hotel—the Tropicana. Ben Jaffe, chairman of the Fountainbleau Hotel in Miami Beach, hired Miami architect M. Tony Sherman to build a Havana-style resort (this was 1955, four years before Castro supplanted casinos with communist ideology). "The Trop" opened in 1957, with J. Kell Housel, a respected local gambling operator, hired to run the casino.

Shortly after the hotel opened, the casino cage was emptied out, and in order to avoid a rampage by the customers, Housel raided the El Cortez, one of his downtown casinos, stuffing several hundred thousand dollars into a shopping bag and rushing it over to the Trop. Eventually he bought off Jaffe, scoring a double coup by hiring Martin Appelt, the chef from the Waldorf Astoria, to orchestrate the cuisine in the gourmet dining room and bringing in the Folies Bergère from Paris in 1959 to perform in the main showroom.

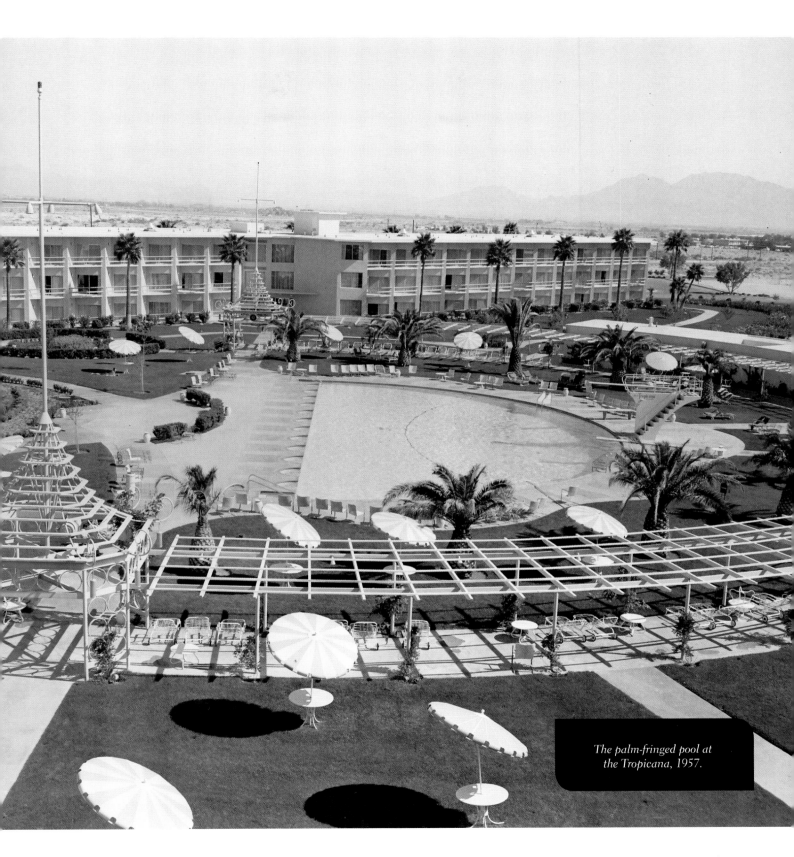

The palm-fringed pool at
the Tropicana, 1957.

Because of their low-rise architecture, these hotels did not create a skyline, but instead generated what Tom Wolfe called a "signline." The hotel signs, as Wolfe discovered, were a source of wonder—"they tower, they revolve, they oscillate, they soar in shapes before which the existing vocabulary of art history is helpless." The largest of these—indeed, the largest on the planet—was the Stardust's sign, twenty-six feet high with 7,100 feet of neon tubing. The signage cast off a collective glow that could be seen

hard-pressed to compete with the Strip. Part of the problem was space; whereas the Strip had nothing to impede its expansion, Fremont Street was hemmed in by the rest of downtown. By day, the street served as a main shopping thoroughfare for locals—there was a Rexall and Woolworth's and, on the corner of Fremont and Fifth, the Sears where mothers took their children for school clothes and fathers bought refrigerators and television sets. Such a prosaic display of commerce, the sort that could be conducted in, say, downtown Des Moines or Ann Arbor, dimmed the luster of the street.

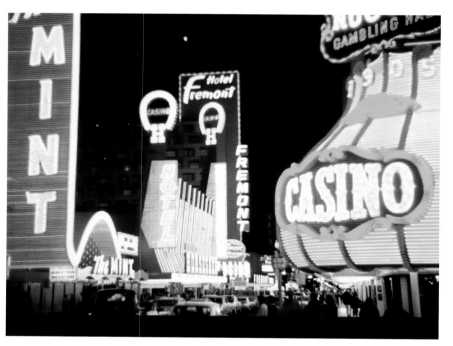

Neon signs on Fremont Street.

With the high rollers defecting to the Strip hotels, Fremont Street needed a fresh injection of capital and class. Ed Levinson, a gambler out of Chicago, partnered with Lou Lurie, a San Francisco financier who had built a hotel in Miami, to build the Fremont Hotel, a 15-story, 155-room skyscraper that opened in May 1956—right in the middle of Helldorado Week, the annual frontier celebration that culminated in a parade down Fremont Street.

Like heady poker players, Levinson and Lurie saw the strong hand the Strip hotels possessed and played

from miles away; there were even claims that it could be seen from space. Imagine Yuri Gagarin, orbiting Earth in *Sputnik,* wondering, *What is that light emanating from the Nevada desert? Perhaps some new kind of secret weapon?* No: it was decadence writ large, a fevered money pit, a call to all Americans to forget the Soviet menace and come to Vegas!

Compared to such cosmic grandiosity, the rest of Las Vegas paled. Even with the Brightest Corner in the World, poor Fremont Street was

their weaker cards with skill and bravado. They brought in a chef who had prepared dishes for the Ritz and The Savoy. For good measure, they also enticed Billy Gwon, a noted Chinese chef from New York, to come out. Big-name entertainment—Wayne Newton, Helen Reddy, Pat Boone—played in the Carnival Room. They even convinced KSHO TV, the local ABC affiliate, to broadcast from the hotel. As a final coup, they added a rooftop swimming pool in 1963, a novelty for Vegas.

The neon sign at the Stardust allegedly could be seen from space.

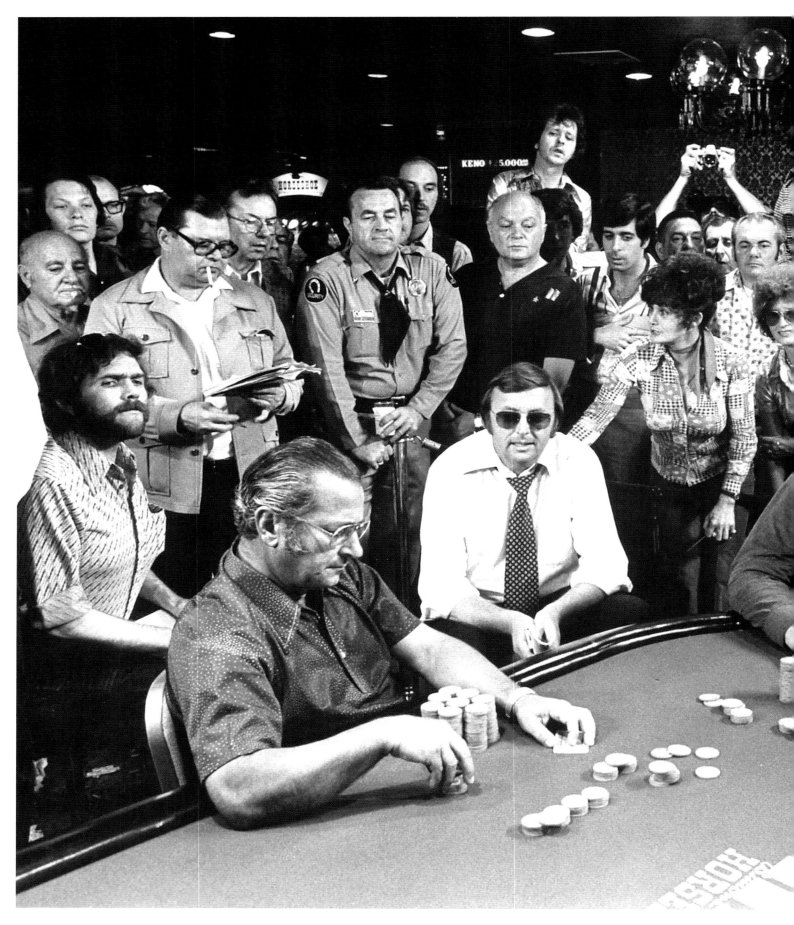

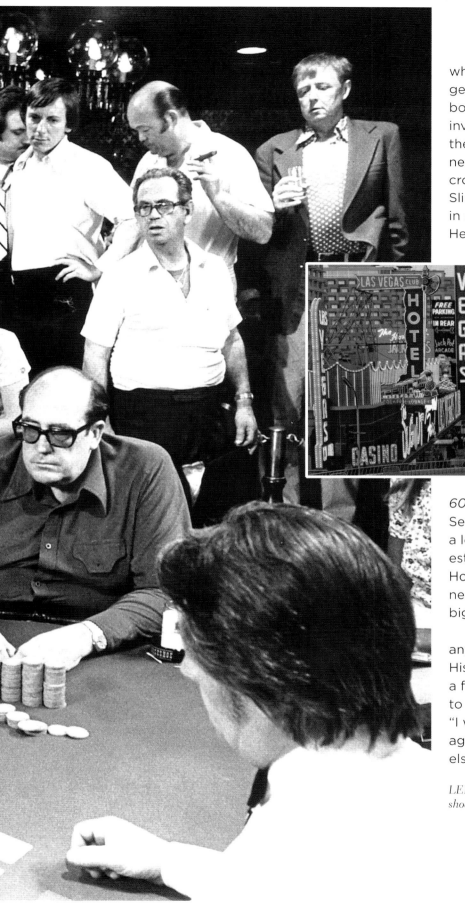

In 1970, Benny Binion came up with what was to become one of the biggest ideas to hit Vegas since the atom bomb—the World Series of Poker. He invited his high-rolling friends to play in the first tournament, positioning the table near the casino entrance to attract big crowds—which it did. In 1972, Amarillo Slim prevailed over seven opponents in no-limit hold 'em and won $80,000. He appeared on *The Tonight Show* and

60 Minutes and spoke before the US Senate. "This poker game here gets us a lot of attention," Binion noted modestly. Eventually the game outgrew the Horseshoe and in 2004 moved to the Rio near the Strip, spawning other prestigious big-money tournaments.

Benny Binion died in 1998, without any illusions about who or what he was. His own self-assessment would provide a fitting epitaph for a city that he helped to grow, and that eventually outgrew him. "I would almost certainly be a gambler again," he said, "because there's nothing else an ignorant man can do."

LEFT: *The first World Series of Poker at Binion's Horseshoe, 1970.* ABOVE: *Fremont Street, early 1970s.*

AN OBJECT LESSON IN THE EVILS OF GAMBLING

"HOWDY, PODNER."

Vegas Vic, a neon cowboy perched atop the Pioneer Club on Fremont Street, boomed out his greeting to the family of five newly arrived in the dead of the desert night. He wore a red kerchief and a cigarette dangled from his lips. He must have wondered: *What are they doing here, these Midwestern greenhorns?*

We had just disembarked from the *Super Chief* out of Chicago, my father in his topcoat, my mother in her good Republican cloth coat, and my two brothers and myself, taking in this street, this city that was to be our new home. We had come to bring culture to the desert.

My father, a PhD in Musicology and a professor at the University of Michigan, had gotten the notion to open a music school in Las Vegas. He was not a gambler, yet here was a gamble. He was playing the odds: (1) that there would be an exponential increase in population; and (2) that there would be a corresponding increase in the demand for culture. He proved to be correct about one of these suppositions.

We started up the four-block gauntlet of casinos with their bright neon signs: the Golden Nugget, the Las Vegas Club, the Pioneer Club, the Fremont Hotel. We paused in front of Benny Binion's Horseshoe Club. This intersection was advertised as the Brightest Corner in the World, and indeed the light emanating from the wattage of the horseshoe and the other signage bathed us in a hot high-noon glare of light. How pale we must have looked in that light, dazed and wide-eyed, like immigrants just off the boat.

We spent our first night in Las Vegas at the El Portal Hotel. As was the case with all Vegas hotels, the game was rigged from the moment

you entered: to get to your food, or to your bed, you had to pass through the casino. The gambling age was twenty-one, so children could not linger there, but they could walk through, and as they did, they could not help but see all the old verities being shattered right before their eyes. It was the dead of night, and we were not in bed. Before us was an assortment of humanity the likes of which we had never seen on the streets of Ann Arbor: women sporting peroxide hairdos, sipping from pale, watery drinks and pulling at the handles of slot machines; men in string ties and silver belt buckles throwing dice or hunched over their cards in a cloud of cigarette smoke. The cacophony of sounds—the whir and clatter of coins, the jangle of bells if someone got a jackpot; and the smell of cigarette smoke and stale booze.

Our father decided to nip our excitement in the bud right on the spot, to give us an object lesson on the folly of gambling. He was an empiricist and did not expect us to take any antigambling lecture at face value: a demonstration was required. He took a nickel out of his pocket. "You see this nickel?" Our three heads bobbed in unison; he was a teacher and knew how to hold an audience. "Watch what happens to it when I put it in this machine." He put the nickel in and pulled the handle. Oranges and cherries and lemons spun and whirred, and when they stopped spinning, nickels came pouring out into the tray. Of course, we were enthralled at this magic trick, and at the same time it must have registered that our father was not omniscient, that here in Vegas, he was fallible. He proffered a hasty explanation—that this

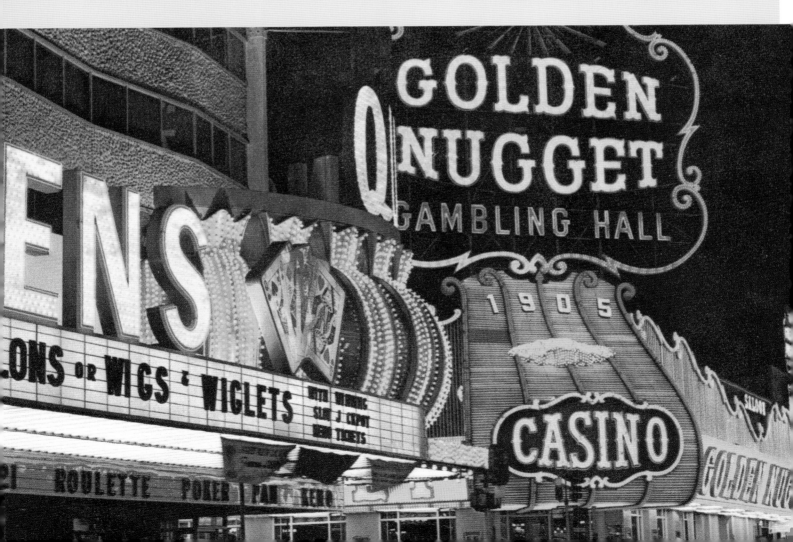

is all part of the plan, that the odds are with the house—but he had discovered, as have many others before and since, that Vegas has a perverse streak.

The nickels were retrieved and pocketed; there would be no more gambling that night, or ever—unless, of course, you count the ultimate gamble of bringing a wife and three children across the country, no gainful employment in the offing. It was like homesteading, only instead of seeds and young plantings, we had music, piles of it, and the Steinway baby grand. It never occurred to our father that perhaps he had underestimated the thirst for classical music in a town where the height of culture was the song stylings of Wayne Newton and Elvis painted on black velvet. He took everything and put it on double zero and let it ride.

The city had many failings, to be sure— the seedy side streets with their pawn shops and bail bonds places, the crowded schools and crumbling roads, the unspoken but pernicious racism—but none of these things dulled our pleasure in our new life in the desert, our embracing of a new aesthetic. We did not

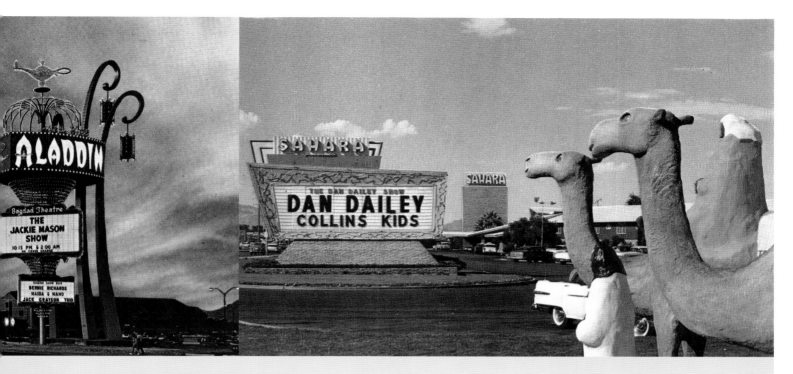

completely abandon our highbrow Michigan sensibilities: there was Bach and Beethoven in abundance, and prints of Van Gogh and leather-bound volumes of the plays of Shakespeare. Yet we took fierce pride in every aspect of this strange and wondrous land: the stark beauty of the desert and surrounding mountains; the sudden, startling turquoise of a swimming pool; the effervescent bubbles that danced up and down the sign at the Sands; that sly wink from one of the plaster flamingoes outside Bugsy's place.

We were untethered, unfettered, newly minted citizens of the Silver State: no more shoveling snow, no more oppressive woolens or gray winters. Every day was spent under a great blue dome of Nevada sky, and if looking off into those great distances created a kind of *trompe l'eoil* effect, causing us to believe that things were closer than they were, who cared? This was Vegas, baby! We were reborn as children of the Golden West.

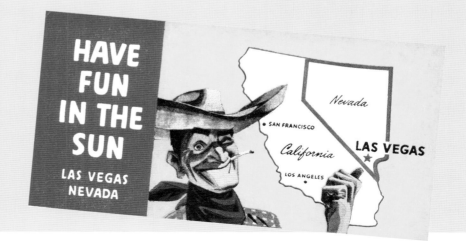

Why Vegas Loved the Bomb

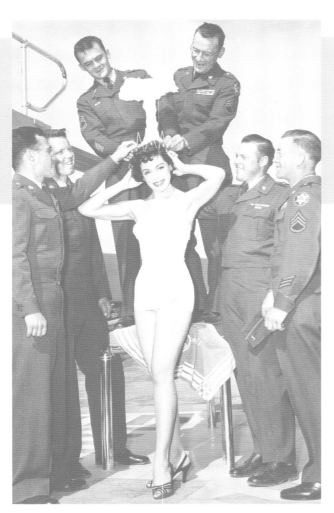

A Copa Girl dressed as Mis-Cue, wearing an A-bomb crown, 1955.

> "EVERY LEADER OF THE WORLD SHOULD HAVE TO LOOK AT ONE OF THOSE AT SOME TIME, AND I THINK IT WOULD MAKE THEM UNDERSTAND A LITTLE MORE."
>
> — TROY WADE, TEST MANAGER NEVADA TEST SITE

It was a perfect morning for a nuclear test—a bright spring day in April 1952, snow-capped peaks glistening in the background, a crystalline blue sky above. So that the occasion—the first such experiment on US soil—would not go unremarked, the lions of the media had been brought in to observe. Millions of viewers heard what were to become the familiar tones of CBS reporter Walter Cronkite:

> This is Walter Cronkite and this is Newsman's Knob, seventy-five miles from Las Vegas. A bomb will be exploded from a tower three hundred feet high. This is the first time newsmen are allowed to watch.

Part of Operation Upshot-Knothole, the Badger detonation was conducted in April 1953, with a yield of 23 kilotons.

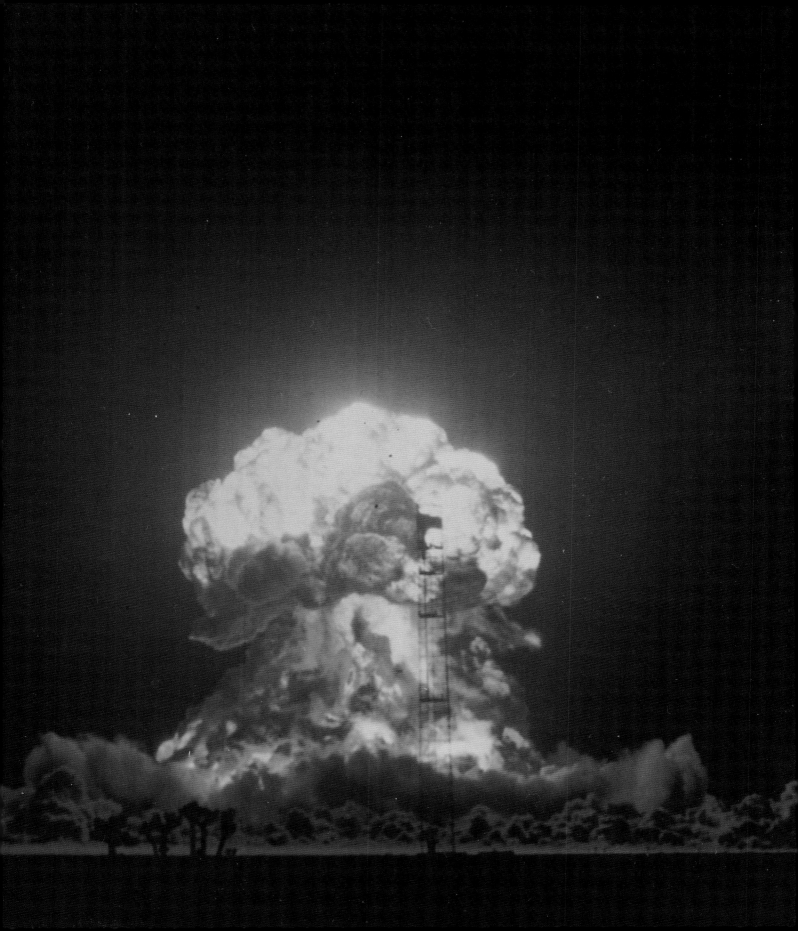

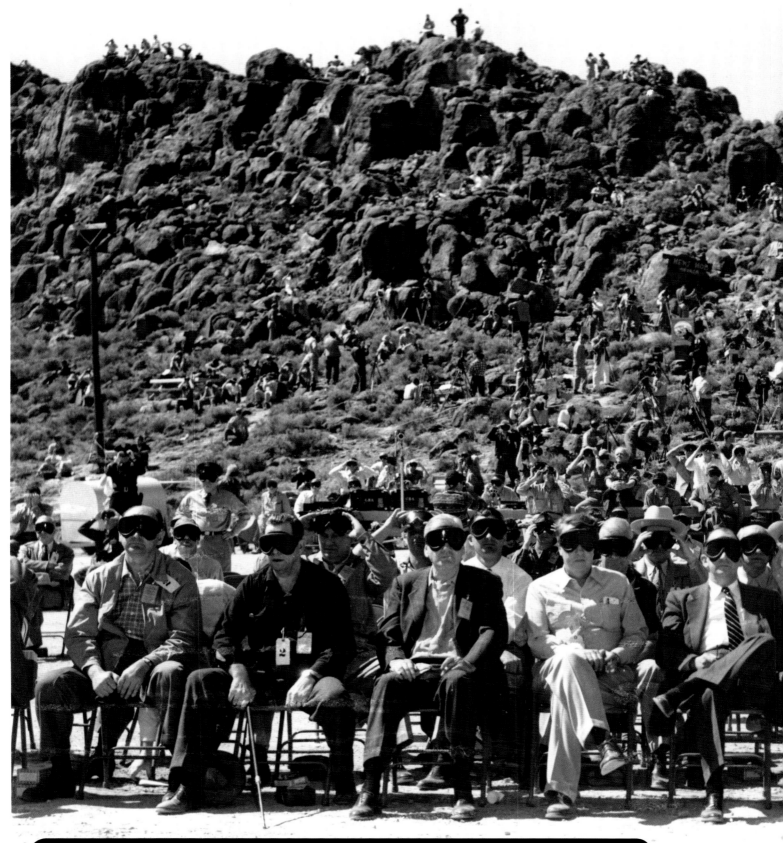

Dignitaries at News Nob Hill wear protective goggles to observe Charlie, part of Operation Tumbler-Snapper, April 22, 1952.

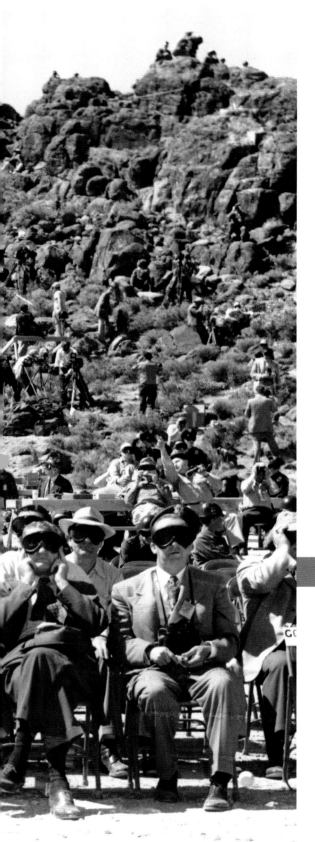

Earlier that month, when the idea of a test was just a twinkle in the government's eye, President Truman put the question to Atomic Energy Commissioner Gordon Dean: "Can this be done in such a way that nobody will get hurt?"

"Every precaution will be taken," Dean assured the president. It wasn't that big a bomb—only one kiloton—and Truman, not one to shy from weighty decisions regarding nuclear weapons, authorized the test.

Cronkite and other members of the press—Dave Garroway, John Cameron Swayze, Bob Considine—were given dark glasses to shield their eyes from the blast, but even with the glasses, the blast was blinding. Cronkite, who was to become the avuncular host for all our national triumphs and

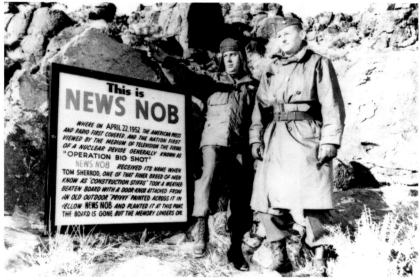

Major E. E. Self and Lt. Col James K. Watts view Yucca Flat from News Nob.

tragedies—the Kennedy assassination, landing on the moon— was dazzled, even smitten, by this vivid demonstration of American technology and power.

Two days after the test, the AEC received a telegram from the National Association of Photographic Manufacturers on behalf of Eastman Kodak in Rochester, New York, alleging that tests of recent snowfall measured radioactivity of ten thousand counts per minute, versus four hundred the previous Friday.

STOP. SITUATION SERIOUS. STOP. *WHAT ARE YOU DOING?* STOP.

But the tests didn't stop, and in Las Vegas, the party was underway. Clearly having studied their Freud, the Las Vegas Chamber of Commerce and the city hotels cheerfully exploited the bomb's obvious sexual connotations. Showgirls posed astride a smoking rocket. A voluptuous girl in a bathing suit brandished a Geiger counter, checking the beard of an old desert rat for radiation, hinting at sexual favors to come. The Sands, which declared itself the official headquarters of the atomic tests, held a "Miss Atomic Energy" contest. The 1955 winner was Linda Lawson, a Copa showgirl who was crowned "Mis-Cue" because of a test delay. Lee Merlin, another Copa showgirl who earned Miss Atomic Bomb honors, was photographed in a bathing suit with cotton batting forming a mushroom cloud.

For an unobstructed view of the blast, there were few better vantage points than the Sky Room of the Desert Inn. On the morning of a test, a standing-room-only crowd would gather, downing Atomic Cocktails [*see recipe*] while pianist Ted Mossman played "Atomic Lullaby Bounce." Comedian Jackson Kay billed himself as the "Original Atomic Comic" (but seriously, folks). Gee Gee, a hairdresser at the Flamingo, came up with the Atomic Hairdo, a kind of precursor to the beehive, with the hair piled up around a mushroom-shaped wire form and sprayed with glitter.

Atomic Cocktail

Mix equal parts vodka, brandy, and champagne; serve during atomic test in heat-resistant, shatterproof glasses.

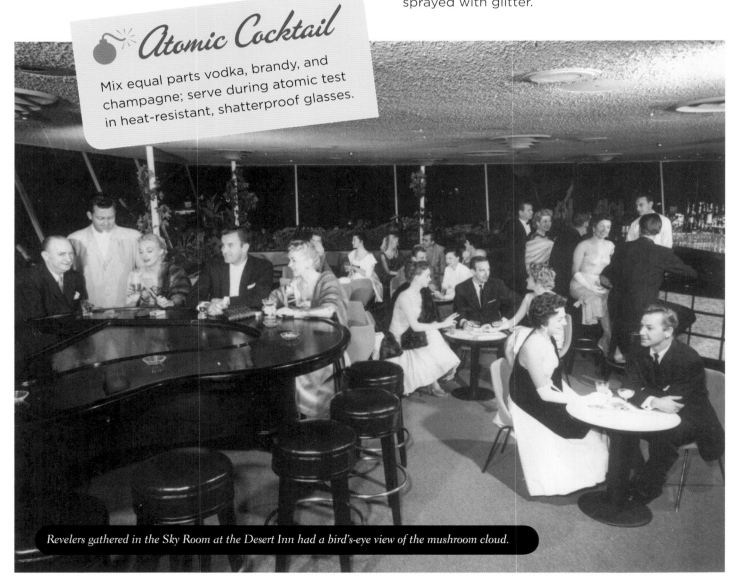

Revelers gathered in the Sky Room at the Desert Inn had a bird's-eye view of the mushroom cloud.

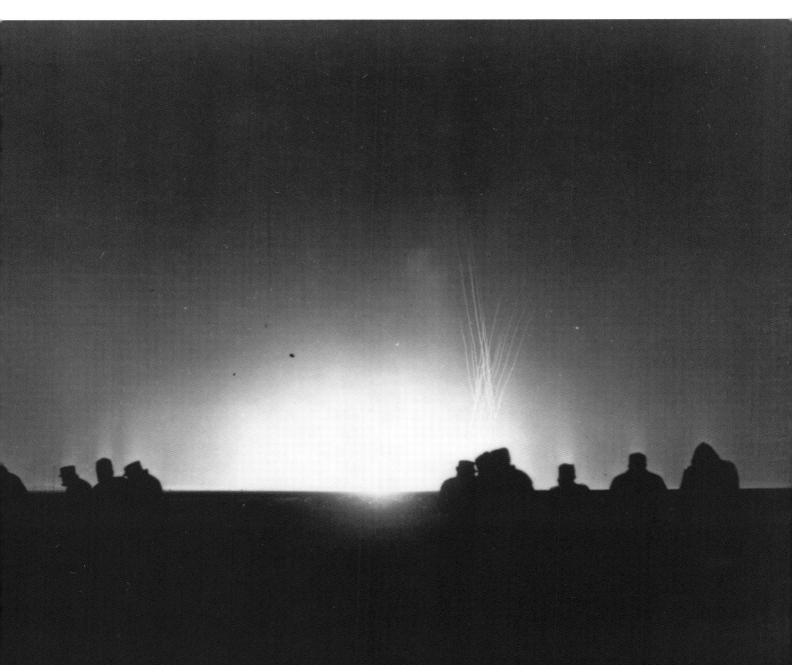

Vapor trails left by a radioactive cloud from detonation of the Apple test at Yucca Flat, March 23, 1955.

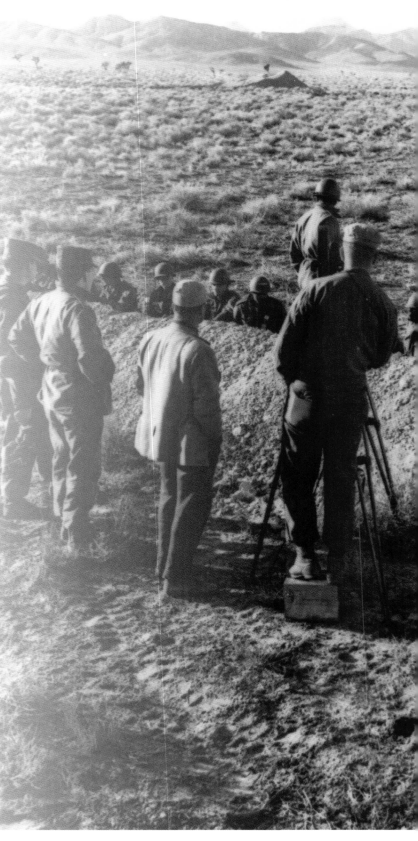

If there was an element of hysteria underlying all of this frivolity—one of the piano players who accompanied the dawn sing-alongs at the Sands said the people "sang like they were on the *Queen Mary* and it was going down"—the main activity in Vegas, which was gambling, continued unabated. There is a story, perhaps apocryphal, that a group of gamblers, playing craps, was startled by the ground shaking during an atomic test. Without missing a beat, the dealer coolly said, "Next shooter." If the dice were to move or the roulette ball to jiggle to the next space, the casinos would brook no argument; they posted signs declaring, with ringing biblical authority, that the house's ruling, as always, will be final.

The national press continued its occasional forays to the desert to observe the spectacle. *The New Yorker* dispatched Daniel Lang to Vegas in 1952. His account placed the bomb in the same category of Vegas oddities as gambling and quickie divorces. "On numerous occasions," Lang wrote, "a piercing flash of light, many times the intensity of the sun's, has burst over the proving ground in the very early morning, momentarily transforming a gloomy Nevada dawn to a dazzling noon." *National Geographic,* with its distant, keen eye for anthropologic oddities, observed, "To Nevadans, the atomic tests are only one more superlative in a State endowed with already spectacular history and scenery."

The local press fawned over the bomb as though it were a lounge singer in a sequined jumpsuit or a heavyweight fighter. "I saw the big guy this morning," wrote John Cahlan in the *Las Vegas Review-Journal,* "and he looked like a champ to me." Hank Greenspun, editor of the *Las Vegas Sun,* viewed it as nothing less than a redemptive *raison d'etre* for his much-maligned city. "We have glorified gambling, divorces and doubtful pleasures to get our name before the rest of the country," he wrote in his column, "Where I Stand." "Now we can become a part

of the most important work carried on by our country today. We have found a reason for our existence as a community."

State senator Dina Titus agreed that the bomb provided a unique opportunity for Las Vegas to spruce up its tawdry image. "Up until that point, we were just a spot in the desert," she said. "We were prostitution. We were gambling. Suddenly, we were helping to win the Cold War, and I think people could grab a hold of that because it was a good thing to do for democracy."

Las Vegas serving on the vanguard of democracy was surely one of the more bizarre by-products of the Cold War. During the 1950s and '60s, the United States and the Soviet Union were engaged in a high-stakes game of nuclear poker. ("I'll see your atom bomb and raise you two hydrogen bombs.") The Soviets, who detonated their first atomic bomb in 1949 and their first thermonuclear device in 1953, were content to let their people go without butter while they assembled a sizable nuclear arsenal. For its part, the United States viewed deterrence as the best defense—which, ironically, meant stockpiling a nuclear arsenal of its own and regularly testing those weapons, for what good were they as a deterrent if they didn't have the demonstrable ability to obliterate the world several times over?

The federal land enlisted in this enterprise was a vast empty space of mountains, valleys, and dry lakebeds north of Las Vegas, sparsely populated but for a few ranches and brothels. The site had been selected over competing sites in White Sands, New Mexico, and North

Soldiers observing detonations from trenches during Operation Buster-Jangle at Yucca Flat, 1951. ABOVE RIGHT: A Geiger counter measured radioactivity released from the atomic tests.

And so they did. In July 1957, NATO representatives from ten countries gathered in Las Vegas to witness the Kepler atomic test, part of Operation Plumbob. They stayed at the Sands for the meetings, where they were treated to a cocktail party and dinner. Having sampled both the glitz of the Strip and the city's other star attraction, they undoubtedly left as bemused as the *New Yorker* reporter: What manner of place was this?

An atomic bomb ring and an atomic disintegrator were part of the play arsenal of children in the 1950s.

Carolina for its ideal weather conditions and small population.

The Nevada Test Site, as it was officially designated in 1955, originally covered approximately 640 square miles but by 1964 had more than doubled in size. "The 1,350 square miles at the Nevada site is probably the most well characterized, well understood piece of geology in the world," said Troy Wade, who joined the test site in 1958 as a test controller. "We have drilled it, sampled it, tunneled it until we understand it and all of its components better than anywhere else."

Wade recalled the visceral effect of witnessing a test in person. "The light and the heat and the shock wave from a nuclear weapon exploding are terrifying," he said in an interview with KNPR. "I mean, you feel the heat. You feel the shock wave. You are blinded if you don't have your eyes closed or have on goggles. And it's an awful thing. Every leader of the world should have to look at one of those at some time, and I think it would make them understand a little more."

It was a place where thousands of people went to work each day. Each morning, in the predawn, they boarded buses on the north edge of town and headed north on the Tonapah Highway to Mercury, the base camp located sixty-five miles north of Las Vegas in Area 23. (Note to conspiracy theorists: Area 51, aka the Ranch, aka Red Square, which was used for developing the U-2 spy plane and, later, the Stealth bomber, was located north of the atomic test site.) Mercury was a collection of drab buildings that included a mess hall, motor pool, administrative offices, and dormitories for overnight stays. To alleviate the boredom

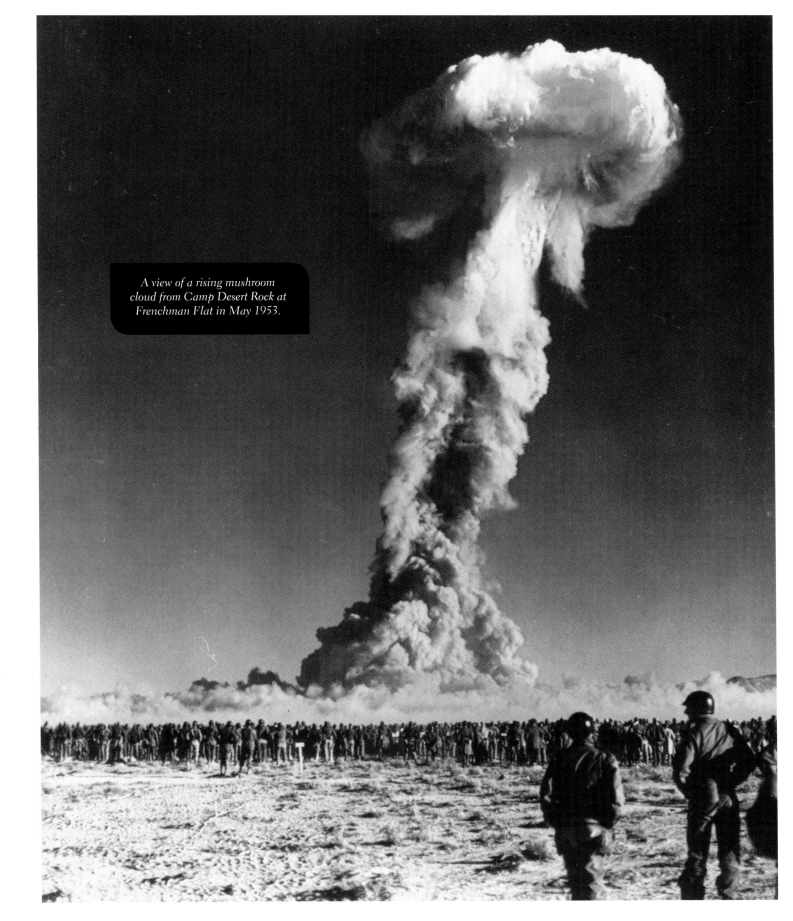

A view of a rising mushroom cloud from Camp Desert Rock at Frenchman Flat in May 1953.

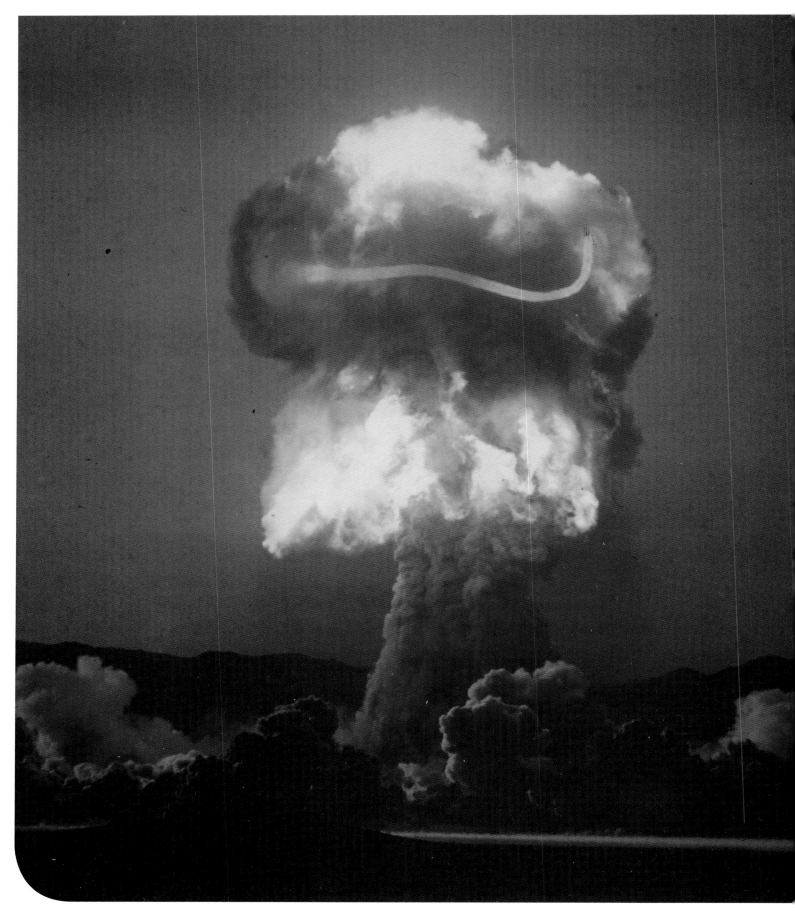

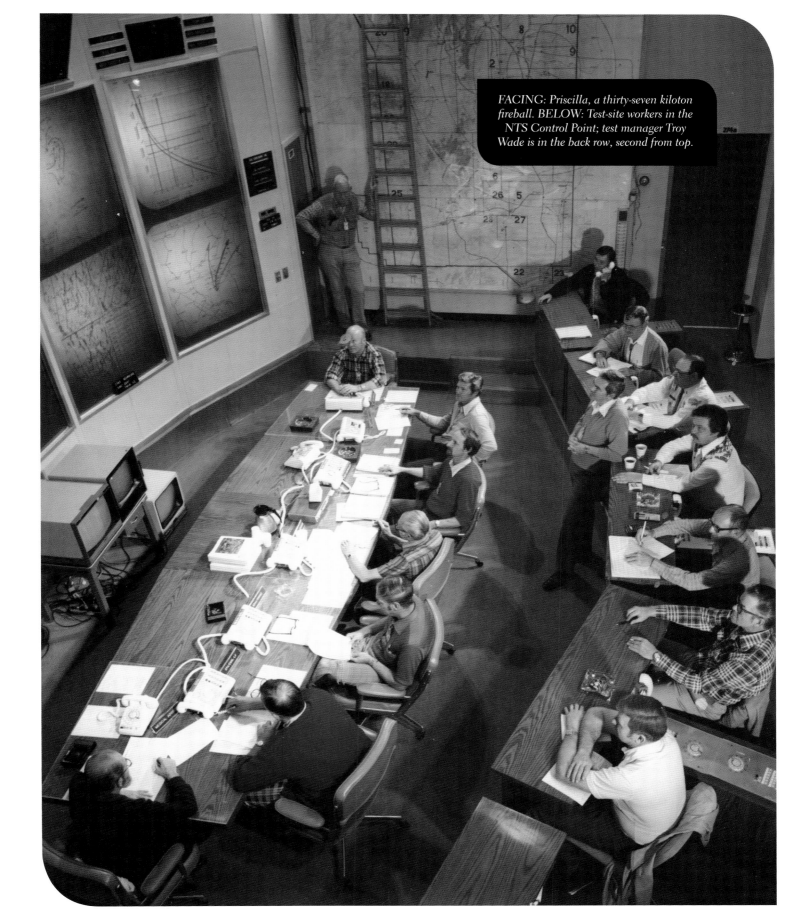

FACING: Priscilla, a thirty-seven kiloton fireball. BELOW: Test-site workers in the NTS Control Point; test manager Troy Wade is in the back row, second from top.

between tests, there was also a bowling alley, softball field, and swimming pool. The Control Point (CP-1), which housed the timing and firing equipment, was located on the crest of Yucca Pass between Yucca and Frenchman flats, the site of most of the tests.

The arcane nomenclature of the test-site operations—Buster-Jangle, Tumbler-Snapper, Upshot-Knothole—was eclipsed only by the names of the tests themselves. The United States nuclear arsenal was harnessed to what could have been a twenty-mule team: Sugar and Uncle, Mike, King and Annie, Badger and Gable, and the aptly named Climax.

Before these powerful forces were unleashed upon the Nevada sky, test conditions were thoroughly vetted by an advisory panel. The panel met the day before each test to assess conditions, then reassembled that evening and again an hour before the scheduled denotation to review the data. The panel had to be unanimous in its agreement that conditions were safe for the test manager to authorize the test to take place as scheduled. "When I was test controller, I never knowingly put anybody at beyond what I deemed to be an acceptable risk," said Troy Wade.

Philip Allen, who served as a member of the panel for Operation Upshot-Knothole in 1952, moved to Las Vegas to head the Weather Bureau Research Station, a civilian weather service independent of the AEC whose task would be to continuously monitor weather conditions to ensure the best possible prediction accuracy. About twenty-four hours prior to the test, Allen and his team would move their forecasting operation to the Mercury base camp, give the afternoon briefing, and then spend the night in the dormitory.

While actual weather conditions were rarely ideal, a test was never allowed to take place if the winds would carry the fallout clouds through rain or over populated areas from which people could not be removed. Calculations of these effects, while imprecise, were made "out to the distance where fallout was expected to diminish to less than a prescribed maximum permissible exposure to humans." (The then-permissible lifetime level of exposure was five roentgens; it has since been reduced to 2.5 roentgens.) Prior to a test, people living on isolated ranches and in small towns within a hundred miles or so outside the test site were paid a per diem to temporarily evacuate the fallout area.

Wearing high-intensity goggles, Allen and other scientists stood on the hillside near the Control Point to watch the blast, which produced what he described as "such intense light that even at that distance through dense goggles, we would be momentarily blinded, and it would be a second or two before one could see the shape of the fireball. With the flash, one's face would feel the heat as if standing too near a large blazing fireplace." After five to ten seconds they removed the goggles, "so fascinated by the spectacle of the rising fireball and formation of the mushroom cloud that one would forget to prepare for the blast arrival." They saw dust kicking up from the desert, followed by the sound of a bang like a loud gunshot and a sudden burst of air pressure that "could knock one's hat off or worse."

Following the denotation of Charlie, a test held as part of Operation Tumbler-Snapper in 1952, Allen and some of the others at the Control Point stepped outside to watch the cloud and felt particles of dust falling on them. "They were probably radioactive," Allen concedes, "but we had no evidence to that effect." The cloud moved off to the northeast, across the barren reaches of the Great Basin.

Ironworker Hal Curtis was at Frenchman Flat, and he didn't go by probability and hard proof; he knew in his gut something wasn't right. In a KNPR interview, he recalled, "And that blast went off, and honest to God, I could see the bones in my arms with my eyelids shut. That's the brightest light I'd ever seen in my

life." Curtis was among those who offloaded the towers after a blast, putting him directly in harm's way. "I was beginning to get the idea that rather than rats and hogs and burros that they was using us for guinea pigs along with everything else," he said. "So I didn't last up there much longer after that. I'm glad I got out of there when I did."

The bombs grew in size and intensity. To test the effects of a nuclear blast on human habitations, houses were built on Frenchman Flat. One house was furnished with furniture from a local department store, and mannequins were placed in the dining room: a 1950s nuclear family of mom, dad, and two kids. While their dwelling, unlike those in other tests, withstood the initial blast, they were reduced to the biblical formulary: ashes to ashes, dust to dust. Their fate, swift and certain, foretold the dreadful end that all mankind faced should these weapons ever be unleashed upon the world. No one wanted to be that family, least of all the residents of Las Vegas. Edward Teller, the physicist who was known as "the father of the H-bomb," was dispatched to the desert to quell any fears Las Vegans might harbor about having the bomb in their backyard. Teller reassured a local audience that "the dangers of radiation pollution have been unjustly overemphasized," adding ominously, "Unless further nuclear testing for peaceful means is continued, man may revert to the Dark Ages."

One man's acceptable risk is another's death sentence; the Dark Ages can take many forms.

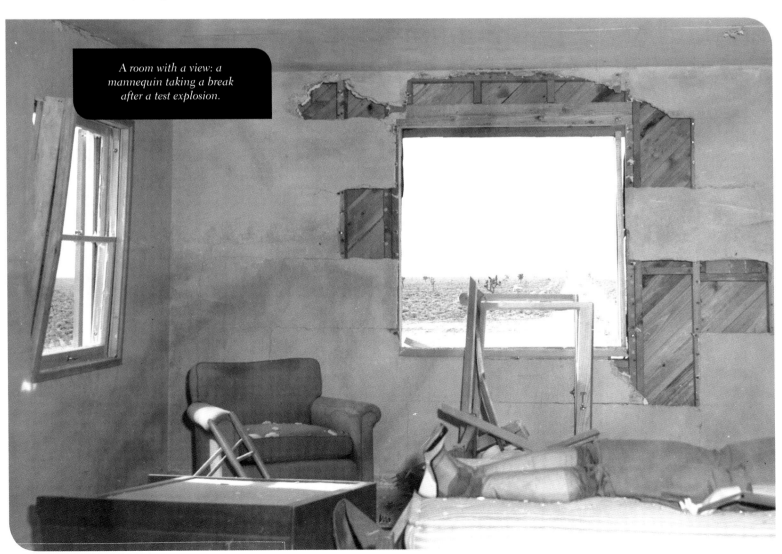

A room with a view: a mannequin taking a break after a test explosion.

THE HOUSE ON FRENCHMAN FLAT

Nuclear slo-mo: Scientists set up a camera six feet away from this house in order to capture the process of atomic destruction.

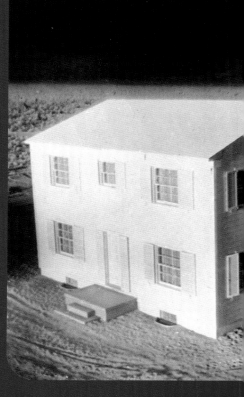

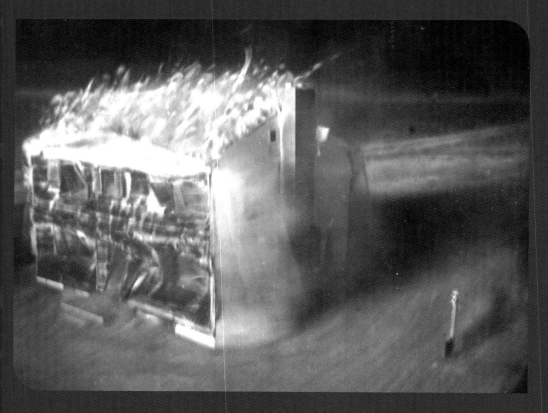

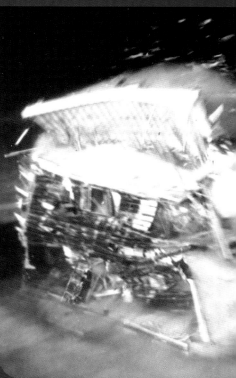

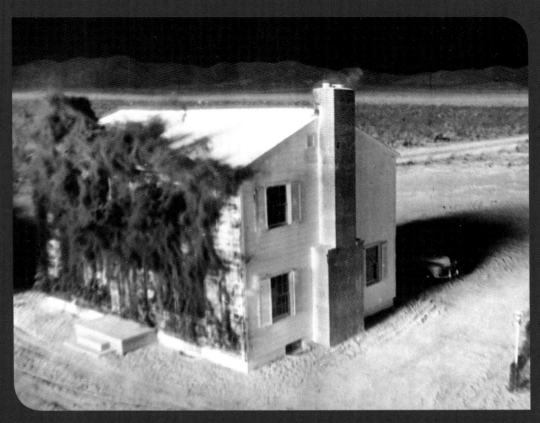

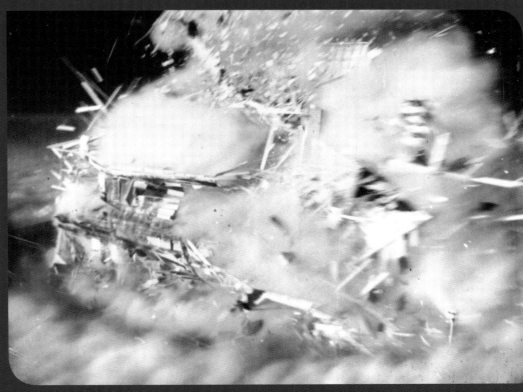

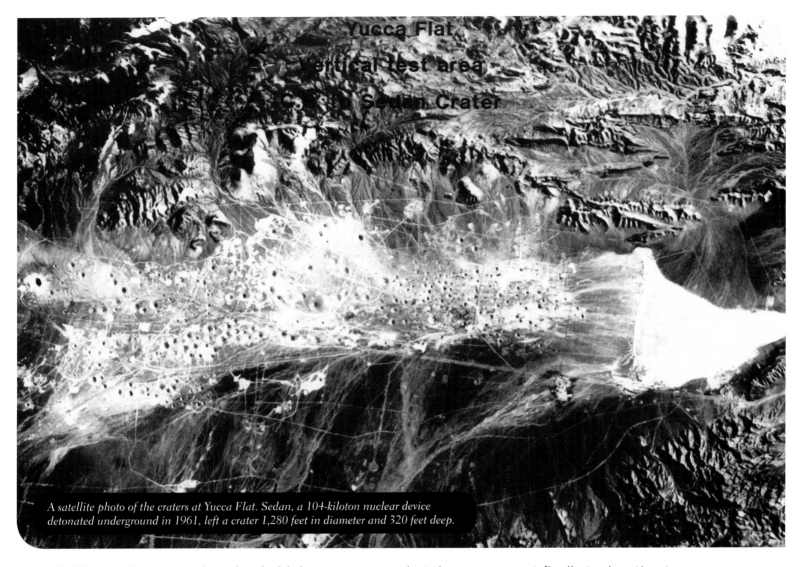

Yucca Flat

Vertical test area

to Sedan Crater

A satellite photo of the craters at Yucca Flat. Sedan, a 104-kiloton nuclear device detonated underground in 1961, left a crater 1,280 feet in diameter and 320 feet deep.

While Las Vegas continued to hold dawn parties and swill atomic cocktails, the inhabitants of southern Utah—the "downwinders," as they came to be called—became the unwitting victims of fallout from the tests. The residents of St. George, Utah, and other communities found themselves directly in the path of radioactive clouds carried to the north and east of Las Vegas on prevailing currents. According to National Cancer Institute statistics, exposure to radiation from the atmospheric testing resulted in an estimated additional 120,000 cases of thyroid cancer, representing a 500 percent increase, with similarly alarming increases in other forms of cancer. It took a half century,

but the government finally took action to compensate the victims with the passage of the Radiation Exposure Compensation Act (RECA) Amendments in 2002, which awarded $50,000 to $100,000 to affected individuals or surviving family members.

In 1958, the tests were abruptly halted. The Americans and the Soviets, apparently having come to their senses, agreed to a moratorium on nuclear testing. The Nevada Test Site was once again a vast empty desert, inhabited by jackrabbits and coyotes. And so it might have remained, except that in 1961, the US government learned that the Soviets had abrogated the treaty, and a livid President Kennedy ordered the resumption

of testing. Operation Nougat ushered in a virtual frenzy of tests, as the American nuclear program struggled to make up for three years' lost time. Two years later, the two superpowers signed the Limited Test Ban Treaty, and nuclear testing went underground.

Even underground testing came under fire from protestors. In 1960, Mothers Strike for Peace, dressed demurely in house dresses, paraded outside the Test Site entrance, pushing baby carriages and carrying posters and stop signs. Members of Lenten Desert Experience held a prayer at the entrance vigil in 1982, their signs imploring the government to Beat Their Swords into Ploughshares. In January 1991, Greenpeace organized a mass demonstration of about two thousand people, some of them children wearing tee shirts with peace symbols.

In 1967, an urgent entreaty to halt the tests came from the city's new savior, Howard Hughes. A recluse and germophobe with a severe case of OCD (and how better to aggravate OCD than conducting nuclear tests sixty miles away), Hughes was incensed that nuclear testing was taking place so close to him and the Strip hotels that he had been steadily acquiring. Hughes threatened to withdraw his considerable investments; according to aide Robert Maheu, he also offered President Johnson $1 million to stop the tests, and later made the same offer to President Nixon. Despite this generous quid pro quo, the tests continued,

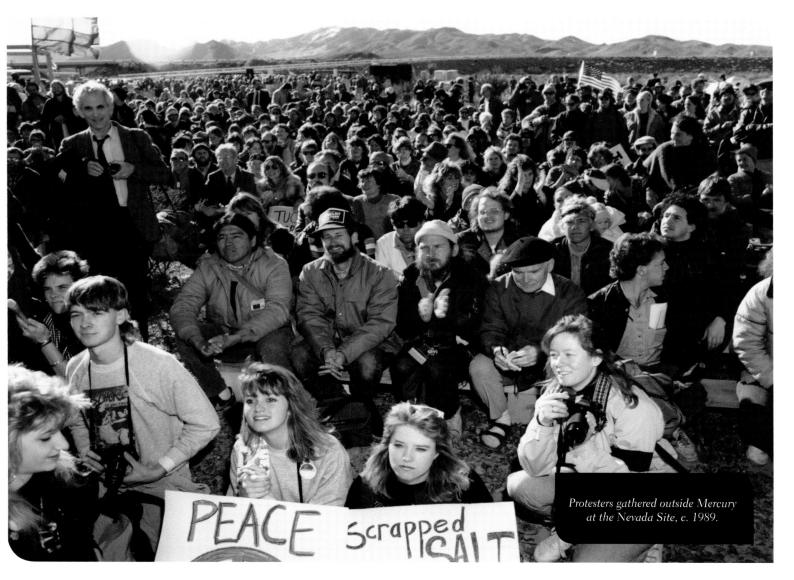

Protesters gathered outside Mercury at the Nevada Site, c. 1989.

PEACE Scrapped ISAIT

and every few months, in the desert predawn, Hughes would awaken in his darkened chamber at the Desert Inn, his bed gently undulating to the strains of the atomic lullaby.

In 1992, the last test, number 1054, was conducted at the Nevada Test Site. Called Divider, its purpose was to "ensure the safety of U.S. deterrent forces." But like radioactive fallout, the test site and the nation's nuclear energy policy continued to engender controversy. In his first term, President George W. Bush selected Yucca Mountain in Nevada as a repository for seven hundred thousand metric tons of nuclear waste. Most Nevadans, including Senator Harry Reid, vigorously opposed what they saw as a kind of vast eastern conspiracy to turn the state of Nevada into a nuclear waste dump and endanger its citizens—not to mention imperil the gaming industry. "A nuclear waste dump is a showstopper for Nevada," said publisher Brian Greenspun, son of Hank Greenspun. "There will be an accident. The only question is, where or when it will happen."

The test site has preserved its legacy at the Nevada Test Site Historical Foundation on Flamingo Road. Here, visitors can enter a bunker and experience a simulated atomic test, complete with blinding light and shuddering ground, much like a ride at Disneyland. The exhibits chronicle the test site's history in a series of sobering photographs and artifacts. The gift shop provides literature about the test-site experience, along with tee shirts, mugs, and refrigerator magnets. For those craving a more immediate experience, the Department of Energy conducts tours of the real test site, which include a visit to the Yucca Mountain Science Center and a bus trip to Mercury and Yucca Flat. In 2002, Rick Bibbero won an award for his mushroom cloud license-plate design, confirming that Nevadans sill harbor a secret affection for the bomb.

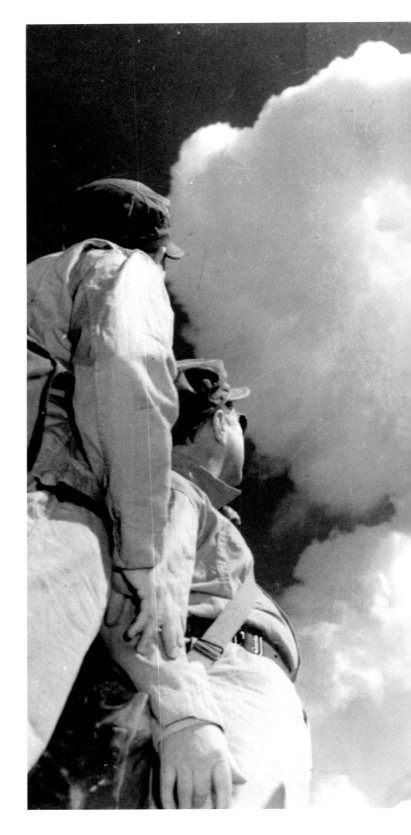

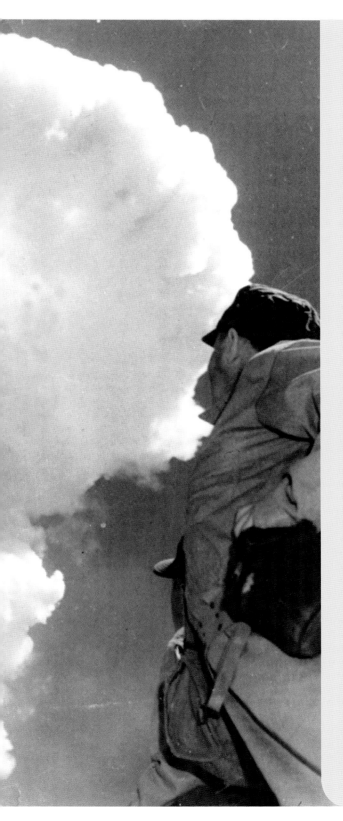

THE BANEBERRY OF THEIR EXISTENCE

I t was 1970, and there were only seven more shopping days until Christmas. Evidently, there was not a numerologist sitting on the Safety Advisory Panel to give the okay for the Baneberry test, as he or she might have noted that this test—number 666, the devil's number—was not propitious from a numerological standpoint. But the panel members were not a superstitious lot. The ten-kiloton device was detonated on schedule at a depth of 910 feet in Area 12 of Yucca Flat.

Then something went terribly wrong. Gas and debris spewed ten thousand feet into the air and vented from the earth for several hours. Several hundred workers in Area 12 Camp, about four miles from the explosion site, were evacuated. Afterward, it was determined that there was a geologic fault in the alluvium, which widened when the explosion occurred.

Two of the guards who had evacuated the workers in Area 12 developed leukemia. Four years later, they died. Their widows filed suit in federal court, charging the US government and its contractors for mismanagement and misconduct resulting in the death of their husbands. Philip Allen, a member of the advisory panel, was called as a primary witness for the government. He was on the stand for two and half days, explaining the videotapes and reports about the incident. The trial dragged on for three months; the judge's verdict took five years. Federal judge Roger Foley finally determined the plaintiffs had not offered sufficient proof that exposure to radiation had caused their husbands' deaths. Their widows did not receive any compensation for their loss—except the grim satisfaction offered by the judge's ruling that the government had not followed proper safety precautions.

"No One's Sister Lives in Las Vegas"

> **"I NEVER WANT ANYBODY TO BE ASHAMED OF LAS VEGAS. IT'S THE ONLY HERITAGE I CAN LEAVE MY KIDS."**
>
> — HANK GREENSPUN
> PUBLISHER, *LAS VEGAS SUN*

It was 1955, and restlessness was upon the land. An Iowa woman, upon learning that her sister was moving to Sin City, exclaimed, "No one's sister lives in Las Vegas!" The mere notion that people lived in this Sodom and Gomorrah on the Mojave defied imagining; that one's flesh and blood would move there seemed to go against any notions of decency and common sense. Would there be schools and hospitals and houses of worship? Would there be houses of any kind, other than those of ill repute?

As for the sister, when she learned that her husband had been offered a job with the Atomic Energy Commission to forecast the weather for the Nevada Test Site, she did not hesitate: "Let's go!"

They came to Las Vegas, along with thousands of others, for here on the desert were wide-open

The Welcome to Las Vegas sign at the south end of the Strip greets new arrivals to the city.

Women playing pool slots at the Sands, 1965.

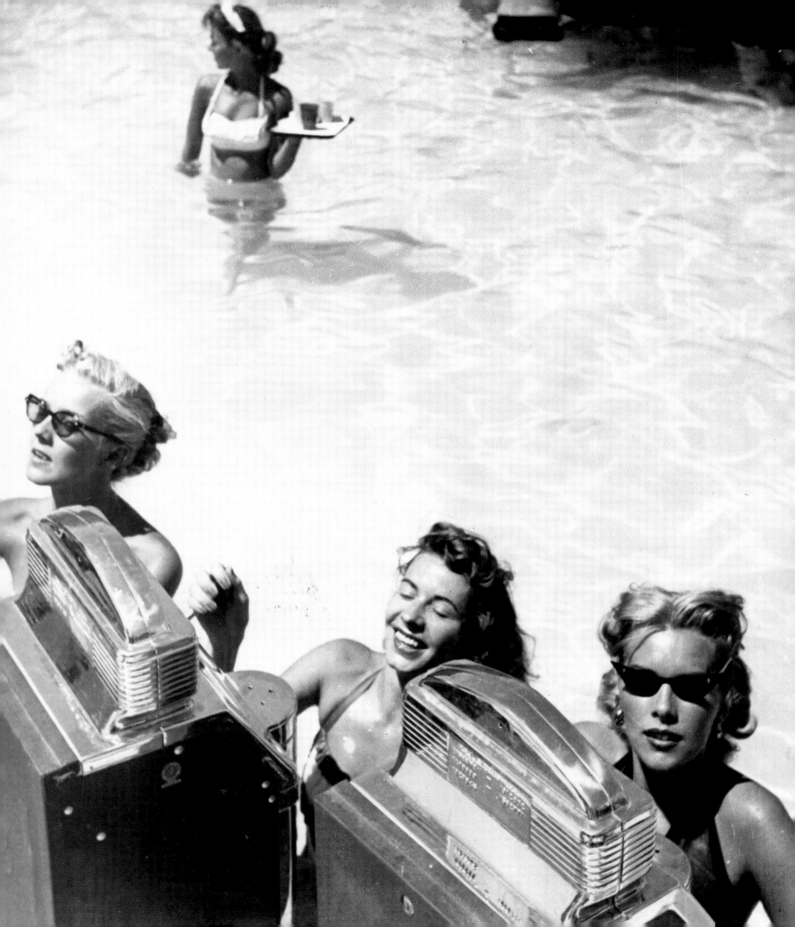

spaces, freedom, a tabula rasa upon which hopes and ambitions, both religious and secular, could be writ large under a high dome of blue Nevada sky.

Angels in America

ROY: Huh. Mormons. I knew Mormons, in, um, Nevada.
JOE: Utah, mostly.
ROY: No, these Mormons were in Vegas.
 —from *Angels in America* by Tony Kushner

The playwright Tony Kushner, one of those writers who knows us better than we know ourselves, got it right—Mormons are in Vegas. They made their first foray into the Las Vegas Valley nearly a century before the arrival of Bugsy Siegel and company. In 1856, Brigham Young, the titular head of the Church of Jesus Christ of

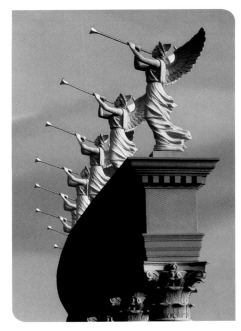

Angelic trumpeters at Caesars Palace.

Latter-day Saints, dispatched a party from Salt Lake City to establish a way station for missionaries traveling to California.

The Mormons believed the native inhabitants of the Americas to be the direct descendants of the Lost Tribes of Israel, who came to the New World some six hundred years before the birth of Christ. Thus, unlike the Spaniards who preceded them, they had an irresistible selling point with which to tempt the Paiutes—who had occupied the region for thousands of years—into

Red Rock Canyon.

converting. Perhaps not cognizant of their lineage, the Paiutes took one look at the newcomers and, according to one report, ran like wild deer. Later they took to making frequent raids on the Mormons' fields; the withering sun took care of the remaining crops.

Three years later, Brigham Young, whose colonial ambitions had sounded an alarm in Washington, recalled his colonizers to Salt Lake City. They returned, along with thousands of others, while in the meantime the Lord looked down upon the desert and said, Yea, verily, let there be light . . . light, power, and water.

Electrifying the Desert

It was an act of man, not God, that finally brought life to the desert. In 1928, President Calvin Coolidge signed into law a bill authorizing $175 million for the construction of a dam in Black Canyon, thirty miles southeast of downtown Las Vegas. Its purpose was to control flooding from the Colorado River; its effect was to unleash a flood of construction in the Las Vegas Valley and channel a river of tourists into the city.

Construction on the dam began in September 1929, just a month before the collapse of the New York stock market. Interior Secretary Raymond Wilbur, who came to town for the ceremonial laying of tracks for a new rail spur to the construction site, had his pockets picked moments after arriving in town.

Unemployed workers descended en masse with their families to work on the dam. In total, approximately 21,000 men were hired. Though the dam was a federal project, all the workers given jobs were white. Only after pressure was put on by the NAACP were ten black men hired in July 1932.

The work was dangerous and grueling. In summer, temperatures in the canyon reached 135 degrees, and the rocks were literally too hot to touch. But the drilling and blasting continued, and concrete was poured twenty-four hours a

Valley of Fire.

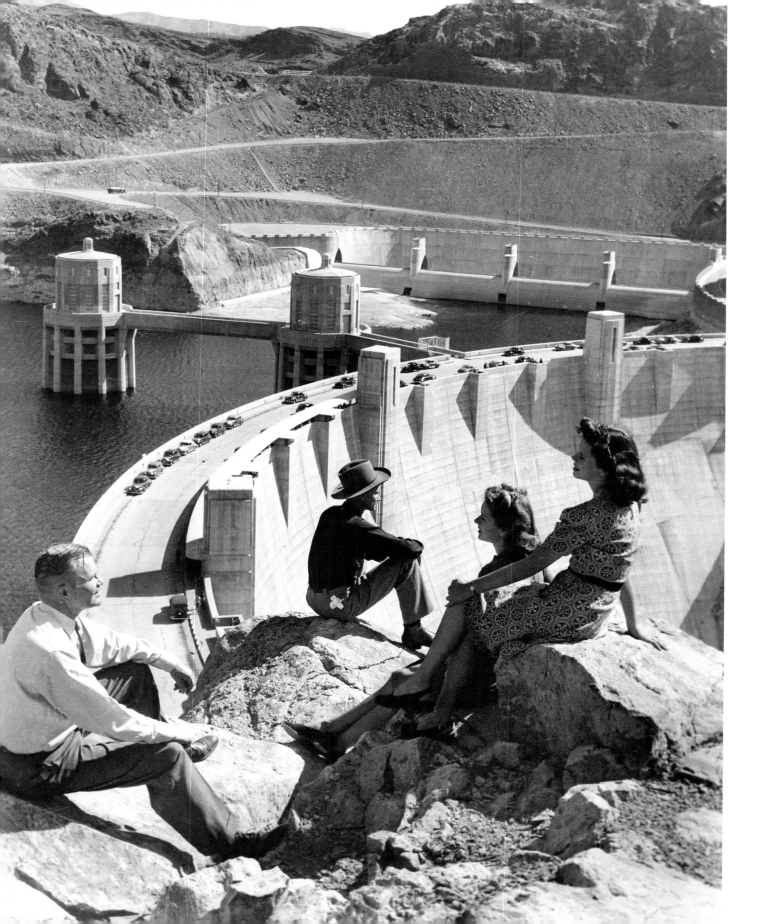

day for two years—enough to pave a sixteen-foot-wide highway from coast to coast.

To alleviate living conditions, the federal government built a town just above the dam site. Boulder City was what Brigham Young might have envisioned: wholesome, clean, sober—a family community. There was no gambling, and the only drink to be had required a trip down to that vale of sin, Las Vegas.

🛠 *Dam Stats*

HEIGHT: 726.4 feet from foundation rock to crest
WEIGHT: More than 6.6 million tons
CONCRETE: 3.25 million cubic yards

The men were free to come and go—and go they did, on payday, into Vegas to drink and gamble and sample the pleasures of the flesh on Fremont Street's infamous Block 16. The Meadows Club, a plush roadhouse on the Boulder Highway, offered what was then an unheard-of luxury: air-conditioning. To the dam workers, it must have felt like the Garden of Eden.

Finally, in 1936, the dam was completed. The cost was $8 million; the death toll from accidents and heat and carbon dioxide ranged from 96 to 112, depending on which account you read. The dedication, with President Roosevelt lending his blessing from Washington, was held on September 26. Though the official name had been changed to Hoover Dam, in honor of the sitting president during the Crash

Winged Figure of the Republic, Hoover Dam. FACING: Visitors perch on a rock for a view of the dam.

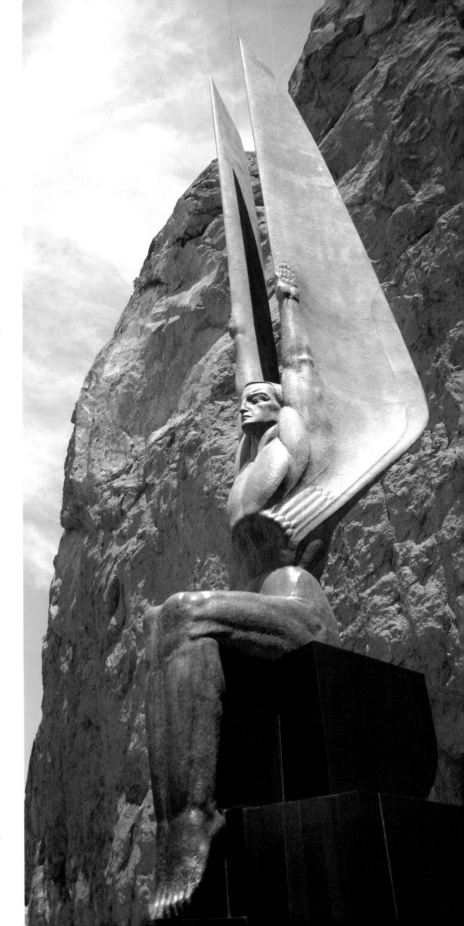

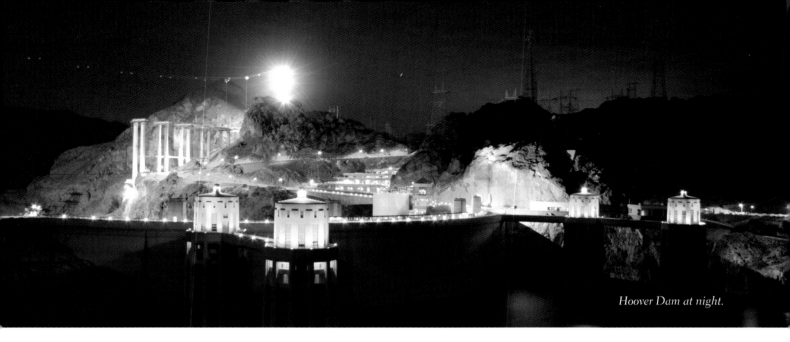

Hoover Dam at night.

of '29, most people continued to refer to it as Boulder Dam for years to come.

This was not merely a dam; this was, like the pyramids of Egypt, a monument to human ingenuity, an engineering marvel, an architectural wonder. Designed in the art deco style of the era, it had that lofty mien of the great civic structures of the day. Sitting atop the pillars were the Winged Figures of the Republic, bronze-shelled statues erected as a monument to higher intelligence. After World War II, the figures were rededicated to the men who built the dam. Today, the dam supplies electricity to much of the Southwest, including the Las Vegas Valley and Southern California.

Would Jesus Split a Pair of Tens?

Hoover Dam was transforming: suddenly, this desolate valley in the middle of the Mojave was viable for human habitation. With lights and air-conditioning, it was conceivable, even desirable, to live here. By the 1950s, the population of the Las Vegas Valley had burgeoned to 44,600. Despite its nickname, this was no Sin City—the chamber of commerce could proudly assert that

the city had more churches per capita than any other city in the nation. The heirs of Brigham Young were everywhere throughout southern Nevada—the classrooms, the school board, the courtrooms, the county commission, the banks—even the casinos. So pervasive was their influence that the term "Mormon Mafia" was occasionally invoked. Financed by Utah banks and run by Parry Thomas, a Mormon banker, the fledgling Bank of Las Vegas made loans to a dozen Strip hotels in the 1950s, including the Sahara, the Desert Inn, the Sands, the Dunes, and the Stardust.

Even though it had in effect financed a gambling empire run by the Mafia, the Mormon Church did not brook any compromise in the standards of behavior for its members. Any unseemly display of the body, particularly by women, was viewed as an affront to Mormon virtue. Thus, when it was discovered that a nudist colony was being run by a Mormon couple in Paradise Valley, a broad expanse of then-undeveloped land east of the Strip, the church dispatched one of the faithful to investigate the "bare facts." Rulon Earl, son of the bishop of the Las Vegas First Ward, and his wife drove out to the camp, where they were greeted by the un-Mormon sight of people frolicking in a

swimming pool in the buff. The couple running the camp insisted that nothing in their practices was inconsistent with the doctrine of their church; indeed, they proclaimed that they would renounce their membership rather than don clothes. A bishop's court was convened, and the nudists were "disfellowshipped"—an LDS euphemism for getting kicked out of the church.

The Mormons were not the only game in town, ecumenically speaking. Located only a few miles from the fleshpots of the Strip, on Charleston just north of the underpass, was the First Presbyterian Church of Las Vegas. Built in 1954, the church was a stolid foursquare structure lacking the panache of the Flamingo or the Sands but providing such creature comforts as padded pews. The minister, Walter Hanney, was a tall, gray, balding man ideally suited to ministering to this flock that he described as "good solid family people, just like you have in any good American city." Within a year, this holy place in an unholy city was named Church of the Year.

Little Beverly Hills

Regardless of religious affiliation, residents of Las Vegas evinced a desire to live away from the heart of the city, to literally turn one's back

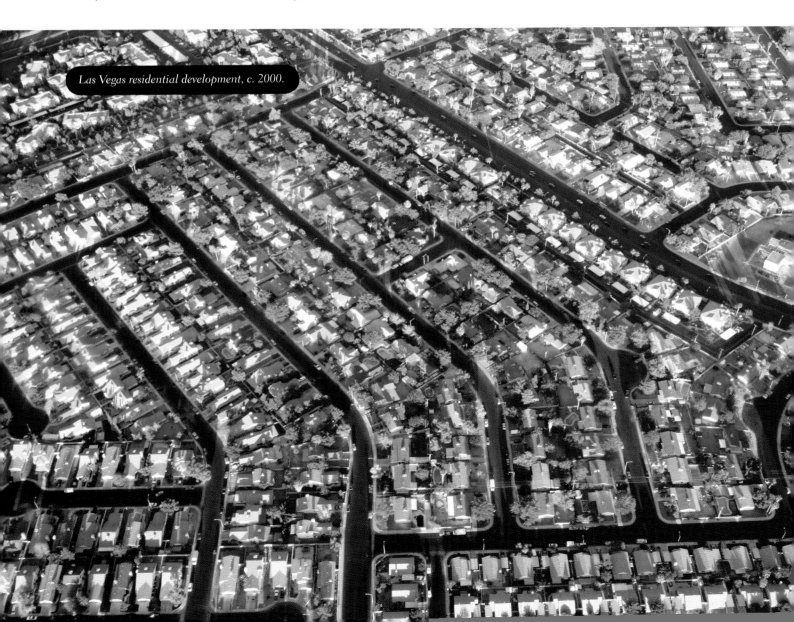

Las Vegas residential development, c. 2000.

on the Strip. The old money gravitated to the exclusive neighborhood of Rancho Circle. In the 1940s, two local entrepreneurs purchased eighty acres from the Union Pacific and built show-places on one-acre lots, selling them for the princely sum of $1,500 each. Early residents included casino executives and entertainers, among them Phyllis McGuire, lead singer of the McGuire Sisters, who referred to her elite sur-roundings as "Las Vegas' little Beverly Hills." Legendary socialite Mitzy Hughes' luxurious home was a popular stop on the Halloween cir-cuit because, as one trick-or-treater recalled in Geoff Schumacher's *Sun, Sin & Suburbia,* "she gave the best stuff." However, being an exclusive neighborhood, Rancho Circle was closed off to the hoi polloi—kids from, say, Bonanza Village, could not enter the portals of this sheltered enclave. One new arrival in town bought several homes here—Howard Hughes, the eccentric bil-lionaire, drawn to this lushly landscaped enclave with its tree-lined streets and faint air of para-noia about keeping out the riffraff.

Metastasis

The writer Susan Sontag once warned against the use of cancer metaphors, but it seems apt to use the term "metastasis" to describe the growth of Las Vegas. Even more than the other Sunbelt cities, Las Vegas is growth run amok, an unchecked sprawl of hastily built develop-ments that stretch from one end of the valley to the other and even crawl up the sides of the surrounding mountains. Between 1960 and 1970, the Las Vegas area experienced a 115 percent increase in population, from 127,000 to more than 273,000; by 1980, that figure had nearly doubled to 461,816. And still they kept coming. By the arrival of the new millennium, the area had reached a staggering 1.6 million people.

Gone is that sweet, clean desert air. Gone are the apricot orchards on Smoke Ranch Road, where children used to swim in irrigation ditches. Gone is that small town where everyone knew their neighbors and you could sell cookies door to door without worrying much about who might answer the bell. The infrastructure—the roads and schools and hospitals—is now barely able to keep pace. Water, that most precious commodity, is lavished on new developments and hotels as though Vegas were in the middle of a rainforest instead of a desert.

In the 1980s, land once owned by Howard Hughes became the site of a master-planned community of twenty-five thousand acres. Named Summerlin, which was Hughes' grand-mother's maiden name, it was conceived as a series of villages made up of condominiums, single-family homes, and golf courses. In a radical departure from the usual Vegas infatua-tion with grass and water-thirsty plants, desert landscaping was generously employed, with a system of hiking trails throughout. Summa Corporation, which developed the project, had its eye on Red Rock Canyon to the north, but a concerted effort by the Nature Conservancy

and the Bureau of Land Management resulted in a land swap, with Summa ceding more than four thousand acres east of Red Rock in exchange for land south of Summerlin. An immediate financial success, Summerlin became known as the "Scottsdale of Las Vegas." Largely lily-white, with 78 percent Caucasian residents, it reflects a particular demographic; with its carefully groomed landscaping and rows of

tax. They can live out their golden years in pleasant retirement communities such as Sun City Summerlin. The young and unskilled come for jobs in the hotels. Vegas has been called "the new Detroit" because it is a place where unskilled workers can afford to buy a house and a car and live the American Dream. Colette Diamond, who moved to Las Vegas with her husband, took a job as a cocktail waitress.

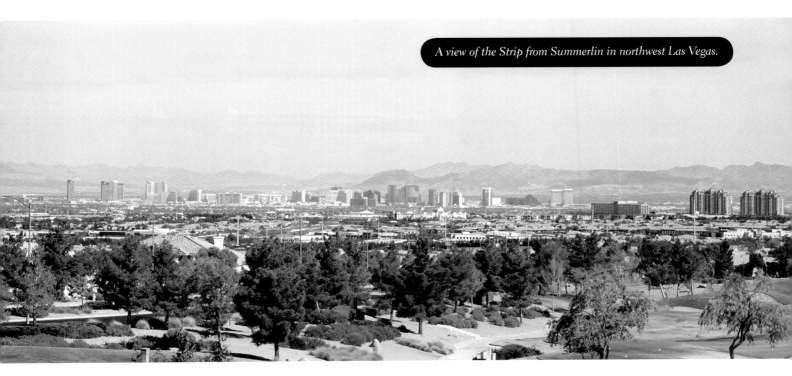

A view of the Strip from Summerlin in northwest Las Vegas.

beige houses with red-tile roofs, it conforms to the master-planned design standards. It is as natty and well groomed as a country-club golfer, but it lacks the character and individuality of the old neighborhoods.

Summerlin and other suburban developments could not mask the fact that Las Vegas had become a large city with all the attendant social and aesthetic problems: crime, congestion, smog, inadequate health care, and a freeway interchange so snarled that it's called the Spaghetti Bowl. So why do people continue to come here? The elderly come to retire, as the weather is good and there is no state income

The couple was able to save enough for a down payment on a house. "If somebody would've ever said that our daughter would go to Las Vegas schools or that her birth certificate would say Las Vegas, you never think that because you think Sin City," she confided in a 2005 NPR documentary.

But living in Vegas is a two-edged sword, especially when it comes to raising children, as Diamond was to discover. She recalled that moment of epiphany: "I came home one day, and my daughter had on my cocktail outfit. She says, 'Mom, I want to be just like you.' So I started real estate school the next day."

IT TAKES A BONANZA VILLAGE

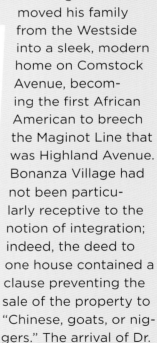

Upon arriving in Las Vegas in 1955, we made our home in one of the new subdivisions that had sprung up on the city's perimeter. Bonanza Village, antecedent to the TV show *Bonanza*, paid homage to the city's frontier heritage, with all of the streets named for the Gold Rush: Comstock, Virginia City Avenue, Gold Mine, Sutro. There were no sidewalks or streetlights, but no one missed these suburban niceties—the lots were large, the houses set well apart, and there was a sense of spaciousness. From her kitchen window my mother had an unobstructed view of the mountains to the north. Also visible to the north, on certain predawn mornings, were explosions from the atomic bomb.

In accordance with Midwestern propriety, we planted a front lawn, a vast, scorched plain of razor-sharp grass that Indian ascetics would have paid good money to walk across. While almost everyone converted their garage into a family room, ours was turned into a music studio.

Next door lived a water district manager; on the other side, a scientist who worked at the test site. He was succeeded by the owner of a used-car lot, and later, a test-site construction worker who also worked as an engineer with the Union Pacific.

There was at least one gambler in our midst: the notorious Benny Binion, the former bootlegger who owned the Horseshoe Club down on Fremont Street. He lived in a mysterious walled compound, and we kept a respectful distance—you did not try to make Benny Binion come out.

"Guess Who's Coming to Dinner?"

An inveterate gambler and murderer was one thing: Dr. Charles West was quite another. In the early 1960s, the doctor and civil rights leader moved his family from the Westside into a sleek, modern home on Comstock Avenue, becoming the first African American to breech the Maginot Line that was Highland Avenue. Bonanza Village had not been particularly receptive to the notion of integration; indeed, the deed to one house contained a clause preventing the sale of the property to "Chinese, goats, or niggers." The arrival of Dr. West caused much consternation among white residents, but despite their fears, property values did not tumble, crack dens did not open on the corner, and no one danced the Watusi down Virginia City Avenue.

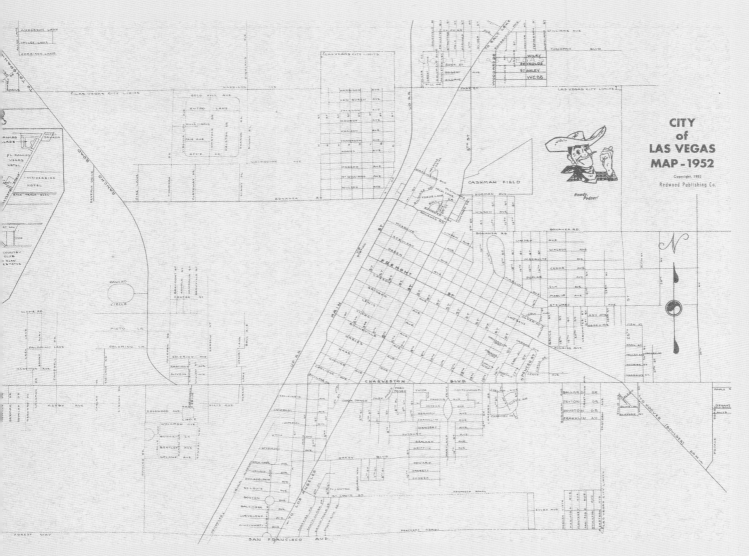

CITY
of
LAS VEGAS
MAP - 1952

Copyright, 1952
Redwood Publishing Co.

Howdy Podner!

One day my brother Peter burst into the house with the news: "Guess who's coming to dinner?" The movie by that name had just been released, and a black family moving in next door seemed the most delicious instance of life imitating art. Curtis Amy, the father, worked on a construction crew at the test site, and Ruby Amy, the mother, worked in personnel at Sears. The oldest of the four children was away in the army; the others were pursuing their talents in arts and math and sports.

On weekends, their driveway was filled with cars of family and friends from the Westside. The smell of the smoke from the barbecued ribs wafted over into our yard, the tantalizing aroma driving us mad. Finally, the day arrived when our families got together for a barbecue. I observed closely how the dad prepared the meat and made his sauce, and later I tried in vain to duplicate it. There was some secret ingredient that he wasn't revealing, some subtle spice or deft technique that was not for me to know.

Other black families eventually followed, and white flight began in earnest. Today, Bonanza Village, a mostly black neighborhood, is surrounded by a cinder-block wall to protect the residents from crime. They escaped one ghetto only to find themselves living in another.

Black, White, and Green

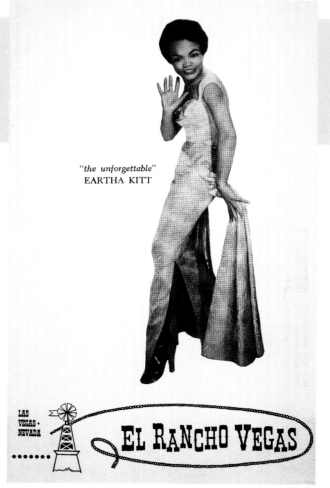

"the unforgettable"
EARTHA KITT

LAS VEGAS · NEVADA

EL RANCHO VEGAS

If ever there was a place on this earth that should have been a model of egalitarianism— where people would be judged not by the color of their skin, nor by the content of their character, but by the number of bills in their wallet—it was Las Vegas, where anyone with enough for a minimum bet should be allowed, indeed, encouraged to take a seat at the table and be dealt a hand in the American Dream. Yet for many years in the life of this raw young city, bigotry and prejudice held the high cards.

In 1947, the best a young black man newly arrived in Vegas could do for entertainment was to head down to Fremont Street and go to the movies. An up-and-coming black entertainer bought a ticket and tried to lose himself for a couple of hours in the song-and-dance routines of Mickey Rooney and Danny Kaye. Abruptly a hand yanked

Eartha Kitt was allowed to stay in a bungalow at the El Rancho Vegas while she performed there.

Frank Sinatra and Count Basie in a backstage dressing room, January 1964.

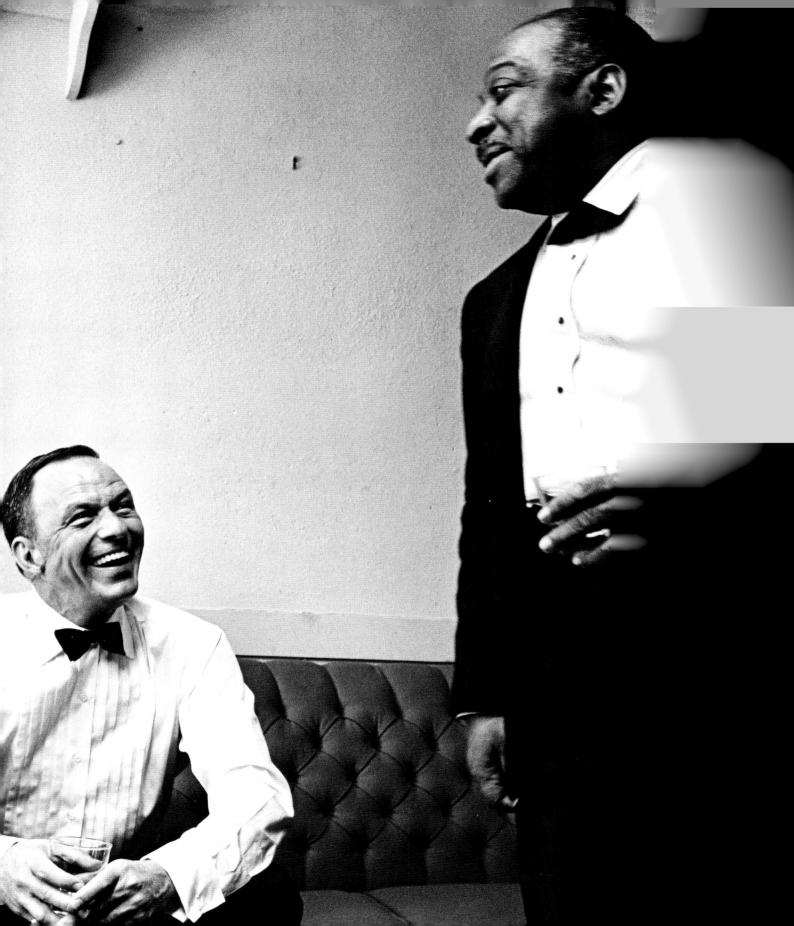

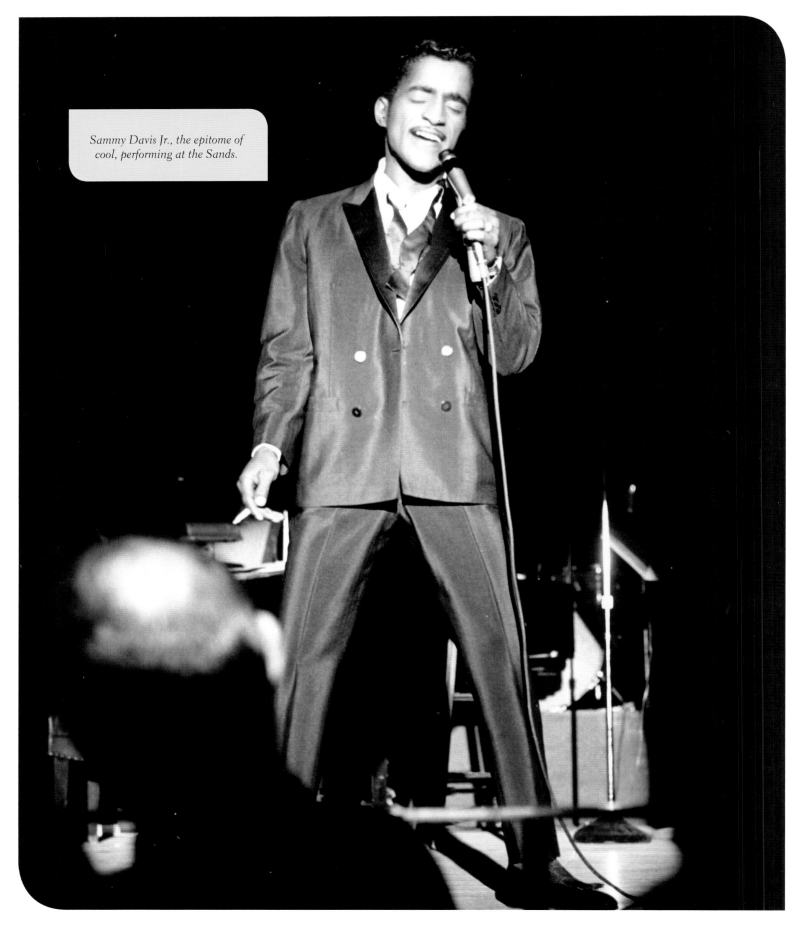

Sammy Davis Jr., the epitome of cool, performing at the Sands.

him from his seat and dragged him out into the lobby. A white man in a ten-gallon hat and sheriff's star pinned to his shirt slapped him across the face. "You're in Nevada now, not New York," he said, pointing to a sign: Colored Sit in Last Three Rows.

Welcome, Sammy Davis Jr., to the Mississippi of the West.

The slap was just one in a series of shocking humiliations that Davis and his fellow black performers endured in the 1940s and '50s in Las Vegas. Davis was a member of the Will Mastin Trio—the "kid in the middle," he was called—and they were booked to perform at the El Rancho Vegas, a swank new hotel on the Strip. When they arrived at the hotel, they were informed that they would have to find rooms on the "other side of town"—the Westside, about a fifteen-minute cab ride from the Strip and a hundred-year regression into the grim realities of Jim Crow. Davis was shocked by the squalor and abject poverty that he witnessed—a naked toddler standing in front of a shack made of cardboard and crates recalled images of Tobacco Road. The trio checked into a Mrs. Cartwright's boarding house, where they were charged $15 for one room, nearly quadruple the $4 room rate at the El Rancho. When they protested, the landlady replied, "Then why don't you go live at the El Rancho?"

She knew the answer, and was cynically exploiting it—in Las Vegas, segregation was as pernicious as that in the Deep South. The big-name black stars signed to perform in the hotel showrooms could sing and dance, but after the performance ended, they had to retreat to the rooming houses and shabby hotels on the Westside.

Somehow Vegas had managed to conceal its shameful secret from the rest of the world; even the larger black community was unaware of

the extent of the racist policies in Vegas. James Goodrich, a journalist on assignment for *Ebony*, arrived in town in 1954 to interview a black star appearing in the showroom at the Sahara. He stood on the curb at the airport as cab after cab passed him by—Ralph Ellison's invisible man. He called the hotel and they sent a car for him. He interviewed the star in her dressing room, and later that day he paid a visit to the Westside, where he walked up and down Jackson Street,

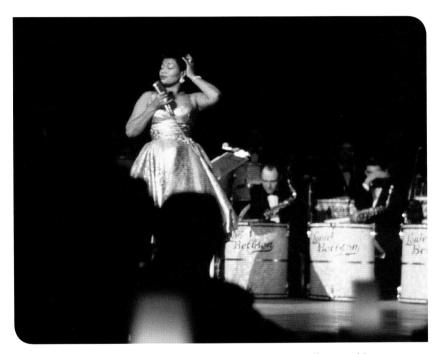

Singer Pearl Bailey with her husband, jazz drummer Louie Bellson, and his orchestra at the Flamingo during the late 1950s.

lined with black-owned businesses and black-owned casinos confined to their ghetto, separate and decidedly unequal.

After experiencing a day in the life of a black man in Las Vegas, Goodrich wrote a scathing indictment of Sin City. Entitled "Negroes Can't Win in Las Vegas," the article charged that Vegas had "more racial barriers than any other place outside of Dixie." Goodrich also accused local blacks of failing to band together to put pressure on city government, attributing their

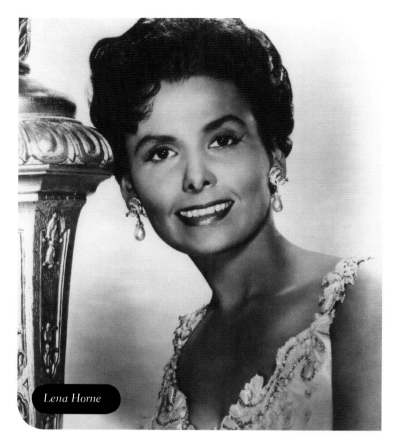

Lena Horne

complacency to the fact that "many are illiterates who only recently migrated west from the rural South."

His fury at his own people caused a stir among the local black community, which had not yet fully embraced the civil rights movement. Among the big-name black stars, however, there were a few who were determined to force the hotels' hands. While the deck was stacked against them, they did have one hole card—their talent that brought people to the hotels—and they played this card shrewdly, winning what concessions they could. In the process, they endured yet a new round of humiliations so unspeakable that they seem apocryphal. Yet in account after account, oral and written, the unspeakable is affirmed, the evidence cumulative and convincing.

In this high-stakes game for respect and equality, black women proved that they could bluff with the best of them. Basking in the pink glow of its success, the Flamingo booked singer

Pearl Bailey to perform, but being black, she was not allowed to stay at the hotel. She feared Bugsy Siegel, but that did not stop her from confronting the mob boss one night, according to an account by Trish Geran, whose aunt was employed on the Strip. Incensed that she had not been provided with a white tablecloth for her dressing table, Bailey swept past Siegel in the hallway, and he obligingly followed her to her dressing room.

Coolly sipping a martini, she asked, "Are you Bugsy Siegel?"

"My friends call me Benjamin, my enemies call me Bugsy."

When she demanded a tablecloth be placed on her dressing table each night before her performance, he said, "Is that all? Anything else?"

Being from the school that "a closed mouth can't get fed," she replied, "Well, since you asked, I would like a fire-engine-red Roadmaster Buick. I'm tired of bumming a ride to the show every night. My car's in L.A. and cabs don't run on the Westside. So how about it?"

The next day, she entered her dressing room to find tablecloths piled high on the table. After the show, when she arrived at her rooming house on the Westside, there was the red Buick out front with the keys in the ignition.

"For months, the whole town talked about Pearl and Siegel," Geran wrote. "It was said to have been her best performance."

Lena Horne upped the ante, demanding that she be put up at the Flamingo. Such was her star power that the management made a concession and installed her in a cabana out by the pool. This preferential treatment, according to Geran, was because of Horne's light skin, allowing her to pass as "almost white." But she was just black enough that management felt obliged to have the sheets stripped from her bed every morning and burned.

Josephine Baker was subjected to a similar pattern of appeasement and egregious insult. The toast of Paris, adored by her French fans,

she made her one and only Las Vegas appearance at the Last Frontier. Appalled to discover that there were no blacks in the audience for her show, she informed the management that unless blacks were admitted to the second show, she was going to walk off. The curtain went up, and there in the front row was a black couple dressed to the nines, the man in a tuxedo, the woman in an evening gown. Ms. Baker did her show, unaware that the couple was in fact a porter and maid who had been ordered to masquerade as guests. Accustomed to going where she wanted and doing what she wanted, Ms. Baker expected to have the run of the place. One hot afternoon, she took a dip in the pool. At the insistence of the white guests, the pool was drained and cleaned. She never returned to Vegas.

In the 1950s, the Strip hotels adopted a variation on the "separate but equal" policy—black performers were allowed to stay as long as they were discreet and did not venture into white domains: the pools, the restaurants, and the casinos. Some took their exile with a kind of wistful resignation. Booked into the El Rancho in 1954, Eartha Kitt was shown to a bungalow that she described as a "cabin of luxury" filled with flowers and champagne. "I felt strange and alone, but wanted," she recalled.

White entertainers were shocked to discover that black entertainers were not treated as equals. Debbie Reynolds invited Sammy Davis Jr. to accompany her to the El Rancho to catch some comics. Davis informed her that he wasn't allowed to leave the Sands. Indignant, she called the El Rancho, certain that there had been an error. This was Sammy Davis Jr., her friend. "Sorry, Debbie," she was told. Reynolds could not countenance this unabashed discrimination. Her wide-eyed innocence and wholesome demeanor disguised an inner toughness; she joined with other white entertainers in refusing to work unless concessions were made for her black friends.

One night at the Sands hotel, Frank Sinatra came across Nat King Cole eating in his dressing room. Cole was not unfamiliar with discrimination, having endured banishment to the Westside, where he paid $15 a night for a filthy motel room. So to even be permitted to stay at the Sands for an engagement was a victory of sorts. But Ol' Blue Eyes was shocked. He asked Cole's valet, who was black, why this major star, who was also his friend, was eating in his dressing room. The valet patiently explained that colored people were not allowed in the dining room. Fuming, Sinatra informed the maître'd that he would have everyone fired if his fellow black entertainers were not allowed in the dining room. That night, he invited Cole to meet him in the Garden Room for dinner. Such was Sinatra's power that no one dared challenge him.

Sinatra performed in concert with the Count Basie Orchestra in 1964. It was a sell-out, two great musicians riffing into the night. But the

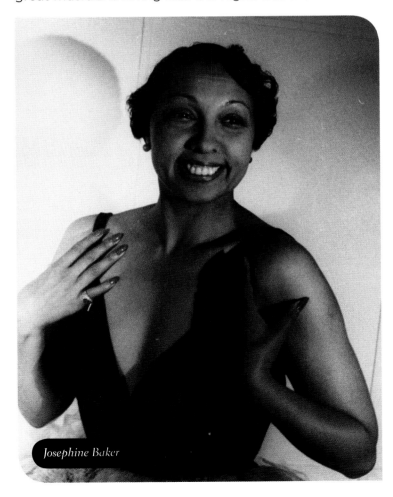

Josephine Baker

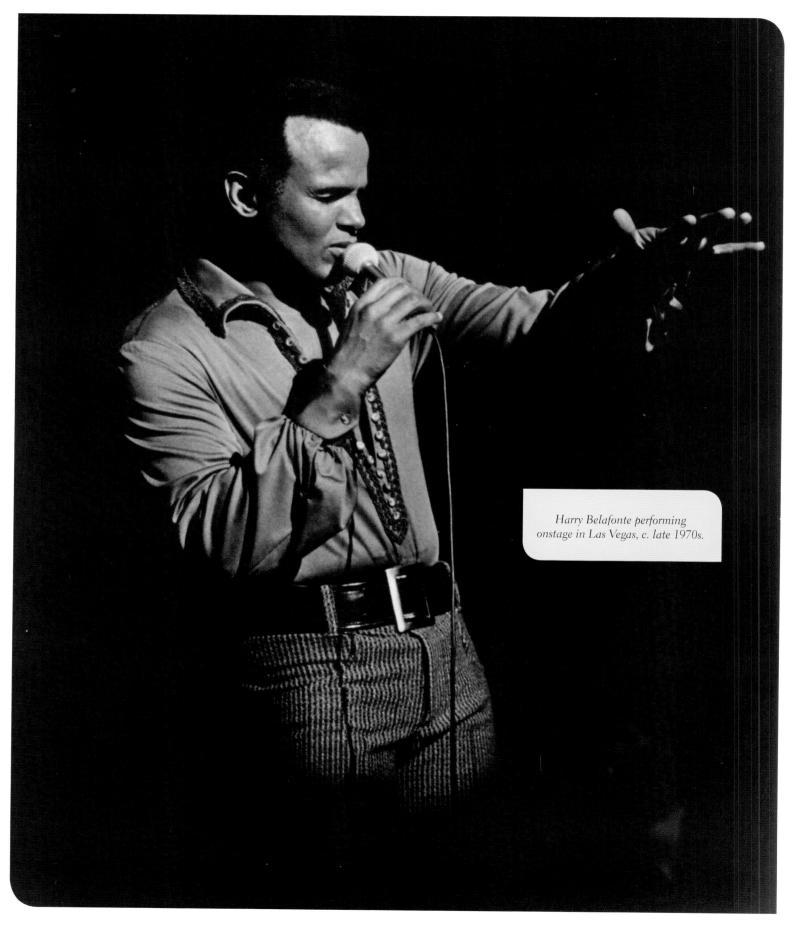

Harry Belafonte performing onstage in Las Vegas, c. late 1970s.

packed house, the swinging music, could not completely erase the bitterness. "You know I've played Las Vegas," Basie once remarked, "and it's a damn shame because of the segregation and discrimination there."

Even after the hotel room and dining room had been breached, one place remained off-limits, creating a powerful yearning among many black performers: the casino. Sammy Davis Jr. used to pause outside the casino and listen with longing to the jangle of the machines and the joyous shouts of the gamblers. "I pictured myself in the midst of it all," he wrote in his autobiography, *Yes I Can*, "the music, the gaiety, the money piled high on the tables, the women in beautiful dresses and diamonds, gambling away fortunes and laughing." That piece of the American Dream—to be allowed to gamble and lose your money with impunity—was still denied to him.

It was Harry Belafonte who decided that the time had come to push the limits on the Vegas house rules. After finishing his second show at the Sands, he went into the casino and took a seat at a blackjack table. The dealer stood there for a moment, not knowing what to do. The floor man got the high sign from the pit boss: Belafonte was green-lighted to lose his green. A crowd gathered around the table, watching the singer try to beat the house; some people even came down in their pajamas to witness what in fact was a historic event: a black man sitting elbow to elbow with whites, playing blackjack, winning or losing at the turn of a card.

Sammy Davis Jr. later returned to Vegas to perform at the Frontier, and this time he tooled up to the front entrance in a brand-new Cadillac. Doormen and bellman scurried to open the door and fetch his luggage. He was escorted to a beautiful suite, complete with a basket of flowers and a fully stocked bar.

Dressed in a black mohair suit, Davis went down to the casino and took a seat at a blackjack table. As a crowd gathered round, he put down a hundred-dollar bill and got a stack of $5 chips. He pushed the whole pile forward. His up card was the ace of diamonds. He flipped over the down card: jack of hearts: blackjack! The crowd went wild. He stuffed some of the chips into the dealer's shirt pocket and walked away, clutching the rest of the chips against his chest.

The next morning, the manager stopped by for a quiet word. If Davis wanted to go out to the pool for a swim, that was fine, but he would attract crowds and pull them away from the tables. "We'll appreciate if you'll keep it down to a minimum," the manager said.

Davis, his pulse pounding, smiled. "I don't know how to swim anyway. Besides, I've already got my tan."

Later, at the tables, he watched $500 magically turn into $25. He now enjoyed the right to lose his green in Vegas.

A Utopian Experiment

Miles from the Strip, across the tracks and beyond the underpass, on the demarcation line between white Las Vegas and black Las Vegas, a quiet revolution was taking place. While the Strip hotels meted out their meager concessions, a new hotel was going up, a showplace as opulent as any being built on the Strip—but one that admitted both blacks and whites. With its swooping neon sign and pink stucco exterior, the Moulin Rouge stood out like an exotic French showgirl among the drab businesses that lined West Bonanza Road. An interracial oasis in the middle of segregated Las Vegas, the Rouge was a thumb in the eye of the Strip hotels and their bigoted policies. The group of white investors who had sunk $3.5 million into the hotel was gambling that it would be a big success.

After finishing their shows on the Strip, entertainers flocked to the Moulin Rouge to gamble, eat, drink, and let their hair down. Nat King Cole. Sammy Davis Jr. Lena Horne. Frank Sinatra. Bob Hope. Gregory Peck. Count Basie.

There were jam sessions and jazz sessions and sing-outs. The joint jumped 'til dawn.

Joe Louis, the black ex-heavyweight boxing champion, was given a nominal interest in the hotel and served as the official greeter for the patrons. Bob Bailey, co-producer for the Tropicana Revue that performed in the showroom, likened the Moulin Rouge to Harlem's Cotton Club, the famed nightclub where blacks and whites intermingled. Recalled Bailey in an interview for "The Las Vegas I Remember," "It was so exciting to be able to entertain people at this level that had come over to the Westside to enjoy themselves and have a good time, let their hair down and just be people. Just great."

It was a good time to be black and a showgirl in Las Vegas. Alice Key, a dancer who also handled PR for the hotel, said, "There was a tremendous amount of excitement because we finally had a place we could call our own. Black people were earning and spending money and it made business good for everyone else in the area."

Dee Dee Jasmine, a showroom dancer, said, "I didn't know anything except that I wanted to dance and come to Las Vegas. Our attitude was, we didn't really need the Strip, 'cause everyone on the Strip was waiting to see the black revue at night."

The stars who showed up every night at the Rouge clowned and cavorted like adolescents testing the bounds of their new freedom. Harry Belafonte would come in singing, and finally the pit boss would have to ask him to quiet down, as he was distracting the gamblers at the tables. Louis Armstrong amused the other stars by ordering everybody to stop gambling, that he had a story to tell. "Of course, [the black stars] couldn't get into the casino areas where

Louis Armstrong was among the black stars who patronized the Moulin Rouge.

they were working on the Strip, so they thought this was a funny thing," Bailey recalled. "And he wasn't embarrassed or anything. But we did pull him to the side and said, 'Louie, we love you very much, but if you come in again and you stop the gambling, we're going to have to have the security guards put you out.'"

The giddy atmosphere that prevailed nightly at the Rouge seemed to prove the hypothesis: not only can blacks and whites mix successfully, but it's good for business as well. Within six months, that early promise began to fade. Despite the hotel's apparent success, it was verging on bankruptcy. There was talk of poor management and undercapitalization; contractors hadn't been paid. There were even hints that the owners were skimming the profits. The Strip hotels discouraged their employees from going to the Rouge. The casino closed its doors.

The hotel was reopened in 1957 under new ownership, but it was discovered that black customers were being charged more for drinks than whites. In 1960, under pressure from the local NAACP, its liquor license was revoked. Without gambling or alcohol—the lifeblood of the Vegas hotel—the Moulin Rouge no longer attracted patronage from the Strip.

"What Does a Black Man Have to Do?"

On the Strip, it was business as usual—no blacks allowed, unless they were entertainers who were granted special privileges. But even these special performers found themselves snubbed by the hotel establishment. In 1958, the Sands invited stars and Hollywood

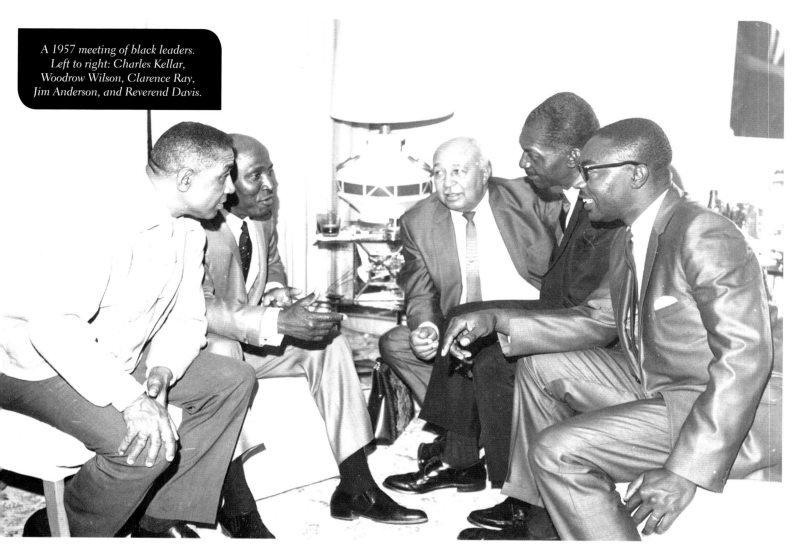

A 1957 meeting of black leaders. Left to right: Charles Kellar, Woodrow Wilson, Clarence Ray, Jim Anderson, and Reverend Davis.

celebrities to a "special party." Lucille Ball, Marlene Dietrich, Jayne Mansfield, and Peter Lorre were all on the guest list. Noticeably absent were Sammy Davis Jr., Pearl Bailey, Harry Belafonte, and Nat King Cole.

The occasional concessions were like salt in an open wound. Dr. James McMillan, one of the first black physicians in Las Vegas, accompanied Bob Bailey to the Dunes, where Bailey's wife, Anne, and McMillan's ex-wife were dancers in the chorus line. The two men went into the bar and ordered drinks.

"I can't serve you," the bartender said.

Major Riddle, the owner, came over to them. "Hello, gentlemen," he said, with elaborate politesse. "How are you?"

"We're fine," Bailey said. " It's just funny. Don't you guys sell whiskey here anymore?"

"Yeah."

"Well, we can't get a drink. I was just not understanding why. You have black girls working in your show."

"Come on now, Bob and Mac," Riddle said. "You guys know what the score is." He turned to the bartender. "Give them a drink."

The bartender brought the drinks over. The two men got up and walked out, leaving the drinks on the bar.

In March 1960, McMillan and other black leaders called for a march on the Strip. Not surprisingly, hotel owners did not take kindly to the prospect of angry protesters marching down

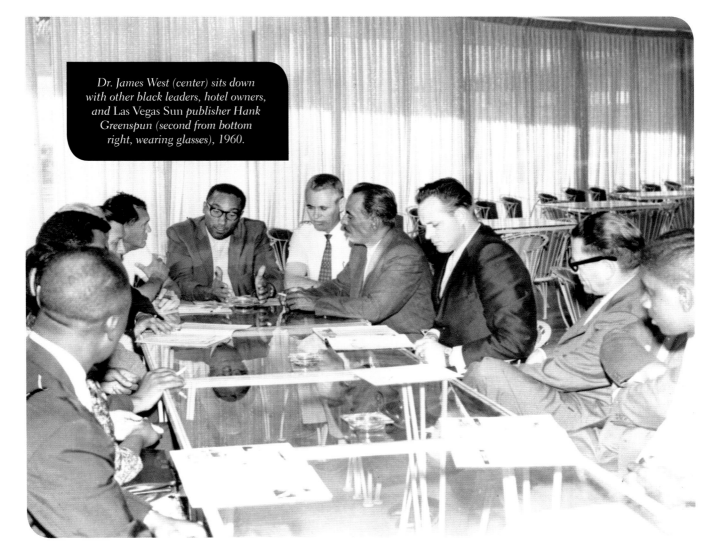

the Strip and waving signs, viewing it as a kind of blackmail. Word got back to McMillan that if he went ahead with it, he would end up in Lake Mead. McMillan sent a message back: "I don't know anything about gambling. I'm not trying to ruin their businesses, and I think it will be better for all of us."

This simple logic did not prove to be sufficiently persuasive, and McMillan turned to his friend Hank Greenspun, editor of the *Las Vegas Sun.* Greenspun prevailed upon the mayor to pressure the owners of the downtown hotels, where he had jurisdiction; Greenspun himself would handle the Strip hotel owners. "You're not going to create the kind of society in which my kids have to live," he warned the owner of

the Flamingo. "You'll sign the agreement or lose your gambling license." And, as Greenspun later recounted with some satisfaction, "the son of a bitch signed."

Hotel owners and black leaders gathered at the Moulin Rouge to formalize the deal. According to McMillan, the Rouge was chosen not for its symbolic value but because it was the only place large enough to accommodate the two hundred-plus people in attendance. At Greenspun's insistence, Nevada governor Grant Sawyer attended. The strategy was transparent but effective—enlist the governor's support and give him credit for brokering the deal. But it was McMillan, with Greenspun's help, who brought about this momentous agreement.

ELEVEN NEGRO DEALERS! EIGHT NEGRO COCKTAIL WAITRESSESS! AT LEAST ONE NEGRO DOORMAN!

It's like a bad nursery rhyme, this litany of black employment in Las Vegas. In fact, it was the cornerstone of the defense by the hotel industry in response to a complaint brought by the local chapter of the NAACP in 1968. Filed with the Nevada State Commission on Equal Rights of Citizens, the complaint alleged "gross discrimination" on behalf of the thousands of black workers in southern Nevada. All the major Strip hotels were named—the Desert Inn, the Sahara, the Thunderbird, the Riviera, the Sands, the Tropicana, the Dunes, Caesars Palace, the Frontier, the Flamingo, the Stardust—along with two downtown hotels, the Fremont and the Mint.

"There is not a single Negro employed in any capacity in a showroom in Southern Nevada," the complaint alleged. "There is not a single dealer at the Fremont Hotel or any other on the Strip." For good measure, the complaint also accused hotels of engaging in sweetheart deals with Teamsters and Culinary Workers unions to preserve the status quo.

The complaint was filed in March, only a month before the assassination of Martin Luther King Jr. The year before, there had been talk of organizing a march in front of Strip hotels to protest unequal employment of blacks. Reprisals were immediate: rifle bullets were fired through the windows of Dr. Charles Kellar,

president of the local chapter of the NAACP. An explosive blew an eight-inch hole in the rear door of his office. Police made no arrests. "I don't think they ever investigated," Kellar said. "It was said on the street that the police were doing it. I wasn't a favored person. They were trying to run me out of the state."

Kellar urged blacks to apply for the 1,900 new jobs at the recently opened Frontier Hotel and the soon-to-be-opened Landmark resort. "When you go for these jobs, make the best appearance you can," he advised potential applicants. "Some of these folks do not love you as much as I do."

The Nevada Resort Association claimed that the reason the hotels did not employ more blacks was "the high turnover rate among Negro employees," which, they alleged, "cannot help but limit the access of Negro employees to showroom assignment." They insisted that "progress is being made and though it may not be as rapid as many would like, it is likewise true that it will not be accelerated by false and irresponsible charges."

Eventually, the hotels and unions signed consent decrees opening jobs to blacks and other minorities. "White folks are coming to realize that they have to talk with us or fight with us," said Kellar. "There are twenty-five million Negroes, and that's a lot of folks to have to kill."

McMillan and some of the other black leaders wanted to put the agreement to the test that night, sending blacks en masse to the lounges on the Strip. Greenspun cautioned against a frontal assault, warning that "all hell would break loose." He also told McMillan that if they went through with the plan, he would inform the public how the black leader had caused the breakup of the agreement.

McMillan relented—but he personally was determined to put the agreement to the test. He and his date, who was part Hispanic, and Dr. James West marched right into the lion's den—the lounge at the Desert Inn, owned by mobster Moe Dalitz—and coolly ordered a drink.

A man entered and pointedly looked over at the threesome. McMillan looked back at him. He knew who the man was.

"McMillan, how are you?" said Moe Dalitz.

"I'm fine," McMillan said, "I just wanted to see if things are working all right."

"Yeah, you see that they're working all right." Then he said, "Boy, you're really trying my patience, aren't you?"

"What do you mean?" McMillan said innocently, choosing to view the word 'boy' as an exclamatory and not a racial put-down.

"You know, you come in with a white woman and a black man into the hotel to sit down to test us? Don't you know that you're pushing it to the end?"

"No," McMillan replied. "This is what we're talking about, to make sure that we're going to integrate the hotels."

"Okay, Mac," Dalitz said. "I know you are."

These words signaled a sea change in race relations in Las Vegas. Except for a few recalcitrants such as Benny Binion, who refused to allow a black person to cross the threshold of his Horseshoe Club, the hotels grudgingly ceded to the new order. McMillan and other black leaders had played a game of high-stakes poker with the mob, and they had won. The agreement signed at the Moulin Rouge was an emancipation proclamation: now blacks were free at last, praise God Almighty, free at last, to drink at the Dunes, double down at the Desert Inn, and feel the cold sweat when you don't roll the seven.

There were several attempts to resurrect the Moulin Rouge and restore her to her former glory. Sarran Knight-Preddy, a prominent black woman, bought the hotel outright in 1989. The only woman of color to have received a Nevada gaming license, she poured every cent of her assets into restoring it, even selling her own house. The city council designated it as a historic landmark, and it was placed on the National Register of Historic Places. There was talk of federal funds and of investment from local Native American tribes.

"The Moulin Rouge is intriguing not for what it is but for what it might have been," wrote John L. Smith, columnist for the *Review-Journal.* "It is the mystery and the ghost of Las Vegas past that make it special." Added Dee Dee Jasmine, a former showroom dancer and head of the Moulin Rouge Preservation Association, "We didn't realize the importance of what we were doing. We never knew we were going to be making history."

In 2002, a fire razed the old structure, leaving only the sign as evidence that this place once existed. In 2008, plans were under consideration to build a new resort on the site, preserving the sign as an icon of the short-lived utopia where blacks and whites were equal. This is one of the rare instances when Las Vegas, which loves to implode its past, is actually contemplating a kind of homage.

Looking back, McMillan questioned whether forcing integration was truly in the best interests of the black community. "Maybe that's on my conscience," he said. Vegas, which does not have a conscience, shrewdly saw the writing on the wall and decided to make a place for blacks at the tables, secure in the knowledge that the house always wins.

Fast Times at Vegas High

POP QUIZ:

WHAT DO YOU THINK OF WHEN YOU HEAR THE NAME "TOM JONES?"

A: THE NOVEL BY HENRY FIELDING

B: THE VEGAS LOUNGE SINGER

If you answered A, then you probably come from a cultured, sophisticated city where a premium is placed on education. If you answered B, it is quite possible that you grew up in Las Vegas and were educated in the Clark County school system. It's not that you would never have heard of the Fielding novel, but the ubiquitous presence of the singer who graced Vegas showrooms and lounges will inevitably conjure up the "What's New, Pussycat?" Tom Jones.

Ten years before Bugsy Siegel built his palace of pleasure on the Strip, Los Angeles architect Orville Clark, with George K. Thompson, built a kind of architectural marvel, with graceful walkways and a central courtyard with a fountain. Fifth Street School, completed in 1936, resembled a Jesuit monastery more than an elementary school. The school hired teachers such as Lily Fong, an immigrant from Canton who was married to Wing Fong, then a grocery clerk. "I had so much fun with them [the students]," said the diminutive Fong. "I felt like I was one of them."

The schools that would follow were nothing quite so grand. Bonanza Elementary, a single-story building with four classrooms and a principal's office, had no graceful archways or fountains, and the pedagogical approach was definitely old school. The teachers (mostly Mormon) drilled students in arithmetic and phonics and grammar and geography, those lost art forms. The pupils were also instructed in civics—every morning, every classroom stood

An aerial view of Nevada Southern University, March 1964.

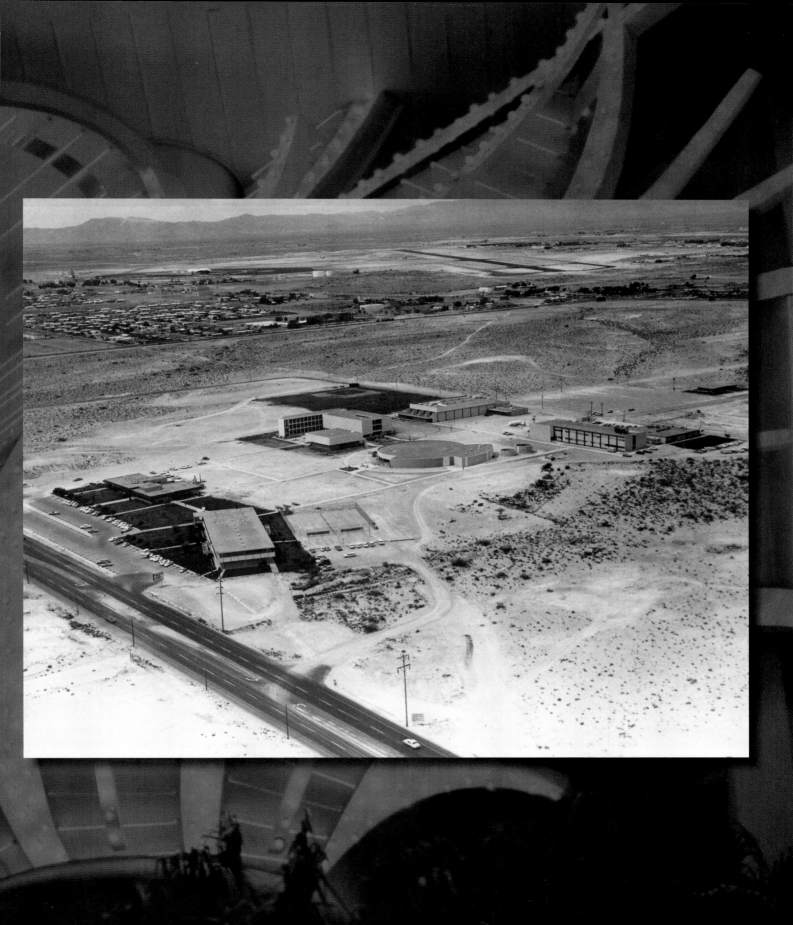

"There was a turtle by the name of Bert

and Burt the turtle was very alert;

when danger threatened him he never got hurt

he knew just what to do . . .

He ducked! [*inhalation sound*]

And covered!

Ducked! [*inhalation sound*]

And covered!"

at attention and said the pledge of allegiance, which was either followed by the singing of a patriotic song or "Home Means Nevada," the official state song. Students were inoculated against the dreaded polio virus with the Salk oral vaccine and protected against the Red Menace by Bert the Turtle, who instructed them in the proper "duck and cover" technique, retreating into his shell while they crouched under their desks.

The Soviet military machine never made it to Vegas, but the city *was* overrun by advancing hordes who wanted to make their home on the desert. The high schools were straining at the seams. Maude Frazier, the first superintendent of schools in Las Vegas, had persuaded a reluctant public to pass a $350,000 bond issue to build Las Vegas High School. Designed by the architectural firm of George A. Ferris and Son, Las Vegas High was built in 1931 on the corner of Seventh and Bridger. Some considered its location—about ten blocks southeast of downtown—to be too far out of town. Within twenty years, it enjoyed pride of place in the heart of the city.

The walls of the two-story main building were accented with cast concrete friezes and polychromatic medallions—architectural details that somehow did not influence the design of the new Strip hotels.

Senator Richard Bryan, who entered as a

Fifth Street School (above) and Las Vegas High (facing) signaled the beginnings of public education in Las Vegas.

freshman in the fall of 1951, said, "Coming to Las Vegas High School was in itself a big event. Everyone who was in seventh or eighth grade looked forward to coming to Las Vegas High School, because, in a sense, it was a rite of passage, you had really arrived. Las Vegas High School was where all the excitement was."

Though Frazier was criticized for building rooms that critics alleged would never be used, she would soon be vindicated. By 1953, another bond issue, this one for $5.7 million, was passed, but even it couldn't keep pace with the city's frenzied growth. In the spring of 1955, when

Rancho High opened, students at Las Vegas High were on double session.

Frazier, who became the first woman elected to the state legislature, continued to fight the good fight in Carson City. During her last term, she fell and broke her hip while touring Hyde Park Junior High School. That same year, when Lieutenant Governor Rex Bell died suddenly in office, Governor Grant Sawyer appointed Frazier as a replacement, making her the first woman to hold the office. Crutches and all, she stumped off to the statehouse in Carson City to testify for an education bill, which was opposed by state senator Floyd Lamb. Brent Adams, a Washoe County district judge who grew up in Las Vegas, witnessed firsthand her excoriation of the senator: "She was hobbling out on crutches, and Floyd said, 'Sometimes you have to act like a politician.'" She just whirled around on those crutches, glared at him, and snapped, 'I didn't expect you to act like a politician, I expected you to act like a senator.'"

Dare to dream, Maude Frazier. In the 1960s,

high schools began cropping up all over the valley—Western High, Clark High, Valley High. The design was maximum-security prison—a cinder-block compound with high windows (so there would be no gazing out, but then what was there to gaze upon?), a gym, and a dusty field. It was left to the students and community to create a more pleasing environment. At Western High, Peter Chase (class of '65) spearheaded a fund-raising campaign to landscape the school and build a football field. A bit of lawn, a few trees to cast some shade, a field on which the Western Warriors could strive for glory—these were paltry things compared to the Strip hotels with their lush landscaping, flamingos, and Olympic-size pools, but it never occurred to students to question the disparity.

Nor did they question why the student bodies of their student bodies were lily-white. A decade after the Supreme Court struck down the "separate but equal" doctrine in *Brown v. Board of Education,* Las Vegas schools were still segregated. Black children went to elementary

school and junior high on the Westside and to high school at Rancho High.

Finally, in the early 1960s, the Clark County School District began the painful process of integration. Each morning, yellow buses picked up black children on the Westside and dispersed them into formerly all-white schools throughout the city. They kept to themselves, sitting together in the cafeteria, congregating outside in the areas ceded to them by the white students. To break down racial barriers and encourage togetherness, there were screenings of *To Sir, With Love,* starring Sidney Poitier as a teacher in a tough London school, and that paradigm of racial stereotypes, *Gone With the Wind.* Then, at 3:00, the buses reappeared and spirited them away to their side of town.

The letter of the law was satisfied—the schools were integrated—but the campuses were powder kegs, and in 1969, they exploded. A minor skirmish between blacks and whites broke out at Rancho High but was quickly quelled by North Las Vegas police, who had been tipped off about potential violence. The next day, school officials met with black and white student leaders to defuse the situation.

The violence spread to other schools. At Las Vegas High, in front of newsmen, white students threw a black student through a trophy case. Black students at Clark High held a sit-in, which triggered a huge melee involving more than a thousand students. The Afro-American Club, led by Francis Edwards, who was employed by the Equal Opportunity Board, was accused of fomenting the unrest. Sit–ins were banned and troublemakers were threatened with expulsion. In late November, a two-day rumble at Western High involved more than two hundred students, resulting in ten arrests and several injuries.

Part of the problem was that integration came late in the game, after kids' attitudes and prejudices had already hardened. Also, it was a one-way street—the black kids were the ones

riding the buses to the white schools. Thus, Dr. Charles Kellar, head of the local chapter of the NAACP, proposed a "sixth-grade plan," in which all sixth-grade students would be bused to schools on the Westside; black children in grades one through five would be bused throughout the city. The district's fifty-two elementary schools remained closed for nine days in September 1972 until the Nevada Supreme Court ordered the schools to open under the sixth-grade plan. White opponents had formed a "Bus-Out" group to oppose the busing, and even went so far as to create schools in secret locations around town. However, these "shadow schools" were unaccredited, and eventually the parents were forced to capitulate.

There were a few alternatives to this "bus or bust" program. Catholic students could seek refuge at Bishop Gorman High, the Catholic school that opened in 1954. Children of wealthy parents could find greener pastures at Meadows School. The K–12 private school opened in 1984 and relocated in 1988 to its permanent location on forty acres of land donated by the Summa Corporation. Set apart geographically as well as academically from the rapidly declining public schools, it was, and remains, a bastion of elitist private education, with 100 percent of its graduates going on to four-year colleges and universities.

For the rest, particularly at-risk youth, there was not much in the way of an alternative until 2001, when the Andre Agassi College Preparatory Academy opened in West Las Vegas. The tennis star, who grew up in Vegas, decided to give back to the community by establishing a charter school. "Early on, we concluded that the best way to change a child's life was through education," he said. To battle the deflating attitude of low expectations, the school runs on two basic principles: a commitment to excellence and a code of respect. Named a National Model Charter School by the US Department of Education, it selects students

by lottery, and there is no tuition. Not surprisingly, there is a long waiting list.

As for the old guard—the crumbling public schools—the Clark County School District is the largest school district in the United States. The schools experience a high rate of turnover. At Petersen Elementary, some children have attended four different schools in the same year. Darla Richards, a teacher at Petersen, told NPR, "I think a huge impact that a twenty-four-hour city has on students is that when they go home from school, nobody's there because they're working. They're busy with other responsibilities, so students often don't spend much time doing homework."

One school was able to secure its place in history and revitalize itself as an academic institution. Las Vegas High is no more. But the building still stands as the centerpiece of the Las Vegas High School Historic District, now on the National Register of Historic Places. The school was reopened in 1992 as the Las Vegas Academy of International Studies and Performing Arts, where today, more than 1,300 students study dance, voice, theater, and visual arts. In 2002, the US Department of Education named it one of seventeen US Blue Ribbon Schools in the nation—heady stuff indeed for a Vegas school.

For education outside the classroom, students and parents can turn to that venerated institution: PBS. The local affiliate, Channel 10, came on the airwaves in 1968, bringing the likes of Julia Child's *The French Chef*, William F. Buckley's *Firing Line*, and *Masterpiece Theatre* into thousands of Vegas homes. In 2009,

A rendering of the Vegas PBS Educational Technology Campus, which opened in 2009 at the corner of Flamingo Road and McLeod Drive.

Vegas PBS moved into a new $49 million, 112,000-square-foot Educational Technology campus, which also houses the Clark County School District's Virtual High School, Educational Media Center, and Homeland Security and Emergency Response support system. The building's "green" design meets LEED standards for sustainable sites, water efficiency, energy use, and more. *There's* a lesson that many developers in Las Vegas could afford to study.

Tumbleweed Tech

If the children of Vegas have hopes of a college education, it might be at the university affectionately known as "Tumbleweed Tech." Having forced a reluctant legislature to support secondary education in Las Vegas, Maude Frazier persuaded legislators to appropriate $200,000 for a college campus in southern Nevada in 1955, but they attached a big fat string: the money would be forthcoming only if $100,000 was raised from private sources. The Nevada Southern Campus Fund Committee kicked off its "Porchlight Campaign" with a one-hour telecast featuring Strip entertainers as well as civic leaders and educators. The campaign was a success, exceeding the goal by $35,000.

Estelle Wilbourne, a former resident and the wife of a Modesto, California, realtor, donated sixty acres of land along Maryland Parkway, with the proviso that an additional twenty acres be purchased for $35,000. (It was later revealed that Wilbourne had purchased the land for $100—but this was Vegas, and there was no shame in a gamble with a big payout.) In April 1956, Frazier was given the honor of shoveling the first spadeful of soil for Nevada Southern University. The campus' first building was named in her honor.

Poor little Tumbleweed Tech seemed destined to remain the neglected stepchild to the University of Nevada in Reno. Local editors inveighed against this prejudice against southern

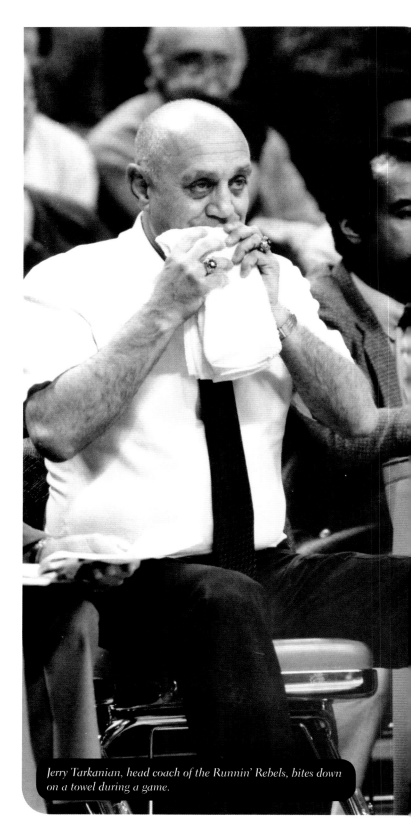

Jerry Tarkanian, head coach of the Runnin' Rebels, bites down on a towel during a game.

Nevada. Al Cahlan, editor of the *Review-Journal,* wrote that Clark County residents were "getting a little tired of being treated like the poor relations." His successor, Bob Brown, reprimanded the board of regents for rubber stamping the pro-Reno policies—despite the fact that enrollment at Nevada Southern had increased 20 percent to Reno's 10-percent jump. The regents were more generous with their budget cuts, sticking Nevada Southern with 15 percent—yet another manifestation of the "Tom Jones" factor. What was a town like Vegas going to do with all that fancy education?

In 1969, the University of Nevada system was formally divided into northern and southern campuses, with Southern Nevada given the more respectable title of the University of Nevada, Las Vegas. Reinvigorated, the university opened the College of Hotel Administration, the first in the Far West. Finally, it seemed, the school had found its true calling.

But in the nation's eyes, this dusty school on the desert was still Tumbleweed Tech—teaching someone how many plates to order for the hotel dining room could hardly be compared to a study of Plato's *Republic*. Weary of the disparaging jokes and eager to elevate UNLV's stature, the university set out to become the Harvard of the West. Recruiting a world-class faculty and attracting the nation's top students would take time and patience; what was needed was a fast track to fame. Dr. Donald Baepler, the academic vice president, found an unlikely individual upon whom to build a scholarly reputation. With his bald head, stocky build, and permanent bags under his eyes, Jerry Tarkanian looked like the man behind the betting window at the racetrack. He was, in fact, every bookmaker's dream. His highly successful basketball program at Long Beach State had put him on the national radar, and he had acquired a reputation as a renegade who bent NCAA rules. Known as the "hoodlum priest" for his willingness to recruit players from the street, Tarkanian put his best players on the

floor, black or white—a defiant deviation from the accepted practice of fielding an all-white starting five.

"This dramatic departure from racial convention established Tarkanian in the black community as a coach who not only talked about equal opportunity but actually practiced it," wrote Richard O. Davis, a professor at University of Nevada at Reno. "That reputation would pay great recruiting dividends later in his career."

Tarkanian made it clear from the outset that he would not be had cheaply, and that he would come to UNLV only if they made it a big-time job. Obligingly, the university offered him double the $27,000-per-year salary he was making at Long Beach State. They threw in an office, a secretary, a full staff, and two cars, and furnished him with a new house at cost. (By contrast, the chairman of the music department made in the low $30,000s at the height of his career and drove to work in a 1964 Volkswagen with no air-conditioning or radio.)

Upon his arrival, Tarkanian implemented an up-tempo game that was to become the hallmark of UNLV's teams. The run-and-gun style, popular with fans, led the Runnin' Rebels to a berth in the NCAA tournament in 1977, where they lost to North Carolina in the Final Four.

Donald Baepler, who was now the university president, was elated: "Prior to 1977 I had to explain at national meetings, 'Yes, there is a university in Las Vegas.' And after that they knew." In 1989, *US News & World Report,* the arbiter of academic excellence, declared UNLV an "up-and-coming university in the West" and a "Rising Star in American Education."

They knew up in Reno as well. Where the lowly school to the south used to come hat in hand to beg for funding, now they could—and did—demand a brand-new arena for their basketball team. Opening in December 1983, the Thomas & Mack Center became the Runnin' Rebels' new home. Raucous throngs packed the "Shark Tank" to witness this high-octane,

playground style of play, the players racing like gazelles up and down the court while Tark sat on the bench, chewing on a white towel. In 1990, led by Stacey Augmon and Larry Johnson, the Runnin' Rebels won the NCAA championship.

But the victory—indeed, the entire program during Tarkanian's tenure at UNLV—was under a cloud of suspicion. Tarkanian's reputation for playing fast and loose with the rules led to numerous accusations and NCAA violations. He was recruiting illegally. His players were being given fancy cars. They were receiving passing grades for classes they never attended. Charged with ten violations that would have resulted in a two-year suspension from coaching, Tarkanian sued the NCAA and was granted a permanent injunction against the suspension. Far from chastened, Tarkanian expressed outrage at what he viewed as persecution, accusing the NCAA of double standards and ethnic slurs.

David Berst, the NCAA investigator, allegedly referred to Tarkanian, who is of Armenian descent, as a "rug merchant." Said Tarkanian, "I could forgive him the bigoted comments but not the witch hunt."

Unrepentant, Tarkanian recruited Lloyd "Swee' Pea" Daniels from the Brooklyn playgrounds. An illiterate high-school dropout, "Swee' Pea" signed a letter of intent with UNLV, declaring, "It ain't worth goin' to no high school now." Tarkanian, who admitted that Daniels was a "million-to-one long shot," finally had to kick him off the team. Later, Daniels was arrested in a drug sting and convicted of second-degree murder. Yet Tarkanian maintained his belief in his reclamation program, insisting that "you can help a kid without graduating him."

Daniels had been brought to Tarkanian's attention by Richard "The Fixer" Perry, a known sports gambler. Tarkanian insisted that he did

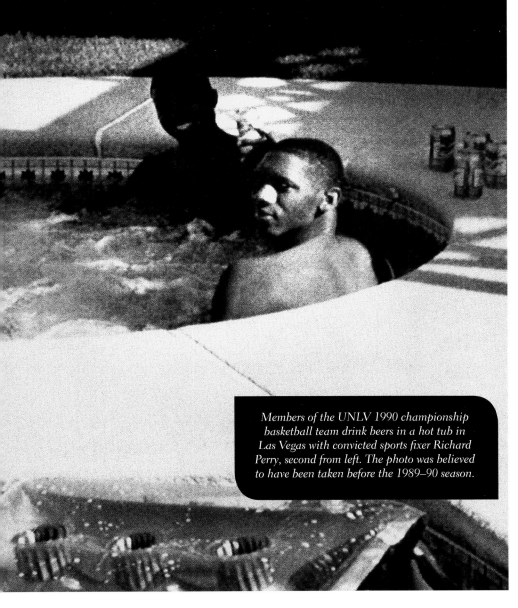

Members of the UNLV 1990 championship basketball team drink beers in a hot tub in Las Vegas with convicted sports fixer Richard Perry, second from left. The photo was believed to have been taken before the 1989–90 season.

transforming UNLV into the Harvard of the West.

With the hoopla over hoops having died down, the university was left to the hard work of building a respectable academic institution, one that perhaps would not compete with Ivy League schools but also would not be the laughingstock of the nation. With 28,000 students and 1,000 full-time faculty, it has grown out of its adolescence into a full-sized university.

Among UNLV's dozens of graduate programs is the graduate creative writing program, which emphasizes "writing that looks out from America to the world," according to Doug Unger, one of the program's founders. The program has partnered with the Peace Corps to send its aspiring writers out into the world to do good. Glenn Schaeffer, who graduated from the prestigious Iowa Writer's

not know of Perry's gambling background, and that once he learned of it, he told his players to stay away from him. However, the publication in the *Review-Journal* of a photo of Perry in a hot tub with several players from the 1990 championship team sounded the death knell to Tarkanian's career at UNLV. Under pressure from academic vice president Robert Maxon, Tarkanian resigned in June 1992, an ignominious end to a career that had brought fame and national recognition to UNLV. While Tarkanian's crimes were mere misdemeanors by Vegas standards, they did nothing to further the goal of

Workshop in 1977 and is now the CEO of Fontainebleau Resorts, has funded a fellowship. In 2007, *The Atlantic,* that bastion of Eastern Seaboard literary high-mindedness, listed UNLV among the Innovative/Unique Programs in its annual "Best of the Best" list of the nation's top MFA programs. The notion that this program might spark a literary renaissance in Las Vegas and put UNLV back on the map is improbable but not impossible—sometimes the ace does come up.

What's a Girl Like You Doing in a Place Like This?

> **"SHOWGIRLS ARE SO DUMB THEY CAN'T SPELL M-G-M."**
>
> — JOAN RIVERS

During his United States tour in 1959, Soviet premier Nikita Khrushchev, having been banned from Disneyland, was taken to the Fox soundstage in LA to watch the filming of *Can-Can.* The cameras from KTLA, a local TV station, caught him in a rare smiling moment posing onstage with some of the dancers. Quick to disassociate himself from this flagrant display of Western decadence, he remarked, "This is what you call freedom—freedom for the girls to show their backsides," adding that "it's capitalism that makes the girls that way."

Perhaps it's just as well that Las Vegas was not among the Soviet premier's scheduled stops. *Can-Can* would have seemed like a chaste tea dance compared to what occurred nightly on the stages of the Strip hotels, which exult in the freedom to bare every jot and tittle of the female body. Indeed, in the city that *Life* magazine called "a showgirl

Bob Mackie design of a costume for a show at the MGM Grand.

Four Copa girls pose onstage with oversized blue ostrich feather fans at the Sands in 1963.

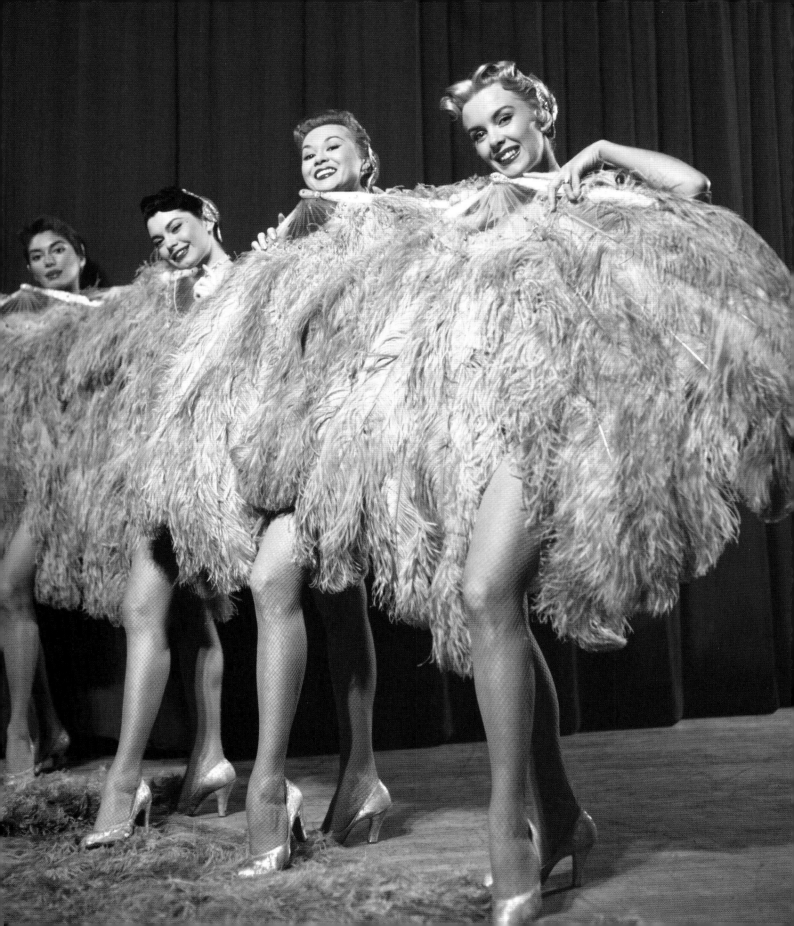

think men like big boobies."

For an enlightened woman, it is nearly impossible to reconcile the showgirl with modern feminist ideals. Libby Lumpkin, who moved to Las Vegas in the early 1990s and later became director of the Las Vegas Art Museum, wrote that "one of the most difficult challenges of living in Las Vegas is coming to terms with its most public icon of prosperity and permissiveness: the Showgirl."

The Vegas showgirl can be viewed as a sad, degraded creature, a piece of meat paraded before the mostly male audience. On the other

Shangri-La," the showgirl is the most familiar icon, an unabashed acknowledgement that sex, indeed, does sell. Where New York has Lady Liberty, sheathed in gleaming marble, beckoning the huddled masses "yearning to breathe free," Vegas has Lady Luck, tarted up in fishnet stockings, stiletto heels, and a come-hither smile, welcoming the masses yearning to double down, hinting at the good fortune to come.

ABOVE: Soviet premier Nikita Khrushchev visits the set of Can-Can *in Hollywood, 1959.*

BELOW: Harold Minsky dancer Bobbi Blair strikes a pose.

FACING: Showgirls performing onstage in the Lido at the Stardust, ca. 1977–78.

The ubiquitous image of the Vegas showgirl is paraded across the stages of the hotel showrooms, lit up in neon signs, blown up on billboards, emblazoned on marquees:

LIVE NUDES
TOPLESS DANCERS
GIRLS GIRLS GIRLS

This cheerful, shamelessly exploitive view of women as sex objects was eloquently summarized by Bill Moore, producer of *City Lights*, the floor show at the Flamingo: "We like big boobies . . . because in general, we

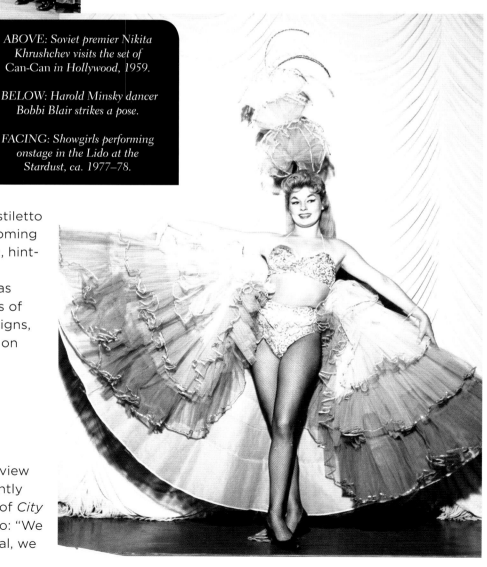

hand, she can be celebrated as a protofemi-nist, freely expressing her sexuality and mak-ing good money doing it. In the 1950s, young women who dreamed of dancing onstage came from all over the world to perform in the glamorous floor shows at the Strip hotels. "They were really all Cecil B. DeMilles," recalled former Nevada governor Grant Sawyer, "all in the same search for the fabulous." In the 1950s, a dancer in the line could make $150 a week (more for nude dancers)—not a queenly sum, to be sure, but it was a chance to dance, to do what she loved.

While 1950s television presented a chaste view of femininity and sex—Rob and Laura Petrie slept in twin beds, and Laura could wear capris only once per episode—the Strip hotels gleefully peeled away the facade. Minsky's Follies, the first topless show on the Strip, was brought in by Major Riddle to perform at the Dunes in 1956. The show was a huge sensation, drawing a record sixteen thousand people in one week. In 1958, Donn Arden's Lido de Paris became the glamorous headliner at the Stardust, where it enjoyed a thirty-year run. The following year, the struggling Tropicana got a face-lift—literally—by importing Les Folies Bergère from Paris to per-form in the main showroom. The show contin-ued its successful run for fifty years, but in 2009, faced with an economic recession and falling revenues, it was forced to close its doors.

Where do they come from, these women? Do they spring, full-blown, from the head of Zeus? Are they produced on an assembly line

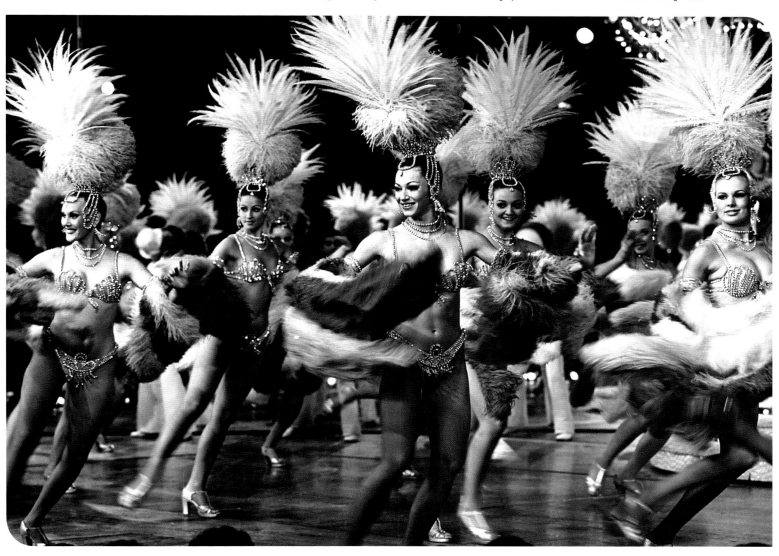

in some secret showgirl factory in Area 51? In fact, they are flesh-and-blood women who come from the far corners of the earth to perform on the stages of Las Vegas. A Moscow girl named Svetlana Faillia began dancing at age five and visited Vegas in 1991. After a stint at the Stardust, she joined the Folies. The five-foot-ten dancer admits that her mother, who never saw her dance in Vegas, would not have approved of her dancing topless, yet she mourns the closing of the show; no more will she appear onstage in a red feather headdress. "I want two more years of sparkle and glitter," she said.

Tracy Heberling made the journey from the lush green of England to the parched Nevada desert to become a showgirl in the Lido at the Stardust in the 1950s. She was a member of Madame Bluebell's dance troupe from London. When Margaret Kelly, owner of the troupe, learned that her dancers would be expected to mingle with the customers in the lounge after the show, she informed the management that her girls were dancers and would not participate in this extracurricular activity.

That is not to say that being a showgirl was not demanding work. Heberling and the other women wore headdresses three to four feet high, which they secured with hairpins from Paris. Though she suffered from compressed discs in her neck from the weight of the headdress, she reflected fondly on her time as a showgirl, evincing that peculiarly British fondness for the desert. "I worked for eleven years in this town, and I loved it," recalled Heberling. "There was a great sense of openness and freedom here. And the air was so incredible, that desert air. The mountains, looking towards Red Rock, they seemed to sparkle. It was just incredible."

Among the high-stepping chorus lines performing on the Strip, there was one notable absence—black women. Though black entertainers did perform at the Strip hotels, the notion of black girls and white girls dancing together

NEAR RIGHT: *The Bluebells dance troupe poses as they arrive in Las Vegas to open the new Lido show at the Stardust.*

FAR RIGHT: *The Golddiggers dancers in front of the Sahara, 1968.*

onstage was anathema to the segregationist hotel owners. For six months in 1955, during the short-lived era of the Moulin Rouge, black showgirls enjoyed a moment in the spotlight, dancing nightly in the integrated hotel's showroom. For Anne Bailey, this merely whetted her appetite to be on the stage. In 1960, following the desegregation of the Strip, she auditioned at the Flamingo, not once but many times, and the hotel finally relented and hired her as the first African American to dance in a "house" chorus line on the Strip.

The positions were coveted, the competition fierce, but making it meant shedding any puritanical notions about nudity. In 1983, Leslie Kay beat out a field of seven hundred in the Folies audition, the "Search for the Ultimate Showgirl." Kay appeared on NBC's *Today*, where she revealed to her parents for the first time that she was a nude dancer. Debbie Lee, a Vegas showgirl, admits that "I wouldn't tell anybody that I had to show my boobs. That is a really scary, degrading thing." Still, Lee's daughter wants to be a showgirl when she grows up.

Some of the women found a kind of cama-raderie in the enforced intimacy of the dressing room. "You get close to people when you are naked," said Georgie Bernasek, who was a show-girl in the Folies and later in the Penn & Teller Spectacular. "It's like being sisters. You are so vulnerable without clothes on, you really get to know each other."

You can't be a showgirl forever. The nightly performances take their toll, the dancing in heavy headdresses chips away at the bones and tissue, the breasts begin their inevitable descent. Kathy Saxe, one of the "parading showgirls" at the Flamingo, auditioned at the Sands in 1960, beating out two hundred other women to become a Copa Girl. Twelve years later, she retired from the Vegas stage, but the lure of performing before an audience was irre-sistible. Saxe adopted a new persona, speaking at seminars as Katherine Llewellyn Rennsallear, PhD. Halfway through her talk, she would start stripping down to a G-string; with the audi-ence now raptly attentive, she fielded questions about Las Vegas.

During their careers, some women were able to escape the glare of the Strip and lose themselves for a few hours in a kind of fairy tale. During their rare evenings off, Heberling and other women from the Lido would drive up to Mount Charleston, where they would ice skate under the stars, performing, not for an audi-ence, but for themselves. "It was truly magical, the snow on the pine trees and these incredibly huge stars," said Heberling. "It was wonderful. I loved it."

Brothel, 29 mi.

So reads the sign posted on Highway 95, north of Las Vegas, past the entrance to the Nevada Test Site. Prostitution is illegal in Clark County, so you must drive north, into the vast reaches of the Great Basin, to find a legal brothel.

Most of the land at the test site is owned by the federal government. Beverly Harrell leased five acres in Esmeralda County from the Bureau of Land Management and opened the Cottontail Ranch Club. When Jack Anderson, nationally

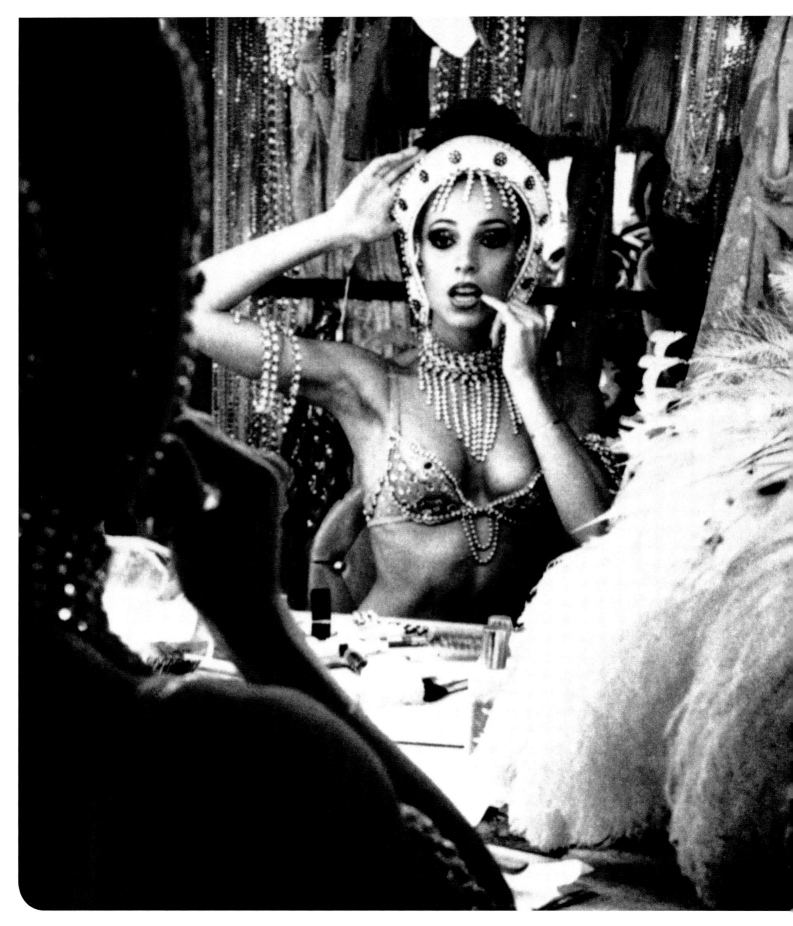

syndicated columnist, revealed this fact in 1971, alleging that it made Secretary of Interior Rogers Morton the landlord of a brothel, district judge Roger Foley ordered Harrell to close her establishment. Not to be outdone, Harrell moved her brothel, a collection of mobile homes, onto private land.

In the premier issue of her company newsletter, "House Organ," Harrell made the case for legalized prostitution, claiming that the girls who worked at the Cottontail were "a better risk than that tight-assed gum-chewing secretary who's been giving it away to anybody who trips going past her desk." She argued that her

employees led the good life, most leaving to get married or to start their own business. "Our door opens easily from the inside and anyone is free to leave whenever she wants," she wrote.

The brothels banded together and formed the Nevada Brothel Association, which established a program for voluntary testing of their employees for venereal disease. This program later became law; moreover, all customers are required to wear condoms. Russ Reed, proprietor of the Chicken Ranch, argues that far from being a blight on the body politic, brothels can actually be a standard bearer for progressive policy. "I think Nevada's brothels are going to be

FACING: *Debbie Bruckner, a 25-year-old Las Vegas showgirl, applies the final touches before a show in November 1982.*

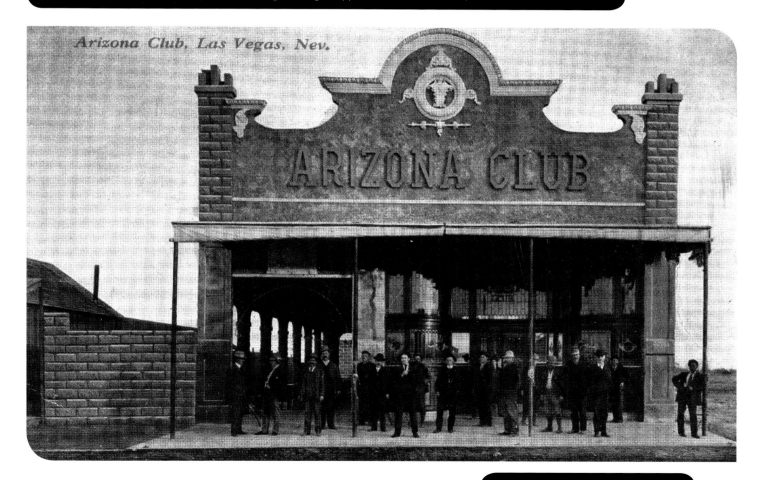

ABOVE: *Exterior of the Arizona Club.*

an example for the rest of the United States for AIDS prevention," said Reed, with no hint of irony.

Clients can pay in cash or by credit card. Capital Corporation handled credit card business for many Nevada brothels, including the Mustang and Chicken ranches. Allegedly unaware of its activities, Bank of America bought out Valley Capital in 1992, only to withdraw its services when it discovered the nature of the credit card transaction.

"Yeah, they cut us off," said Reed.

For nearly a half century, Clark County harbored its own houses of ill repute. The Arizona Club, which opened in 1905, was located on notorious Block 16 on Fremont Street, where prostitution was rampant. The clubs were frequented by the workers who came to southern Nevada in the early 1930s to build Hoover Dam. World War II brought an influx of military personnel to Las Vegas to serve at the gunnery station. While Nevada state law required that prostitutes have weekly medical exams for gonorrhea and monthly blood tests for syphilis, the army was worried about the spread of venereal disease and pressured the county commissioners to close Block 16. After a legal skirmish, the Nevada State Supreme Court ruled that the commission did have the right to take action, and at midnight on January 10, 1942, Block 16 was shut down. Of course, prostitution did not vanish from the streets of Las Vegas. Some of the girls became streetwalkers, while others repaired to the meadows, outside the city limits, where prostitution was not banned.

Las Vegas was eager to distance itself from this tawdry activity, preferring to court visitors with the wholesome activity of gambling. Thus it was something of a civic embarrassment when, in 1954, the *Las Vegas Sun* accused Clark County sheriff Glenn Jones of having a financial interest in a brothel. Publisher Hank Greenspun hired an undercover agent to pose as a mobster

trying to buy the brothel and the protection of Nevada politicians. Secretly recorded conversations revealed a scandal that went as high as the statehouse in Carson City. Lieutenant Governor Cliff Jones resigned as Democratic national committeeman for Nevada and never again held important public office.

In 1971, the state legislature amended its "local option" provision, which allows counties to pass their own ordinances regarding legalized brothels, to exclude counties with populations of more than two hundred thousand from permitting houses of ill repute. The law is periodically amended to increase the population ceiling, now four hundred thousand—effectively preventing Clark County, which includes Las Vegas, from legalizing prostitution.

But those looking for female companionship in Las Vegas do not have to drive to Nye County; they need only open the Yellow Pages to "Escort Services," more than 120 pages of listings and ads, a Freudian smorgasbord of sexual fantasies. Every ethnic and age group is represented: blondes, brunettes (including blacks), Asians, young, old. Clients can enjoy an evening with a French maid, a Catholic schoolgirl, a kitten with a whip—the choices are virtually limitless.

The hotels also obligingly—and discreetly—provide services for their clients. In 1964, an executive at Circus Circus got a call from Jack Entratter, president of the Sands, asking him to send over two of his girls from the "Bed Toss," a peep show where naked blondes in G-strings cavorted on red satin beds. The women were dispatched to the Sands, and the next morning reported that they had spent the night having sex with Senator Ted Kennedy, who was in town for a fund-raiser for Nevada senator Howard Cannon. The Circus Circus executive was incredulous—but when the women, who "didn't

know politics from a polo shirt," described the senator to a tee, he was convinced: "These two blondes were dumb as a post, they couldn't have made it up."

The sex industry in Las Vegas today is a thriving concern, generating an estimated $1 billion to $6 billion a year, with $24 million worth of advertising, according to Melissa Farley, author of *Prostitution and Trafficking in Nevada: Making the Connection.* A report released by the US State Department in 2007 found that there is nine times more illegal prostitution than legal prostitution in Nevada, and that 90 percent of prostitution in Nevada occurs in Las Vegas, whether in illegal brothels or private homes. Prostitutes have quotas amounting to more than 1,800 customers a year, according to the report, and the money gets split between taxi drivers, pimps, and bellhops at casinos, leaving very little for the women themselves.

Kathleen Mitchell, who was a prostitute for twenty-one years, says that while most of the casinos are quick to toss out any working girl who doesn't keep a low profile, that doesn't always keep them away. "There are women in and out of the casinos," Mitchell said. "If the girl is slick enough or quiet enough, they may turn a blind eye and let her be as long as she doesn't rob anyone or until she becomes noticeable, then they'll throw her out."

Eventually, Mitchell was arrested and decided to call it quits. "I left that business with nothing but rage and anger. I could have hurt someone at the drop of a hat." She quickly discovered that there are few services for prostitutes who want to leave their lifestyle behind.

Valerie Carp ran a network of fifty madams across the country, a lucrative

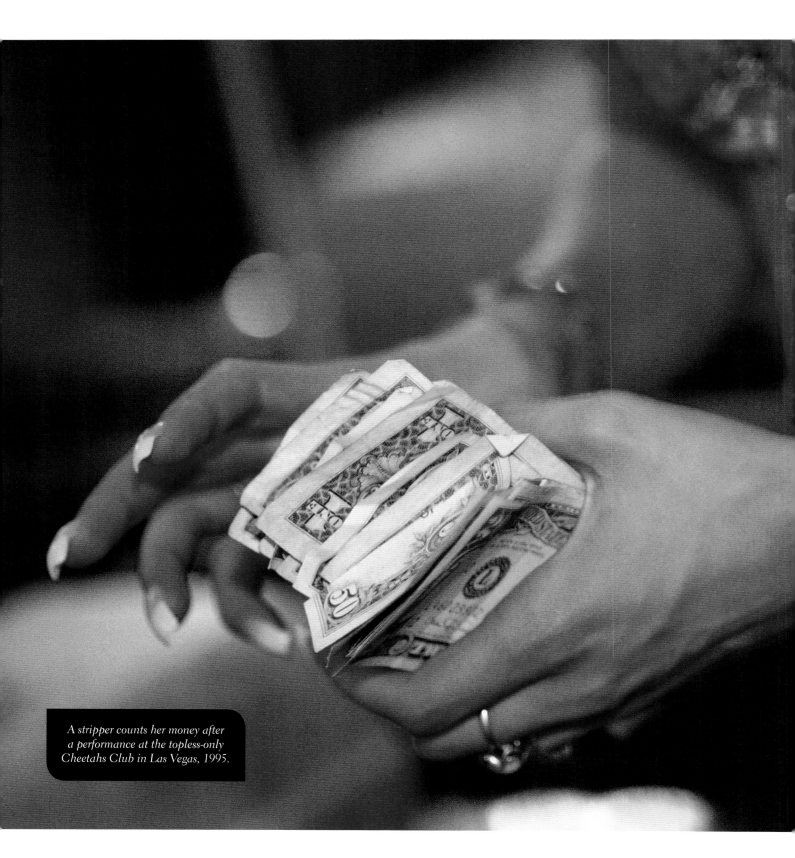

A stripper counts her money after a performance at the topless-only Cheetahs Club in Las Vegas, 1995.

call-girl ring from which she took 40 percent of the take. It was Carp's policy to run background checks on clients, or "johns," to weed out any potential problems. A john could pay up to $3,500 for a two-hour date, but he would have a full menu of options, including bondage. In Vegas, the ring worked Caesars Palace and the MGM, which attracted a well-heeled clientele. A casino host at the MGM who steered clients to her service tipped her off to an undercover sting, but too late—Carp and her operation were busted.

The problem was worse downtown, where hookers were working the streets. In 1996, the Order Out Corridor was put into effect. Women who were arrested for prostitution had a choice: they could go to jail for six months, or they could go free if they stayed out of downtown Las Vegas for six months. If they were reapprehended, jail time was mandatory. Curiously, the "johns"—i.e., the demand side of the supply-and-demand equation— were not targeted in this operation.

More than a decade later, Vegas was grappling with a growing sex-trafficking problem. Family court judge William Voy, who presided over a weekly teen prostitute court, said, "With a lot of these kids, the only place they ever felt safe and secure was with their pimps." Voy formed a nonprofit foundation, the PSEC Nevada Foundation (Protection of Sexually Exploited Children), to raise the $2 million needed to construct a safe house for these at-risk girls. Two million seems a modest enough sum for a town where high rollers drop half a mil in a night—but when it comes to social services, suddenly the money dries up.

Terri Miller, civilian director of the Anti-Trafficking League Against Slavery and long one of Nevada's leading activists against the sexual exploitation of women and children, asserted that the problem is exacerbated by Las Vegas' aggressive advertising promotions that encourage tourists to come here and sin all they like. Miller was alluding to the city's slogan: What Happens in Vegas Stays in Vegas. "We're basically giving a green light for people to come here and exploit women and children," she said.

"No, not even close," retorted an indignant Billy Vassiliadis, president of R&R Partners, the firm that created the slogan for the Las Vegas Convention and Visitors Authority. "I think using the slogan to suggest that takes things to a level that becomes really problematic."

Mayor Oscar Goodman came up with his own solution—create a legal red-light district on Fremont Street, similar to the one in Amsterdam. That way—so the former mob lawyer argued—the business could be monitored and regulated, and, of course, add to the tax base of the city.

Bob Herbert, a columnist for the *New York Times,* found this suggestion appalling. "Vegas is already a paradise for pimps, johns and perverts," he wrote. "There is probably no city in America where women are treated worse than in Las Vegas." In his column, he accused the mayor of "setting the tone for the systematic, institutionalized degradation of women."

But the mayor is merely reflecting the misogynistic attitude that permeates Vegas, from the blackjack player who tips a cocktail waitress with a $5 chip and calls her "sweetheart," to the senator ordering up a couple of hookers to his suite, to the casino host procuring these services, to the A-list Hollywood types frequenting the VIP booths at the Club Paradise Gentleman's Club.

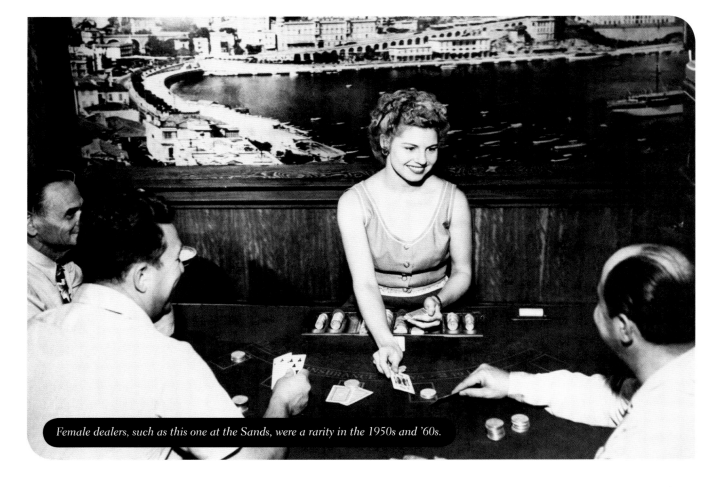

Female dealers, such as this one at the Sands, were a rarity in the 1950s and '60s.

"Can I Be a Dealer When I Grow Up?"

If you're a woman in Vegas and you don't want to be a hooker and you don't have the legs to be a dancer, you can always become a dealer. Once strictly *persona non grata* in the dealer's slot, women now are valued for those quick hands that can deal cards and change money with lightning speed. No fishnet stockings or snug bustiers—they wear the same uniforms as the men. Nevertheless, they encounter the same sort of sexist attitude that permeates Vegas. "Shift bosses could be really mean," recalled Sally Smith, a former dealer at the Silver City. "They would call you Sally the Dumpster. They'd lean down and whisper in your ear: 'You stupid bitch! Can't you win a hand?'" Once she dealt a hand

to a male player who had a stack of greens ($25 chips). He lost it all and threw his last silver dollars at her, bruising her. She decided enough was enough and quit dealing.

Young girls growing up in Vegas have other role models besides the showgirl, the dealer, and the hooker. There is Maude Frazier, first superintendent of schools and the first woman to serve in the state legislature; Lily Fong, businesswoman and philanthropist who served on the Board of Regents of UNLV; Libby Lumpkin, director of the Las Vegas Art Museum; Claytee White, PhD, director of the Oral History Project at UNLV. There is the leader of Troop 199 who helped her young charges stuff kapok into sock monkeys and put up tents in a sandstorm; the violin teacher who coaxed music out of her improbable pupils. These, too, are the women of Vegas.

SHE'S GOT RHYTHM!

To become a showgirl was not the dream of every young girl growing up in Las Vegas—some wanted to become doctors or lawyers, and at least one, a writer—but for those who aspired to this ideal of Vegas womanhood, there was the Las Vegas Rhythmettes, an elite precision marching and dance troupe at Las Vegas High. Phyllis Berman (then Nelson), who had watched in awe as the group performed on *The Ed Sullivan Show* in 1955, dreamed of become a Rhythmette. Her mother envisioned her daughter as a concert pianist, or, in good Mormon fashion, simply being a mother and replenishing the earth—not, as she said, in "some trumped-up organization, like the Las Vegas Rhythmettes."

Undeterred, Phyllis tried out in her freshman year but didn't make it. Then, sophomore year—*praise be!*—she made the cut. "I was one of the girls," she exulted. "A Las Vegas Rhythmette. I was somebody."

"My babies"—this is what Miss Evelyn Stuckey, their leader, called the girls. She ran the troupe like a drill squad, checking grades each semester, monitoring whom the girls were dating, insisting that they stand up straight and carry themselves proudly. The Rhythmettes, with their innocence and bright smiles, were in constant demand. They performed at the state basketball championship. They marched down Fremont Street in the annual Helldorado Parade. (Phyllis was invited to be queen

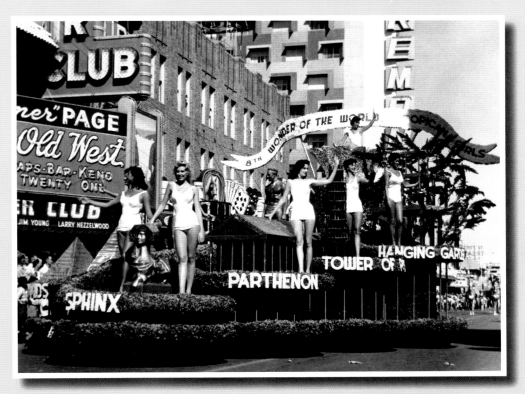

and ride on a special float but had to decline because the parade was on a Sunday.) They strutted their stuff for the dedication of the new freeway from Las Vegas to LA. They represented Las Vegas, sister city of San Remo, Italy, in the Festival of Europe in Flower in 1966.

For Phyllis, though, the high point in her Rhythmette career was greeting Leonard Bernstein. On tour with the New York Philharmonic in the summer of 1960, the conductor arrived at McCarran Airport and paused briefly for a photo with the Rhythmettes in the background. He scarcely took notice of the young girls in their fringed cowgirl outfits, white boots, and cowboy hats, nor did he pay heed to the chastely attired Young Friends of the Symphony at the concert. Phyllis took the slight hard. "Your judgment was swift, and maybe, just maybe, it was wrong. Lenny, Lenny, why didn't you notice?"

Sex, Politics, and Other Crimes and Misdemeanors

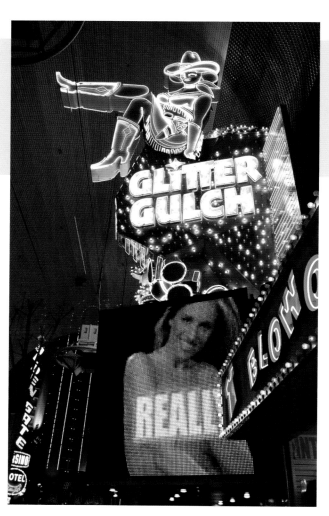

MEYER LANSKY: "WHAT'S SO BAD ABOUT GAMBLING? YOU LIKE IT YOURSELF. I KNOW YOU'VE GAMBLED A LOT."

ESTES KEFAUVER: "THAT'S RIGHT. BUT I DON'T WANT YOU PEOPLE TO CONTROL IT."

In the early 1950s, just as Americans were kicking off their shoes and settling into a decade of shiny new appliances and Eisenhower prosperity, there emerged two new plagues upon the land: one was gambling, and the other, Communism. Las Vegas, a town whose politics were shaded toward green rather than red, was called to account for its *pas de deux* with the mob; its leading publisher was accused of flirting with Communism. The perpetrators of these assaults against the good name of Vegas were two formidable members of the United States Senate.

Estes Kefauver, the Democratic senator from Tennessee, was shocked—*shocked!*—to discover that there was gambling going on in the United States. "Big-time gambling is immoral, " he declared. "Gambling produces nothing and adds

Vegas Vicky beckons visitors to Fremont Street, aka Glitter Gulch.

Casinos generate huge amounts of cash, which occasionally disappears in "the skim."

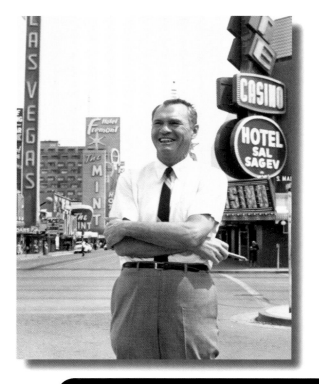

ABOVE LEFT: Las Vegas Sun *publisher Hank Greenspun, standing on Fremont Street. ABOVE RIGHT: Senator Estes Kefauver (standing), chairman of the Senate Crime Investigating Commission, opens a one-day hearing in Las Vegas on November 15, 1950. FACING: Estes Kefauver on the cover of* Time, *March 12, 1951.*

nothing to the economy or society of our nation." The senator, who himself had a secret gambling problem and was chronically broke, was actively bidding to run for president on the Democratic ticket in 1952, and he needed a cause, one that would create headlines and generate national media attention. He launched a full-scale congressional investigation into the role of organized crime in interstate commerce. Enlisting five colleagues from the Senate, he took his show on the road. (Is there anything a politician loves more than a taxpayer-financed junket?) He also made use of that nascent medium—television—and his were the first in the national spectacle of live televised Senate hearings.

The Kefauver Committee visited fourteen cities in seventeen months, holding hearings on everything from bookmaking to numbers-running to backroom craps games. The committee arrived in Las Vegas in November and held a hearing in the downtown federal courthouse. Vegas oddsmakers took bets; the heavy money was on Kefauver to lose, especially since most of the central figures were conspicuously absent from the proceedings. "They fled subpoenas like the black plague," wrote Hank Greenspun in his column in the *Las Vegas Sun.*

The brunt of the testimony was left to the likes of Wilbur Clark, a local builder who admitted selling a controlling interest in the Desert Inn to mobster Moe Dalitz. When asked if he had looked into Dalitz's crooked background, Clark replied, "Not too much." The committee adjourned for three hours so that the members could take a ride out to Hoover Dam for a tour.

The proceedings lasted less than a day. The report, issued nine months later, concluded that the Nevada licensing system "has not resulted in excluding the undesirables." Las Vegans responded to this startling revelation with a collective "duh." In fact, the Mafia had created an elaborate shell game in which their interests were carefully hidden in an intricate web of shareholdings and partnerships.

TWENTY CENTS MARCH 12, 1951

TIME

THE WEEKLY NEWSMAGAZINE

CRIME HUNTER KEFAUVER
Gamblers + Politicians = Corruption.

$6.00 A YEAR [REG. U. S. PAT. OFF.] VOL. LVII. NO. 11

Kefauver proposed that a 10 percent federal tax be placed on gambling—not the revenues, but the actual bets. The very notion sent a shudder through the gambling community. Nevada would effectively be finished as a viable entity—they could just turn the state back to the Joshua trees and the jackrabbits. Nevada senator Pat McCarran called in all his chits from his colleagues in the Senate, and the bill never made it out of committee.

Hank Greenspun took on formidable opponents, such as Senator Joseph McCarthy.

As illegal gambling operations in other states were closed down, the former owners came to Nevada. "I love that man Kefauver, " said one man who was driven out of Florida only to open up an operation in Nevada. "He made me a respectable, law-abiding citizen and a millionaire."

Kefauver made the cover of *Time* magazine: "Crime Hunter Kefauver," read the headline. The image of an upright, bespectacled man was accompanied by an illustration of an octopus, its tentacles grasping at dollar bills and dice, one tentacle holding a gun, another wrapped around the leg of a showgirl. This new notoriety gave him an advantage for the Democratic presidential nomination in 1952. But it was Adlai Stevenson, a write-in candidate, who finally became the Democratic candidate running against Eisenhower. Kefauver had his fifteen minutes of fame—and he spent it recklessly on a sucker bet.

Perhaps inspired by Kefauver's example, Senator Joseph McCarthy began searching out Communists under every bed in America. Wrapped in the flag that was the House Committee on Un-American Activities, the senator from Wisconsin cut a swath through the country with his Red-baiting attacks on Hollywood, government, academia, and even the press. At a rally in Las Vegas, he chose a curious target: Hank Greenspun. He accused the publisher of desertion during the war and of being an ex-Communist, later clarifying that he meant "ex-convict," a reference to Greenspun's conviction for running guns to Israel. As people booed and hissed, Greenspun strode up to the stage and took the microphone, invoking the phrase that would follow McCarthy across the country: "Show me your proof, Senator."

A tough customer who relished getting down and dirty with his opponents, Greenspun used his column to launch a relentless attack on McCarthy, calling him "the most immoral, indecent and unprincipled scoundrel ever to

sit in the United States Senate." He offered up a prediction of the senator's demise: "The chances are that McCarthy will be laid to rest at the hands of some poor innocent slob whose reputation and life he has destroyed through his well-established smear technique . . ." Greenspun was indicted for publishing and mailing matter "tending to incite murder or assassination," which he called "just another attempt to muzzle a newspaper which has been critical of McCarthy . . . "

Eventually Greenspun was acquitted of this charge, but the indictment only seemed to inflame his hatred of McCarthy. Calling the senator a "sadistic pervert," he wrote that McCarthy "seldom dates girls, and if he does, he laughingly describes it as window dressing." He added that McCarthy frequented a known gay bar in Milwaukee, dubbing the senator "the queer that made Milwaukee famous." These allegations, Greenspun delighted in claiming, helped damage the senator's reputation and led to his eventual demise in 1957.

Natural-Born Killers

Las Vegas was the one place where sin was not only forgiven, it was openly embraced. Casino owners meted out their own rough form of justice—anyone attempting to cheat at the tables was taken out into a back alley and beaten to a bloody pulp. Otherwise, Vegas had a fairly laissez faire attitude toward criminal activities, enjoying, for a time, dubious distinction as the Murder Capital of the Nation. Criminals harboring murder in their hearts came here, either in anticipation of a terrible crime, or having committed it—and sought to lose themselves in the anonymity of this gambling town, to make a quick score, to settle a score, or simply to join the millions partaking of its pleasures.

It was the day before the last day of 1959, and a black Chevrolet with Kansas license plates was parked outside the Las Vegas Post Office on Stewart. Dick Hickock sat in the car, waiting for his partner, Perry Smith, reviewing his latest scheme: disguised as an Air Force officer, he was going to go from one Strip hotel to the next— the Sahara, the Sands, all the posh casinos— cashing bad checks. The unsuspecting cashiers would happily oblige him, assuming he was going to drop all that money at the tables. He estimated that in twenty-four hours, he would have around forty grand—enough to rid himself of Smith, who had outlived his usefulness.

The Las Vegas post office where the Kansas Killers were apprehended in 1959.

Finally, Smith emerged from the post office, carrying the box that he had shipped from Mexico. When they had met in the Kansas State Penitentiary, Smith had informed Hickock that he had killed a colored man in Las Vegas—beaten

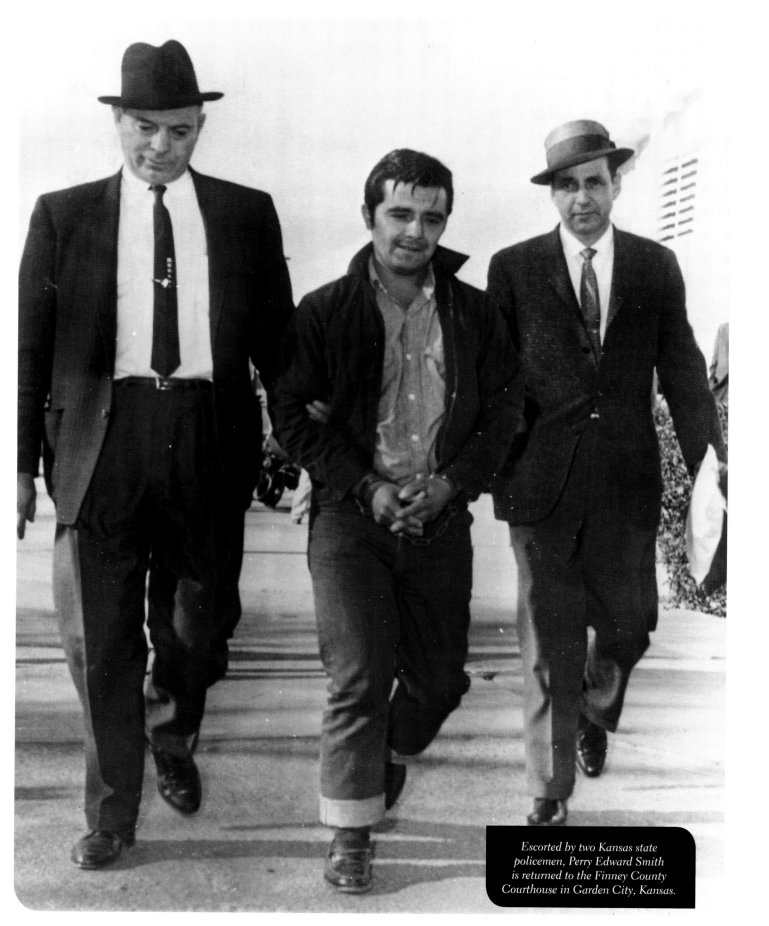

Escorted by two Kansas state
policemen, Perry Edward Smith
is returned to the Finney County
Courthouse in Garden City, Kansas.

him to death with a tire iron "just for the hell of it." This had impressed Hickock, who judged his new running mate to be a natural-born killer. On that score, at least, he had proven to be a good judge of character. On a November day in the Kansas farming community of Holcomb, Smith and Hickock entered the home of the Clutter family, and Smith shot and killed the father and son in the basement. Then the two men went upstairs and shot the mother and daughter in their beds.

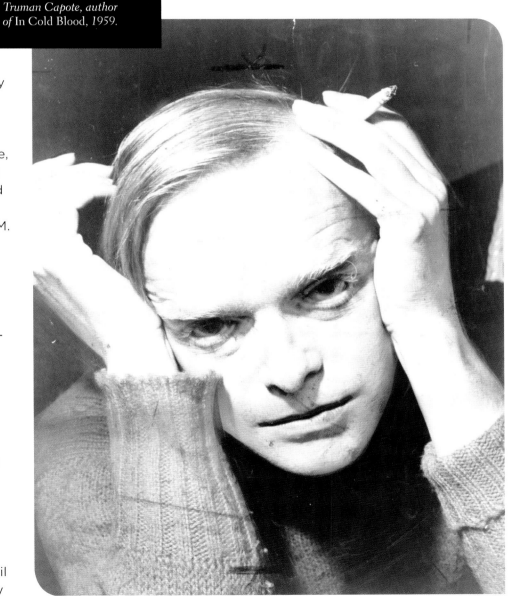

Truman Capote, author of In Cold Blood, *1959.*

They fled across country, ending up in Las Vegas. A patrol car drove by and saw the Chevy parked in the front of the post office. It was no novelty in Vegas to see cars with out-of-state license plates, but this one, JO16212, was on their all-points bulletin. The patrol car followed the Chevy north to a seedy motel with a sign that said OOM. Police took Smith and Hickock into custody, booked them at the downtown jail, and put in a call to the Kansas state police.

The box that Smith had retrieved at the post office contained damning evidence—a pair of boots, one with a cat's paw on the heel, the other with a diamond pattern. These were a perfect match to the bloody footprints left at the Clutter farmhouse. That he had bothered to ship these pitiful belongings—and to Vegas, of all places—was a curious thing for him to have done; he had committed the perfect crime, yet he created this sad little trail that he perhaps subconsciously hoped someone would follow.

The killers were put into two police cars and transported across the country to Kansas. The *Las Vegas Sun* proclaimed: "Fear Lynch Mob Awaiting Return of Killer Suspects." Surveying the scene of onlookers and reporters gathered outside the courthouse in Garden City, Captain Murray of the Kansas Highway Patrol remarked, "Don't look much like a lynch mob to me."

While on death row, Smith confided in Truman Capote, who had seen a small

item about the murders in a newspaper and decided to pursue the story. Smith told Capote that he had a recurring dream: he was in a Las Vegas nightclub, dressed in a white top hat and tuxedo, strutting onstage, tap-dancing and singing "You Are My Sunshine." The audience, mostly black, observed this performance in silence. Smith realized that they were the ghosts of those who had been executed before him, and that the stage was a scaffold, opening beneath him.

The real execution took place at the Kansas State Prison in 1965. Capote's account of the crime and the execution, *In Cold Blood,* became a national best seller. Las Vegas—the actual Vegas, not the one in Smith's dream—barely blinked: it was business as usual, a new shooter coming out.

What Made Patty Run?

A: He took me to Las Vegas.
Q: He took you to Las Vegas?
—Excerpt from transcript
of the Patty Hearst trial

The prosecutor in the infamous Patty Hearst trial could not believe his ears. On the stand was this heiress who alleged she had been kidnapped by a radical group known as the Symbionese Liberation Army, forced to participate in a bank robbery, and then spirited across the country, stuffed into closets and kept under constant surveillance, with no possibility of escape. She had just revealed, under oath, that one of the SLA members, Jack Scott, had taken her to Vegas. A story that had already strained credulity had just gotten more bizarre. On the one hand, Vegas afforded an anonymity that might be attractive to a criminal; on the other, when you've got a kidnapped heiress in tow and

every law-enforcement official in the country is looking for you, Vegas might prove to be too big a gamble.

Scott dropped her at a motel and went to visit his parents, who managed an apartment building in town. There she was, left alone, the perfect opportunity to flee. But she suffered from what psychiatrists refer to as Stockholm Syndrome, in which captors hold the psychological edge, and their captive starts to identify with them.

Had she instead had Vegas Syndrome, she would have done the desperate thing, she would have taken the chance, because she was in a city of chance, where, despite the incontrovertible fact that the house always wins, people keep betting that Lady Luck will smile down upon them. All she had to do was stride out into the glare of the desert sun and find a cab that would whisk her to the federal building downtown and then turn herself in to the FBI. Or go into an air-conditioned casino and sit down at a blackjack table and play a few hands while she collected her wits. The dealer would scarcely notice her; if a pit boss looked down from the eye in the sky and saw this face that had been in every newspaper and on every news program in the country, and he came down to see for himself, she could just pick up her chips (she was, after all, due for a change in luck) and walk out.

Instead, she remained in that motel room until Smith returned. They watched TV together and then he departed for good; later, two SLA members arrived to bundle her off to the next location.

Eventually, Hearst was apprehended in a shootout in Los Angeles and put on trial. Up on the stand, when she said, "He took me to Las Vegas," did she not realize that the mere admission that she had passed through that place, like a captive ship in the night, meant that she had busted, that Vegas Syndrome trumps Stockholm Syndrome every time?

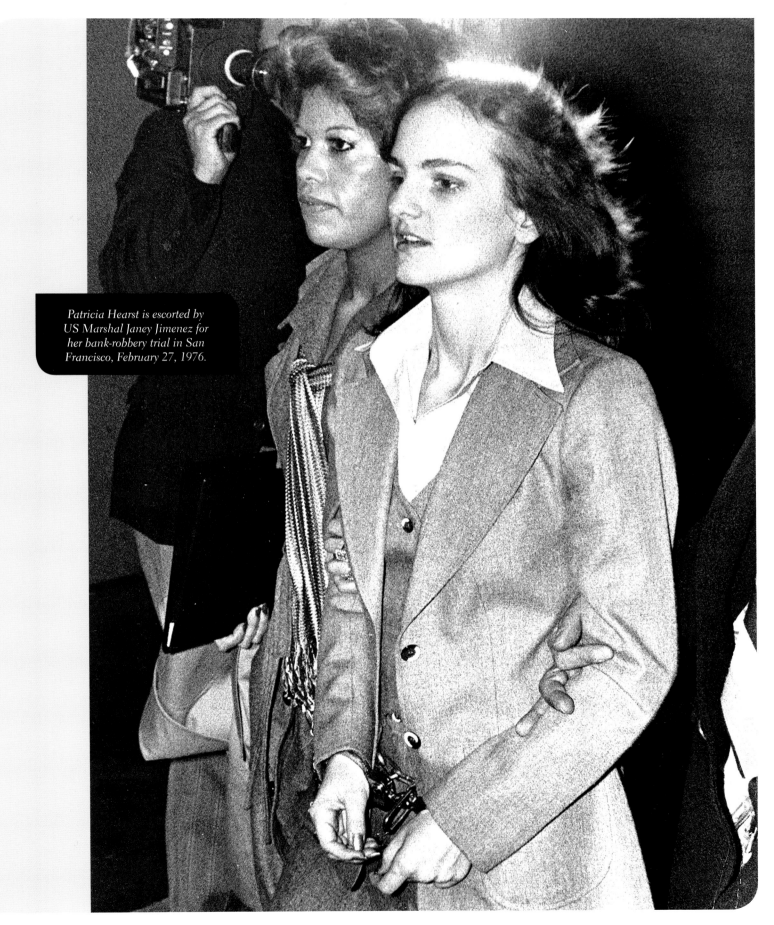

Patricia Hearst is escorted by US Marshal Janey Jimenez for her bank-robbery trial in San Francisco, February 27, 1976.

KICKING ASS IN VEGAS: A CAUTIONARY TALE

It beats in the heart of every gambler: a consuming fantasy of walking into a casino and, through cunning and skill and a modicum of luck, taking the house for all it's worth. This fantasy has been lived out numerous times in books and films. In *Rain Man,* Dustin Hoffman plays an autistic savant with an uncanny gift for counting cards. He and his brother, played by Tom Cruise, go to Caesars Palace and play blackjack, with Hoffman counting and Cruise betting. They make a killing, walking away with $50,000. "We're kicking ass in Vegas!" Cruise's character exults, for the first time appreciating the value in having an idiot savant for a brother.

Successful card-counting schemes, in the age of multiple-deck shoes, are improbable but not impossible. In the 1990s, a group of MIT students formed a team that, with the planning and precision of a strike force, descended on Vegas casinos and cleaned up at the blackjack tables, winning millions of dollars. Using aliases and even disguises, they worked as a unit, with several spotters fanning out across the casino in search of a deck that was "hot"—i.e., containing a high ratio of high cards to low cards. Through a series of signals, they alerted the designated "Big Player," who bet huge sums on each hand, splitting and doubling down to maximize the returns. It was a huge risk—if discovered, they could be thrown out, or taken into a backroom and roughed up—but the risks were well worth the rewards.

This was heady stuff, beating the casinos at their own game, living the life of the high roller, with comped luxury suites, house seats for the top shows, lavish midnight feasts, and, of course, women at the ready.

Eventually, all good things must come to an end, and the MIT team was found out, word spreading like a Vegas dust storm from casino to casino.

Jeff Ma, a straight-A student and math whiz who for a time used the pseudonym Kevin Lewis, was one of the members of the team whose exploits were recounted in Ben Mezrich's book *21,* as well as the film by the same name. Ma profited from the venture, buying a townhouse in Boston and investing in a bar, all before the age of twenty-three. Today, he is a pariah in most Vegas casinos—one won't allow him to stand within twenty-five feet of a blackjack table. Still, he remains proud of his accomplishment—in five years of playing, his team never had a losing year. In fact, in each year, the returns on investment were 40 percent or better. Said Ma, "You find a stockbroker or trader who can claim that!"

Card counting is adrenaline-driven, fraught with risk, not for the faint of heart. That is part of the attraction—the frisson of danger, the high-stakes betting, the delicious prospect of beating the house at its own game, of walking away with thousands of dollars. Of course the casinos are not going to sit idly by while teams of card counters assault the casino vaults with their clever schoolboy schemes; they use every device in their arsenal—eyes in the sky, private detectives, infiltration, intimidation—to discourage such activities. Technology has also come into play—the advent of continuous shuffling has made card counting virtually impossible. While still popular, blackjack has ceded the limelight to poker, with its million-dollar tournaments. But it is that old staple, the slot machine, which accounts for 60 percent of casino revenues. No longer simply "one-armed bandits," slots are now highly sophisticated video machines with clever animation and addictive sound tracks, and feature pop culture figures from Elvis to Tony Soprano.

Damon Zimonowski—a former casino host who knew Jeff, aka Kevin, in the heyday of the MIT scam—echoes Benny Binion in an interview in Mezrich's book, calling Vegas "the last fucking place on earth where a bum with no skills can make a living." His summation of Vegas serves as a cautionary note to anyone who thinks they can kick ass in Vegas. "Over time, nobody beats the house," he says. "You fuck with the cardinal rule, you fuck with Vegas. And sooner or later, Vegas finds a way to fuck you back."

7 Come 9-11

August is the worst month for weather in Las Vegas. Not only is it blazing hot—with daytime highs frequently 110 degrees or higher and lows rarely below ninety—but the moisture streaming up from the Gulf of California turns what is normally a dry heat into a steambath.

But time was running out for three men who came to Las Vegas in mid-August 2001. They couldn't wait until October, when the weather would cool down. If they wanted to see Las Vegas and partake of its pleasures, it was now or never.

Mohamed Atta, Nawaf Alhazmi, and Hani Hanjour—names that now live in infamy—slipped into town unnoticed. They stayed at the Econo-Lodge in the dismal industrial area north of the Strip. One can surmise either that Al Qaeda's per diem was not a generous one, or, as many US government employees do, the men stayed in a cheap motel and pocketed the difference.

Why Vegas? Why had these three men, who in a month would be flying airplanes into the World Trade Center in New York and the Pentagon in Washington, DC, come to this town out in the middle of the Mojave?

The 9/11 Commission was perplexed by this question, noting, "Beyond Las Vegas' reputation for welcoming tourists, we have seen no credible evidence explaining why, on this occasion and others, the operatives flew to or met in Las Vegas."

Of course they came to Vegas! Just look around: neon signs promising every sin under the sun, half-naked women, craps tables, and ninety-nine-cent shrimp cocktails. And for good measure, some comforting reminders of home: the Gardens of Allah, the Great Pyramid, the sultanic excess, the desert itself.

So what if there were no vestal virgins to be found in Las Vegas? That would come later. For now, there were real live flesh-and-blood women who would do whatever you wanted, providing you with your last moment of earthly pleasure before finding yourself at the controls of a plane that was going to take you straight into the arms of Allah.

"Crazy Girls" display their wares at the Riviera.

In the aftermath of 9/11, federal authorities seem to have awakened to the allure of Las Vegas as a potential target for terrorists. "We know this is a meeting ground," said Dave Staretz, supervisory special agent with the FBI in Las Vegas. "The pro-Western ideologies of leisure are something that would be of interest to radical Islamic fundamentalists."

There are many easy targets in Las Vegas—towers and pyramids, ninety-nine-cent breakfasts and $9,000 suites. But if they plan to strike at the soul of the city, good luck in finding that.

SIN CITY ON CELLULOID

Hollywood owes a deep debt of gratitude to Las Vegas. With its cinematic flair for spectacle, its exuberant love of mobsters, its dark underbelly of greed and corruption, Vegas has proven to be an irresistible allure to filmmakers. From caper movies to gangster epics, broadside comedies to bleak indie films, a large and varied contingent of films takes place in Las Vegas. Most trade in the stereotypes about Vegas, which is fair enough, given that many of the stereotypes are based in truth; but the real truth, the deeper truth about Vegas as a reflection of American society, is revealed in a very few.

Las Vegas even has its own film festival. Started by film and art lovers, independent filmmakers, and movie industry veterans, including Dennis Hopper, the first CineVegas Film Festival took place at Bally's Hotel and Casino in 2002, screening "The Best of the Fests"—independent films that had won awards and acclaim at other festivals around the world.

A festival of films shot in Vegas would have to include the following:

HELLDORADO (1946)
Roy Rogers, Dale Evans, and Trigger gallop into town for the annual frontier celebration. The Frontier enjoys a brief cameo.

THE ATOMIC KID (1954)
Shot on location in Las Vegas, this slapstick comedy about a uranium prospector who eats the wrong peanut butter sandwich and ends up radioactive stars Mickey Rooney and his then-wife Elaine Davis. The glow-in-the-dark hero tracks a ring of spies through the old Fremont Street casinos, setting off slot machines in his wake.

OCEAN'S 11 (1960)
Still the definitive Vegas movie, the original stars the Rat Pack—Frank Sinatra, Sammy Davis Jr., Dean Martin, Peter Lawford, Joey Bishop—and Angie Dickinson. Sinatra plays Danny Ocean, who reassembles his old army unit to take down five casinos—the Sahara, the Desert Inn, the Riviera, the Sands, and the Flamingo.

The boys clown around in their alpaca sweaters, smoking cigarettes, displaying that sixties brand of cool. The movie was in the can before the deal was brokered to desegregate the Strip hotels. Thus, Sammy Davis Jr. doesn't get a job working inside the casino like the others. Instead, he's a garbage man. But what a dapper garbage man! In one scene, Davis, dressed in overalls and a natty ascot, does a dance routine for his fellow trash collectors. The film has a very Vegas ending—though the scheme goes off without a hitch, the big dream of making millions by beating the house ends up unrequited.

VIVA LAS VEGAS! (1964)
With sexy Ann-Margret at his side, Elvis sings his way up and down the Strip, visiting such notable Vegas sites as the Sahara Hotel, the Tropicana, and the Little Church of the West.

DIAMONDS ARE FOREVER (1971)
Sean Connery (the original and only Bond) finds himself in pursuit of an international diamond-smuggling ring, with the evil Blofeld at the helm. Bond and the lovely Tiffany Case (Jill St. John) follow the trail to Vegas, where they swing with trapeze artists at Circus Circus, ride the exterior elevator at the Landmark (later imploded, though not by Bond), and participate in the obligatory car-chase scene on Fremont Street.

THE GODFATHER (1972)
Michael Corleone (Al Pacino) is moving the family business to Las Vegas, but his offer to buy out Moe Green is refused: "You don't buy me out, I buy you out." You shouldn't have said that, Moe. Not one to take defeat lightly, Michael puts out a hit on Green, who is enjoying a massage when he takes a bullet through the eye.

THE ELECTRIC HORSEMAN (1979)

Robert Redford portrays an ex-rodeo star met with the final indignity: appearing onstage in a suit covered in lights to hawk breakfast cereal. Instead, he horse-naps the $12 million Thoroughbred, which has been drugged, and rides off into the desert with Jane Fonda. Scenes filmed at Caesars Palace.

DESERT BLOOM (1986)

Set in Vegas in the 1950s during the atomic-testing era, this bleak family drama features John Voight in an affecting portrayal of a damaged alcoholic and Annabeth Gish as his stepdaughter.

BUGSY (1991)

Warren Beatty plays Bugsy Siegel, the mobster as visionary who in the 1940s built a resort out in the middle of the desert. Thanks in part to this movie, Siegel is credited with being the founding spirit of Las Vegas. The film neglects to point out that there were already two hotels on the Strip before Siegel arrived: El Rancho Vegas and the Frontier. Moreover, Siegel's brainchild was actually that of Hollywood *Variety* publisher Billy Wilkerson, who conceived the idea for the hotel but ran out of money. Siegel builds his dream palace but then suffers the inevitable fate of those afflicted with hubris.

HONEYMOON IN VEGAS (1992)

Nicolas Cage stars with James Caan in this playful Vegas send-up that includes the now-infamous "Flying Elvis" troupe of skydiving impersonators.

INDECENT PROPOSAL (1993)

A young couple in dire financial straits (Woody Harrelson and Demi Moore) heads to Vegas, where a high roller (Robert Redford) offers them $1 million if he is given one night to sleep with the comely Demi. The offer, while attractive, tests the limits of their relationship. Scenes filmed at the Las Vegas Hilton.

CASINO (1995)

Martin Scorsese finally took on Vegas in his chronicling of the mob experience in America. The film's fiery opening scene is actually the finale for a casino owner, played by Robert DeNiro, who gets caught up in the greed and corruption of a gambling operation.

LEAVING LAS VEGAS (1995)

In director Mike Figgis's dark tale, Nicolas Cage won the Oscar for his searing performance as Ben, an alcoholic who goes to Vegas determined to drink himself to death. Elisabeth Shue received an Oscar nomination for her portrayal of a prostitute—a bleak variation on the hooker with a heart of gold.

SWINGERS (1996)

Jon Favreau wrote and starred with Vince Vaughn in this hipsters' ode to young actors prowling the nightclub scene in LA. An impromptu road trip to Vegas ("Vegas, baby, Vegas!") finds them at the Stardust and the Fremont Hotel, with interior shots of the Paradise Buffet.

FEAR AND LOATHING IN LAS VEGAS (1998)

Director Terry Gilliam brings Hunter S. Thompson's hallucinogenic novel to the screen with Johnny Depp and Benicio Del Toro tripping out on a psychedelic, psychopathic pursuit of the American Dream. The Stardust and the Riviera are featured in the film.

OCEAN'S 11 (2001)

What was a good idea in the sixties seemed worth reviving for a new century, with a new, much glitzier Vegas on display. The opulent Bellagio is the backdrop for much of the action, starring George Clooney. Somehow, this remake and its sequels, special effects and all, failed to capture the "real" Vegas as definitively as the Rat Pack version.

Bringing Down the House

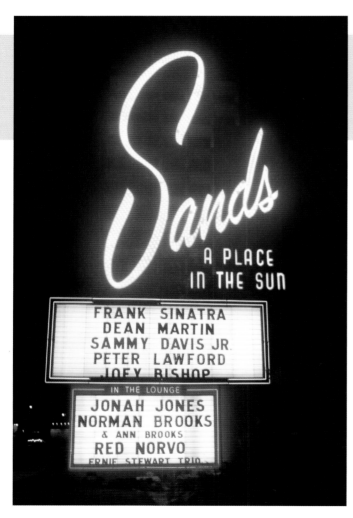

Marquee at the Sands, c. 1960.

Ms. Bankhead, who interrupted her Hollywood career to perform at the Sands, had no illusions about why she and other performers were courted by the Strip hotels. The self-proclaimed "Entertainment Capital of the World," Las Vegas used its high-priced marquee talent to lure people into the hotel showrooms and thence into the casinos. The lavish floor shows and singers and comedians were merely loss leaders for the main attraction, which was gambling.

In the 1950s and '60s, the Strip's glittering firmament of stars included the top-name singers of the day: Andy Williams, Mel Torme, Tom Jones, Peggy Lee, Ella Fitzgerald. Comedians tumbled into town like clowns in a clown car: Buddy Hackett, Norm Crosby, Red Skelton, Don Rickles—everyone who had a schtick performed it in Vegas.

Dean Martin's opening night in the Copa Room, March 6, 1957. In the front row are Jack Benny, Desi Arnaz, Lucille Ball, Jack Entratter, and Debbie Reynolds.

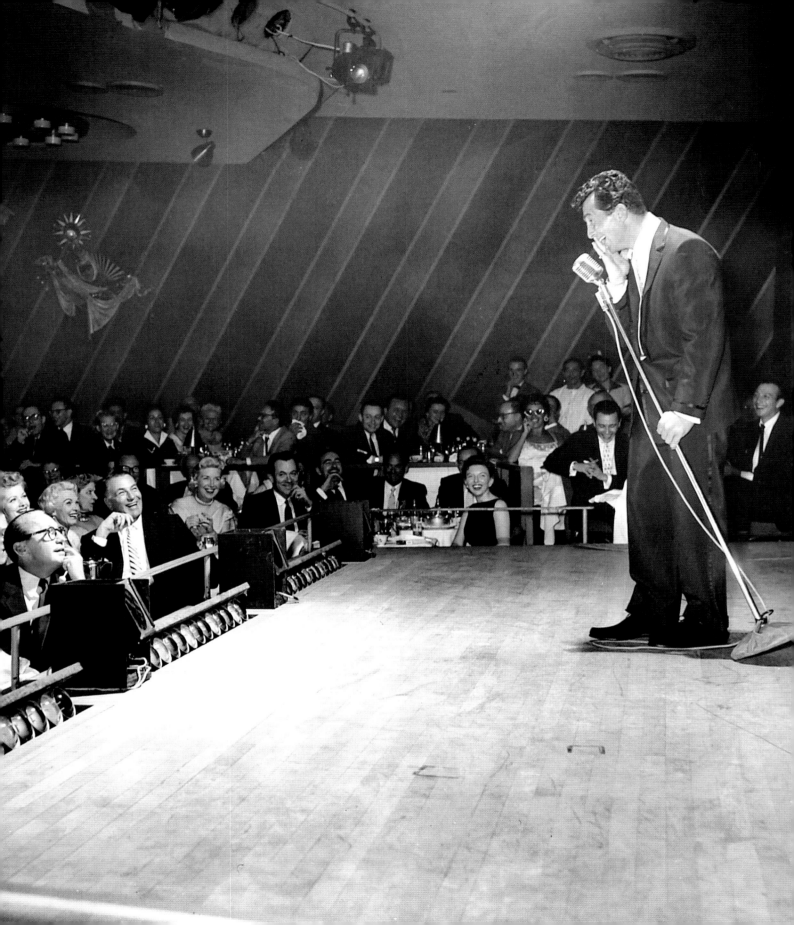

Some entertainers looked to Vegas to resuscitate a fading career. Ronald Reagan, whose film career was slipping away, signed to perform at the Last Frontier in 1954. The Gipper trained like a prizefighter, abstaining from smoking or drinking, conserving his energy for the four-hour rehearsals. He opened in February 1954. Flanked by showgirls attired in Latin costumes and three-foot headdresses, he told jokes, did a song with a male quartet, and, for his finale, recited a sentimental poem. The critics, who could not have foreseen that the man capering onstage would one day become president of the United States, panned the performance, and the short-lived engagement proved to be the last frontier for Reagan's Vegas career. Humiliated, he returned to California to pursue a career in politics. "Never again," he vowed, "never again will I sell myself so short."

Other entertainers fared better in Vegas. In 1956, crowds gathered in the rooftop lounge at the Fremont Hotel to view the atomic tests, and to hear the song stylings of a twelve-year-old local boy named Wayne Newton. "Danke Schoen" became his signature song, and he sang in his tux with the blue ruffled shirts, and he grew into the thing he was put on earth to become: "Mr. Las Vegas."

But no one defined the epitome of Vegas cool more than Frank Sinatra and the Rat Pack. Headquartered at the Sands, Sinatra and his group of friends—Dean Martin, Sammy Davis Jr., Joey Bishop, Peter Lawford—sang, swung, drank, gambled, and womanized with a hip, brash swagger. The press dubbed them the "Clan," but Sammy Davis Jr. protested: "I ain't belongin' to nothing that's called a *clan*." Instead, they

Ella Fitzgerald, pictured in a 1940 photo, performed regularly in Vegas in the 1950s and '60s.

Members of the Rat Pack perform onstage at the Sands, ca. 1960. Left to right: Sammy Davis Jr., Joey Bishop, Frank Sinatra, Peter Lawford, an unidentified man, and Dean Martin.

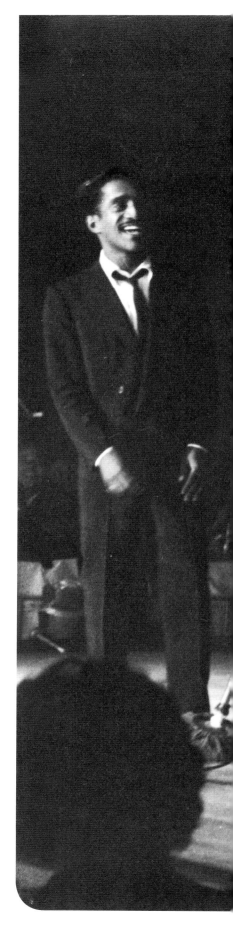

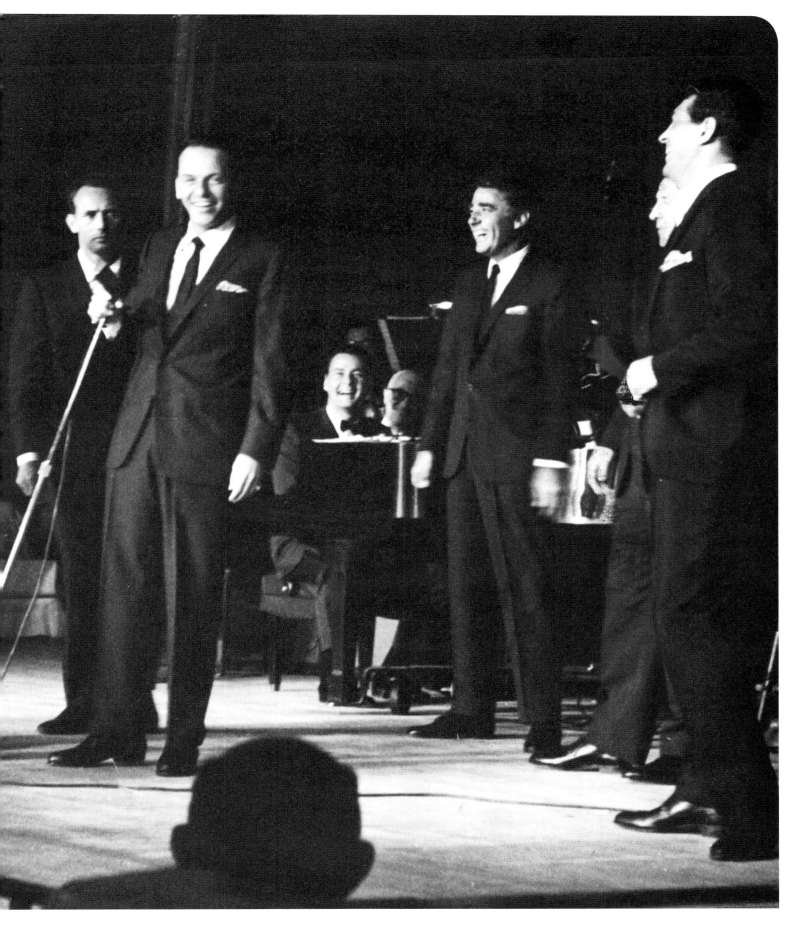

became known as the Rat Pack, and they wore cardigan sweaters and called people "baby" or "Charley." With their breezy, irreverent style, heavily scented with sex, money, and politics, they signaled the end of the Eisenhower era and ushered in a new decade.

In 1960, the group was in town to shoot a caper movie, *Ocean's 11,* and perform at the Sands. With Eisenhower, DeGaulle, and Khrushchev planning a summit conference, Sinatra joked that the gang should hold its own little summit. The local papers picked it up, and within a week, the town, normally slow for February, was booked solid. As Steve Wynn said, "Every swinger and do-da-diddy guy, every sporting-life character on the face of the earth was in Las Vegas, taking every room in this small town so they could get a seat at The Rat Pack." Hundreds of people crowded into the Copa Room, using money and connections to get a table and watch the hijinks:

(Davis, wearing gray flannel slacks, blazer, and ascot, is in the middle of a dance number; Peter Lawford wanders onstage. Davis motions for Lawford to join him.)

LAWFORD: I'm not prejudiced, Sam. I'll dance with you.
DAVIS: But will you go to school with me?

(Joey Bishop, dressed as a Jewish waiter, introduces Sinatra and Martin as the "Italian bookends." He warns them to watch out.)

BISHOP: I got my own little group, the Matzia.

(Sinatra and Martin, dressed in tuxes, wheel in a portable bar and mix drinks. Sinatra turns to the band.)
SINATRA: Cut.

(He beckons Davis to come over.)

SINATRA: Look what Peter's wearing. Look what Dean and I are wearing. Now look at yourself. Where do you get off coming on stage in that little toy suit? Just where do you think you are—on your yacht? Now you go and get yourself into a regular grown-up tuxedo like the rest of us. Go on. Get out of here. Get off this stage.
DAVIS: Hold it! What're you, *Esquire* magazine? You don't tell me what to do. Y'hear that, Mr. Sinatra? (He pokes Sinatra in the chest.) What're you, some kind of big deal? Not to me! I'll change my suit when I'm plenty good and ready.
SINATRA (quietly): When'll that be?
DAVIS (with sickly grin): I'm ready, Frank.

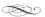

(Sinatra introduces a member of the audience, John F. Kennedy, the senator from Massachusetts. Martin comes lurching out of the wings.)

MARTIN: What did you say his name was?

(Davis jumps into Martin's arms, and Martin holds him out to JFK.)

MARTIN: Here. This award just came for you from the National Association for the Advancement of Colored People.

Kennedy, who was running for the Democratic nomination for president, roared along with the rest of the audience. After the show, he sat with his entourage at Sinatra's table in the lounge. Among the women at the table was Judith Campbell, a twenty-six-year-old divorcee with whom Sinatra had had a brief affair. However, she found his sexual preferences

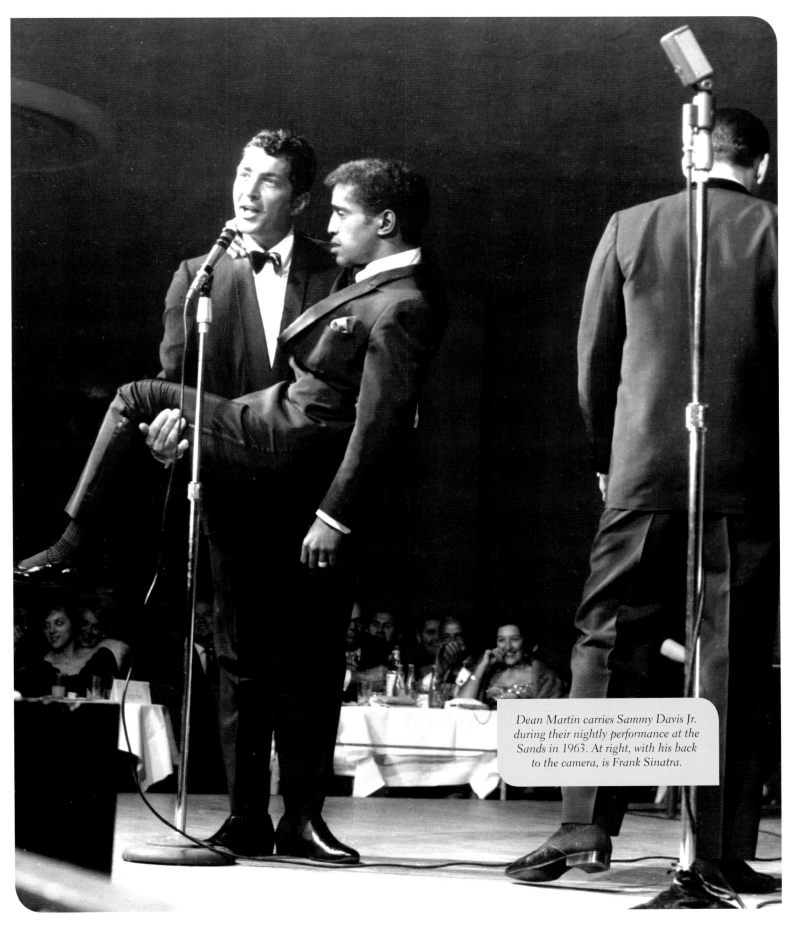

Dean Martin carries Sammy Davis Jr. during their nightly performance at the Sands in 1963. At right, with his back to the camera, is Frank Sinatra.

*John F. Kennedy with
Peter Lawford in Las Vegas,
summer 1960.*

too kinky, and he in turn accused her of being a square. "Get with it," he told her. "Swing a little."

And so she did—with the future president of the United States. That night, talking with JFK, she fell under the Kennedy spell. "It was as if every nerve and muscle in his whole body was poised at attention," she wrote in her autobiography. "As I was to learn, Jack Kennedy was the world's greatest listener." The next day Kennedy invited her for lunch in Sinatra's suite, where he exhibited "an almost insatiable interest in what and who I was."

JFK did very well in Vegas: he left town with a new love interest and, reportedly, a satchel stuffed with $1 million, a contribution from the hotel for his campaign war chest. He may have also left with the name of his agenda for the nation. Gazing out at the lights of the Strip, perhaps he saw the sign in front of the hotel that replaced Reagan's old venue and thought, *the New Frontier*—not bad.

In July, at the Democratic convention, Sinatra sang the national anthem and a rendition of "High Hopes," with lyrics by Sammy Kaye: "K-E-double-N-E-D-Y. Jack's the nation's favorite guy . . ." When Kennedy beat out Adlai Stevenson for the nomination, Sinatra slapped Peter Lawford on the back, exclaiming, "We're on our way to the White House, buddy boy. We're on our way to the White House!"

The satchel donation proved to be money well spent. JFK carried Nevada in the election, winning the state's paltry three electoral votes—this despite the fact that Pat Nixon, wife of Richard Nixon, his Republican opponent, had been born in Ely, Nevada, a true daughter of the Silver State.

JFK paid another visit to Las Vegas in September 1963, speaking to a cheering crowd at the convention center. Robert Kennedy, in his capacity as attorney general, had warned his brother away from Sinatra, who was in trouble with the state gaming-control board for his mob connections. Riding in the limo with Governor Grant Sawyer, JFK asked, "What are you guys doing to my friend Frank Sinatra?" That night, he enjoyed the companionship of what was described as "several comely prostitutes."

The affair with Judith Campbell, which had already ended, was such a closely guarded secret that it did not come to light until 1975. The revelation, though posthumous, put a permanent tarnish on the glowing legacy of Camelot.

That early promise of the sixties embodied by the JFK presidency began to unravel, as did the effortless, swinging male bonhomie of the Rat Pack. With mob money drying up, and anxious to dissociate itself from its tawdry past, Las Vegas looked to a new savior: Howard Hughes. Profligate in his acquisition of Strip hotels, Hughes acquired the Sands.

Sinatra made it very clear that he was still the alpha male in town. "Welcome to Las Vegas, Howard Hughes' Monopoly set," he quipped to his audience. "You're wondering why I don't have a drink in my hand? Howard Hughes bought it."

Sinatra and Hughes had a history going back to 1945, when Hughes was trying to win over Ava Gardner with lavish gifts and shopping sprees on his chartered jet. Now Sinatra demanded that, as part of his contract, Hughes buy the Cal-Neva Lodge, which Sinatra owned but was prohibited from running. Hughes refused, and adding insult to injury, the Sands cut off Sinatra's gambling credit. Sinatra went into a frenzy, shouting, "I built this hotel up from a sand pile and I can tear the fucking place down." To prove the point, he drove a golf cart up to the front entrance and hurled a cigarette ashtray into the plate-glass window.

Then he did what a few years before would have been unthinkable—he defected. He signed a $3 million contract with Caesars Palace guaranteeing him $100,000 a week—the highest salary ever paid to a Vegas performer.

A joke made the rounds that when told of Sinatra's departure, Hughes said, "Frank who?"

Sinatra did not go quietly into that good Vegas night. He returned to the Sands in a drunken rage, demanding to see Carl Cohen, executive vice president and casino manager. Cohen finally agreed, but when Sinatra tipped over a table and called him a kike, Cohen smashed his fist into Sinatra's face, knocking the caps off his two front teeth. Ordered to investigate the incident, the Clark County district attorney considered legal action, but such was Sinatra's popularity that no one would press charges. Indeed, Hank Greenspun, editor of the *Las Vegas Sun,* took Sinatra's part: "Not everybody in the world of theatricals can be Ronald Reagan or Shirley Temple . . . [Sinatra's] value to Las Vegas is legendary, for every night he performed here is New Year's Eve."

It wasn't long before Sinatra was wearing out his welcome at Caesars Palace. Working undercover as a cashier, an IRS agent discovered that Sinatra was using markers to gamble, then turning the winnings into cash that he pocketed rather than paying back. When Sinatra signed another marker, Sandy Waterman, the casino manger, was summoned: "You don't get chips until I see your cash." During the ensuing shouting match, Waterman pulled a gun and put it between Sinatra's eyeballs. Laughing, Sinatra called him a crazy Hebe and walked out. Though Waterman was booked for pulling the gun, Sheriff Ralph Lamb was outraged at Sinatra: "He gets away with too much. He's through picking on the little people in this town." For his part, Sinatra said he was through with Vegas, and in 1971, he announced his retirement.

Two years later, at the urging of President Nixon (politically, Ol' Blue Eyes could swing both ways), Sinatra came out of retirement. He re-signed with Caesars Palace, which agreed to pay him $400,000 a week and provide free bodyguards. For opening night, 1,300 people packed in the Circus Maximus showroom. Each guest in attendance received a gold medallion

that was inscribed: "Hail Sinatra. The Noblest Roman Has Returned."

Beatlemania

Having weathered the unpredictable force of nature that was Frank Sinatra, Vegas should have been impervious to the phenomenon known as Beatlemania. How could four mopheads from Liverpool possibly hold a candle to Tom Jones, Liberace, or Elvis? The press was blasé. Don Digilio, columnist for the *Review–Journal,* referred to the Beatles as "those fly-by-night entertainers from England."

In August 1963, the Fab Four arrived at McCarran Airport and were driven through back streets to the rear entrance of the Sahara and whisked up to their suite in the freight elevator. Ringo, upon entering the suite, asked the *Sun* reporter, "How do you work this telly?" Then he settled in to watch an old movie.

Somehow, word got out where they were staying, and three hundred teens rampaged through the hotel, the sound of "Ring-o-o-o!" reverberating through the halls. Some even tried to scale the outside wall. A paddy wagon and police dogs were summoned.

The Beatles performed before a sold-out crowd at the convention center. During "I Wanna Hold Your Hand," their hit single, the crowd went into a frenzy, screaming and pressing forward, threatening to storm the stage. Photographer Don English vividly recalled the moment:

Then all of a sudden, the crowd rose and started walking towards the Beatles. I've never experienced or seen anything like this in my life. They had a ring of guards in front

of the Beatles on stage, and these guys linked arms. In fact, I talked to one of them later, and he said he's never been so scared in all his life. He'd never seen anything like this happen.

The Sahara survived the visit; the convention center was still standing. The Beatles continued on their US tour, and Vegas returned to its normal routine—desert heat, air-conditioned casinos, a few jokes, a few songs, the spin of the wheel, the roll of the dice, and everywhere, Elvis.

"Love Me Tender, Love Me True . . ."

This plaintive plea by Elvis Presley might have been directed at Las Vegas. In 1956, Elvis was booked in the Venus Room at the Last Frontier. Advertised as "the atomic-powered singer"—yet another attempt to use nuclear testing as a tourist come-on—Elvis received third billing behind orchestra leader Freddy Martin and comedian Shecky Greene.

The mostly middle-aged audience had no use for this upstart with his rock 'n' roll music

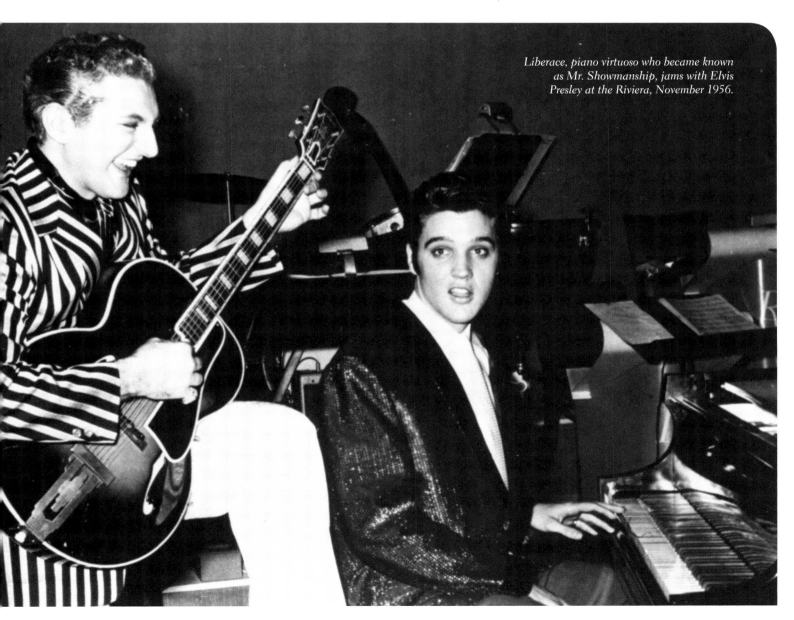

Liberace, piano virtuoso who became known as Mr. Showmanship, jams with Elvis Presley at the Riviera, November 1956.

and gyrating pelvis. Likening Elvis's presence to a "jug of corn liquor at a champagne party," *Newsweek* said the stunned audience sat motionless "as if he were a clinical experiment." On closing night, Elvis told the audience, "We've had a pretty hard time . . . uh . . . had a pretty good time while we were here."

Elvis's return to Vegas was practically pre-ordained, a joining of a city with its spiritual incarnation. In 1963, the King returned to film *Viva Las Vegas* with costar Ann-Margret. Elvis and his entourage, which was dubbed "the Memphis Mafia," took over the top floor of the Sahara. Ensconced in the presidential suite, Elvis proceeded to conduct a discreet affair with his costar. Despite attempts to literally smoke them out—members of his entourage once lit a news-paper and shoved it under the door—the door was not opened for anything but room service.

The opportunity for an Elvis comeback came from Kirk Kerkorian's new International. Alex Shoofey, the hotel's general manager, approached Colonel Parker, Elvis's man-ager, about signing Elvis as the opening act. "Absolutely not," Parker declared. "We will not open under any conditions. It's much too risky. Let somebody else stick their neck out."

Parker came around, and twice nightly, audi-ences were treated to a trimmed-down Elvis with sideburns, dressed in a white sequined jumpsuit, the pelvis not quite as spry but still suggestive of a latent sexuality. Over the next seven years, Elvis earned $125,000 a week and set attendance records—837 consecutive sold-out performances.

The King hated to fly. He tooled back and forth from his home in Graceland or Beverly Hills by car. In the seventies, his touring sched-ule having forced him to travel by plane, he purchased a four-engine Convair 880 from Delta Airlines for $250,000 and spent three times as much on customizations. Named the *Lisa Marie* after his daughter, the plane was, in typical Elvis fashion, over the top—even the

bathroom fixtures were gold-plated, down to the soap dishes.

Elvis's Vegas domain was the Imperial Suite, on the thirtieth floor of the International, where he and his entourage would party until dawn. Regular guests included Tom Jones and actors Jack Lord and Lee Majors. "This is the only place that celebrities and people he didn't know had an opportunity to hang out with Elvis," said Jerry Schilling, Elvis's former producer and con-fidante. "He was comfortable, he was on his own turf. He didn't do that at Graceland or at the L.A. houses we lived in."

In fact, he was so comfortable, so much at home, that he felt free to indulge in his habit of firing off a gun in the room, aiming at any object that caught his fancy—TV, light switch, chande-lier. One night a bullet went through the wall, almost hitting his girlfriend.

The press descended from around the world to witness Elvis's wedding to Priscilla at the Aladdin. Elvis told the reporters, "Listen, I would like all of you to be my guests for a wedding lunch, but no pictures, no questions, no inter-views or anything. After the lunch, we'll have a cake, and everybody can shoot pictures and ask questions and anything at that time."

Liberace came backstage to greet Elvis, who sat down at the piano. Liberace picked up the guitar, and the two symbols of Vegas kitsch per-formed together, the photographers busily tak-ing pictures.

Elvis indulged his prodigious appetite for food. Occasionally, he would have the hotel chef up to the suite to prepare steak and mashed potatoes. He also frequented a nearby Italian restaurant, Villa d'Este, which was owned by Joe Pignatello, personal chef for Frank Sinatra. Elvis dined in a private dining room and always ordered the same dish: spaghetti and meatballs.

Elvis also stuffed himself with pharmaceu-ticals. His prescriptions—usually for Valium and Dialudid, a painkiller—were provided by oblig-ing local physicians, filled at the Landmark

Pharmacy, and walked across the street to the International. If he wasn't in town, the prescriptions would be delivered to Graceland or wherever he happened to be. Over the years, he ran up a tab in excess of $500,000, according to Jeff Burbank in his book *Las Vegas Babylon.* Elvis had "more power to get things done for him than anyone else in show business," Burbank observed.

Occasionally, Elvis submitted to the tender mercies of Dr. Elias Ghamen, Vegas' "physician to the stars." Once a casino house doctor, Ghamen treated Elvis in a room specially built for the singer in his palatial home. Later, Ghamen was implicated in the drug controversy surrounding Elvis's death, and came under FBI scrutiny for alleged collusion in steering union members and state employees to his clinic.

The performances, the food, the pills, the smiling doctors—all proved much too potent for Elvis. He returned to Graceland in 1976 and died eight months later. Vegas loved him, but not tenderly, and not truly. It tolerated, even encouraged, the excesses that led to his demise. Today, countless Elvis impersonators perform in the lounges and at the wedding chapels, a nonstop parody of the man who would be king.

"Mr. Las Vegas"

Parodies abound in a town that is in effect a self-parody. There is one star who invites this

Wayne Newton performs before the start of the NBA All-Star game at the Thomas & Mack Center in Las Vegas, 2007.

sort of mockery yet somehow seems to emerge with his reputation intact. That hardy perennial—"Mr. Las Vegas"—Wayne Newton. A loyal son of Vegas, true to its traditions, Newton signed to perform at the Frontier in 1981, only to learn that the hotel was discontinuing the dinner show. The dinner show had been a fixture in Vegas for three decades. The fare was simple—prime rib, baked potato, an iceberg lettuce salad with bleu cheese or Thousand Island—but it provided a kind of value added to the evening.

Newton decided to take a stand. "I feel it is a rip-off to the people, and I certainly think it is another step toward de-humanizing the entire Las Vegas showroom scene," he said.

His contract contained a clause that the showroom must be run in a "manner I consider suitable"—and this was not suitable, an affront to the patrons and detrimental to the workers who would be laid off. The Frontier reconsidered its position—Sinatra was one thing, but this was Wayne Newton—and they reinstated the dinner show.

A new millennium came, and yet still, and forever, there was Wayne Newton, as immutable as the Sphinx. A homeboy to his core, he owned a ranch outside of town, Casa de Shenandoah. He signed to perform at the Stardust, and when they blew that up, he went to the MGM Grand. There will always be a place for him on the marquees of Las Vegas.

"Lenny is coming!" The news spread like wildfire through the small percentage of the Vegas population that cared about such things. It was the summer of 1960, and Leonard Bernstein and the New York Philharmonic were touring the country, bringing classical music to the hinterlands. To have Vegas on the itinerary was akin to having Moses drop by and read from the stone tablets. Marjorie Dickinson, who sat on the Young Audiences committee with my father, called it "the greatest coup this side of the Mississippi!"

Leonard Bernstein! Young, brilliant, charismatic, he was the new godhead of classical music, one who looked, as composer John Adams put it, "more like James Dean than Toscanini," and who had what *Variety* called "the knack of a teacher and the feel of a poet." My parents, who were strictly old school when it came to conductors, were of two minds about this wunderkind; with his turtlenecks and his flamboyant style, he was (a word that would never occur to them) groovy. (Later he would invite the Black Panthers up to his New York pad to rap and solemnly assure them, "I dig absolutely.") But his musicianship was impeccable, and his Young People's Concerts introduced Bach and Beethoven to millions of culturally deprived children. His presence in Vegas would validate my father's dream of bringing culture to the desert.

Bernstein was having a blast traveling around the country with his orchestra. Everywhere he went, adoring crowds turned out to pay homage. "In some places, we have received standing ovations before playing a note," the maestro said. In a letter to his sister Shirley, he described the tour as a "pool-to-pool vacation," adding, "I hope I last."

Las Vegas, which knew a celebrity when it saw one, rolled out the red carpet. The Rhythmettes, the precision dance team from Las Vegas High, greeted him at McCarran Airport in fringed cowgirl outfits and white boots. The concert, held at the convention center, was packed. Afterward, the maestro commented, "In Las Vegas, where no major symphony orchestra had ever played before so far as I know, we filled a hall that had never been filled before—7,000 persons."

There had, in fact, been a performance in Vegas by a symphony orchestra, though not a major one. Maurice Abravanel and the Utah Symphony came to town and performed a concert that, if a tad condescending, was still enjoyed by young and old. On the program was the "Londonderry Air" (not, the maestro reminded us, to be confused with that other famous tune, "London Derierre"—he knew how to work a room, did Maurice) and Ferde

"ROLL OVER, WAYNE NEWTON, TELL LEONARD BERNSTEIN THE NEWS"

Grofé's *Grand Canyon Suite* (people marveled that you could almost hear the mules' hooves going down that canyon).

Abravanel was sort of the warm-up act, the Shecky Greene to Lenny's Sinatra. Lenny was the consummate showman, and Vegas turned out en masse to see him—in the front row, the Young Friends of the Symphony sat primly in their black suits and dresses with white gloves; behind them was the rest of Vegas, decked out in their bolo ties and leather vests, powder blue

tuxes, strapless evening gowns, and fur stoles of dubious origin. The noisy crowd settled into their folding chairs, some with popcorn and drinks purchased in the lobby, and waited for the concert to begin.

The maestro raised his baton, but the lights failed to dim. A technician in a green jumpsuit popped up on the platform and fiddled with

the cords. Mrs. Dickinson came up to admonish the restless crowd: "Let's show them Las Vegas knows its p's and q's." Well, it was worth a shot.

Finally, the concert got underway, the hall filling with the strains of Beethoven's Sixth, the Pastoral. The mood was anything but—people talking, popping gum, and taking flash pictures with their Brownie Instamatics. The orchestra struggled manfully through the evening, but you could feel, even with his back to us, that Lenny was seething.

That night, my parents accompanied him to a show at one of the Strip hotels. A comic was up on stage doing his schtick, and Lenny, by then rather drunk, was not amused. He stood up to leave. My mother reached up and put a hand on his arm. Like a mother admonishing a misbehaving son, she reminded him that the comic, however bad, was up there doing his best, and that he should sit down and listen. "Down boy," she said. Either from the shock of someone having the nerve to reprimand him, or because he was drunk and figured what the hell, Lenny sat down.

The large turnout aside, Bernstein by all accounts was appalled by Vegas—the boorish crowds (the final indignity was that someone dropped a cookie crumb on his kettle drum), the gambling (he noted acerbically that Vegas had recovered some of the money it had paid to the Philharmonic from the losses his musicians suffered at the tables). Even with his perfect pitch, he did not sense the presence of kindred spirits—the well-dressed girls and boys sitting in the front row, hands in lap, earnestly drinking in every note; the music professor who, for a brief shining moment, had realized his dream—only to have it snatched away.

Roll over, Beethoven, tell Wayne Newton the news: Lenny has left the building, and he isn't coming back.

Bread & Circus Circuses

The Golden Age of Vegas lasted a mere twenty years, from the opening of the Flamingo in 1946 to 1966. A civilization rises out of the Mojave, a glittering neon vision, an eighth wonder of the world visible from space. But it isn't enough; it was never enough. Each excess demanded even more excess, every extravagance begat even greater extravagance. Thus a new era was ushered in: the Age of Bread and Circus Circuses.

The hedonistic excesses of the Roman Empire inspired the idea for a new extravagance that would make previous efforts seem like dim, dusty relics of a crumbling, second-rate civilization. To

Gamblers enjoying the action at Caesars Palace, 1966.

Forum shops statuary at Caesars Palace.

create the illusion of a Greco-Roman pleasure palace, Caesars Palace was lavishly appointed with fountains and statuary and imported Italian marble encircling the inner temple—the casino.

In its celebration of excess, Caesars was the sort of place that Caligula might have found to his liking. The desk clerks were required to wear tunics suggesting Roman military uniforms. In the Bacchanal Restaurant, patrons were fed grapes and given massages by waitresses clad in skimpy, off-the-shoulder togas. The notepaper in the guestrooms suggested weathered parchment for those late-night Latin musings.

The $24 million resort, which opened in 1966, was the brainchild of Jay Sarno, an inveterate gambler who, according to his business partner Stanley Mallin, "would pawn his clothes for gambling money." Sarno sought the good offices of Teamster president Jimmy Hoffa for funding. Hoffa was already well acquainted with this type of investment, having funneled money through Las Vegas Valley National Bank into at least a half dozen Vegas resorts, including the Desert Inn, the Dunes, and the Stardust.

Caesars Palace was an immediate success. "We hit lightning in a bottle with Caesars," recalled Mallin. "It took right off. It was the nicest thing in Las Vegas and maybe in the country."

ABOVE: *Designs and statuary, Caesars Palace.* RIGHT: *Caesars Palace exterior, 1976.*

Hoping that lightning would strike twice, Sarno and Mallin took the Roman notion of bread and circuses to its logical, bizarre extension. Circus Circus was a casino built in the shape of a tent, with live pink elephants riding round and round in a kind of elevated tram and trapeze artists flying through the air above the gaming tables. Sarno himself would dress up as a ringmaster and walk through the casino. It was, as Hunter S. Thompson wrote, "what the whole hep world would be doing on Saturday night if the Nazis won the war."

The Nazis didn't win, and the hep world gave Circus Circus a wide berth. This novelty item, with its $2 admission and family-friendly ambience, represented a major breech with the old Vegas, in which children were meant to be neither seen nor heard. The gaming action under the striped tent was not enough to make it profitable. "About that time there was a gasoline crunch, and you could shoot a cannon down the Strip and not hit anybody," Mallin said. With losses around $5 or $6 million, Sarno and Mallin leased the casino to Bill Bennett and Bill Pennington. Bennett, formerly an executive with Del Webb Corporation, and Pennington, his partner in a slot machine business, added a hotel, eliminated the $2 admission, and moved the circus acts away from the gamblers. "To tell the truth, they were probably better operators than we were," Mallin admitted. In 1974, Bennett and Pennington exercised their option to buy, and Circus Circus became a permanent, highly profitable fixture on the Strip. The circus stayed in town.

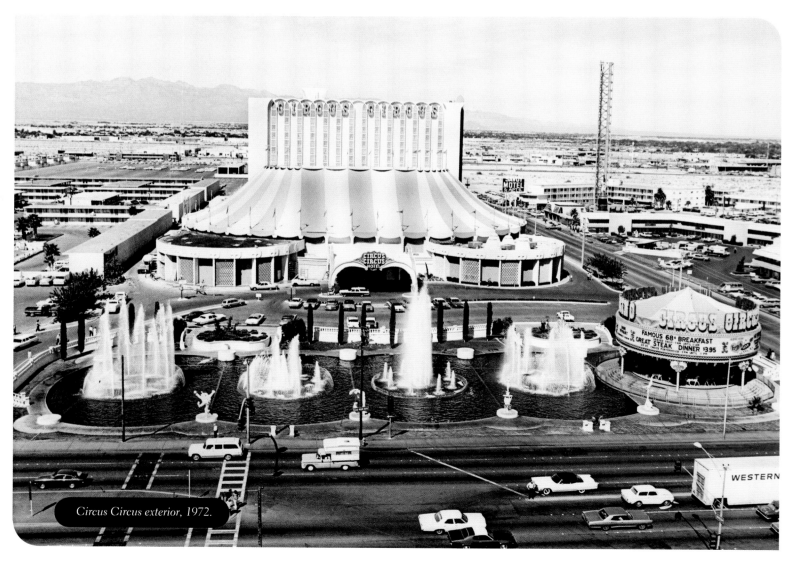

Circus Circus exterior, 1972.

Circus Circus didn't turn out to be the clean family establishment that its public persona implied. Amongst the clowns and pink elephants was Tony "the Ant" Spilotro, a Mafia boss with nefarious dealings in Vegas, and the owner of the Circus Circus gift shop. "When we did learn who he was and told him he had to leave, that it was making problems for us, he didn't raise any objections," Mallin said, with innocent guile. And in a 1979 trial involving skimming at other casinos, gaming executive Carl Thomas testified that he had skimmed Circus Circus profits.

If you live by the roll of the dice, you die the same way. Not one but two of Sarno's brothers dropped dead at the craps tables at Caesars Palace. Sarno, whose dream of building another Strip resort, the Grandissimo, was never realized, suffered a fatal heart attack in a suite in 1984. Though a cardiologist maintained an office in the medical center at Caesars, evidently he couldn't reach Sarno in time.

Following his death, Sarno's daughter, September, would still stay at Caesars. "I walk through the same casino I did as a kid, and I see some of the

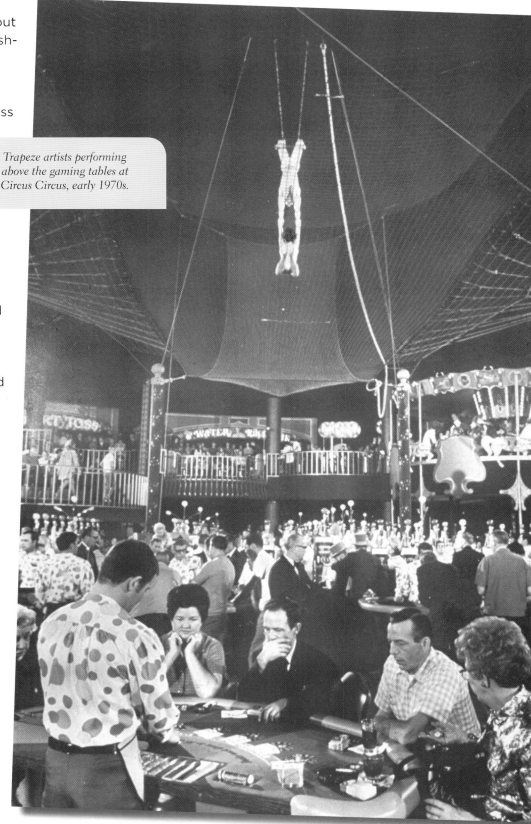

Trapeze artists performing above the gaming tables at Circus Circus, early 1970s.

same people," she said. Occasionally, she would try to shoot that elusive seven at the craps tables. "It's where I grew up," she said. "I feel happy here. I feel close to my dad."

Such was the powerful bond between father and daughter that they found common ground, not on the green grass of home, but at the green felt of a craps table. Only in Vegas.

King of the Strip

In the predawn hours of Thanksgiving 1966, two private Pullman cars rolled into the depot on Main Street. The inhabitant was whisked to the Desert Inn, where he took up residence on the top two floors. Howard Hughes was no stranger to Vegas, having previously lived in a small five-room bungalow called the "Green House" next to the Desert Inn. He had stayed for a year in that bungalow, ordering it to be sealed up with special caulking and tape while he lived in it. Now he was back, with $252 million from his sale of Trans World Airlines burning a hole in his pocket. He refused to vacate his digs at the Desert Inn, and management was livid—that suite had been reserved for a high roller. Hughes, deciding that he preferred buying to renting, entered intense negotiations with owner Moe Dalitz, finally making the mobster an offer he couldn't refuse: $13.2 million.

Nevada's political and media establishment welcomed Hughes' presence as nothing short of the Second Coming. At last, here was a figure both wealthy and crazy enough to unseat the mob and legitimize the gaming industry. With the sycophantic support of publisher Hank Greenspun and Governor Paul Laxalt, Hughes was granted a gaming license even though no background check was run and the application was missing such pertinent information as the recluse's photograph and fingerprints. The announcement, made forty-eight hours before the meeting of the licensing board, that Hughes had agreed to endow a medical school for the University of Nevada, Las Vegas—to the tune of $200,000 to $300,000 a year for twenty years—no doubt went a long way toward swaying any recalcitrant board members.

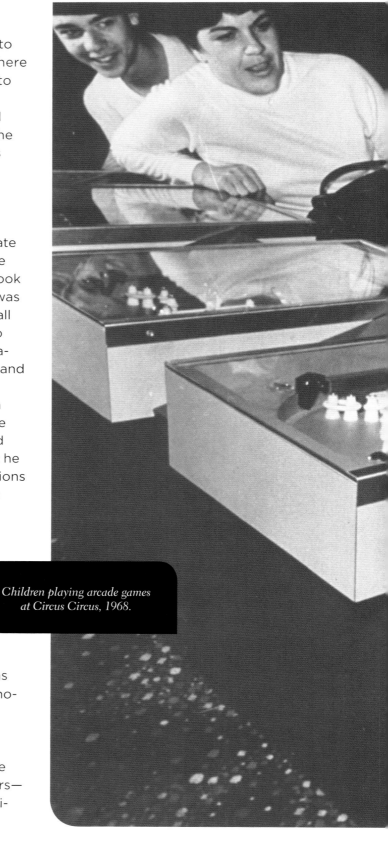

Children playing arcade games at Circus Circus, 1968.

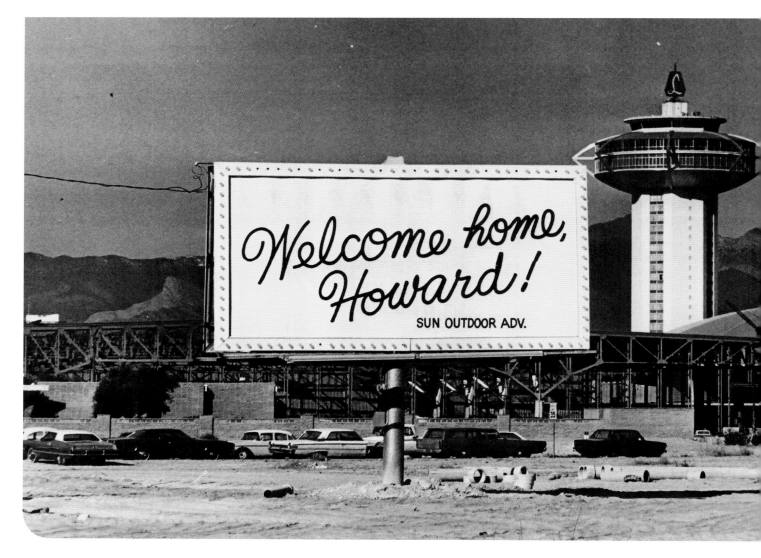

On April Fool's Day, Hughes became the registered owner of the Desert Inn. "How many more of these toys are available?" he demanded of his aide-de-camp, Robert Maheu. "Let's buy 'em all."

Hughes proceeded to gobble up Strip hotels like "some demonic demigod playing an out-sized Monopoly game," as biographer Michael Drosnin put it. Hughes paid $14.6 million for the Sands, a paltry sum for the hotel that was, only a few years before, the swinging playground of the Rat Pack. The purchase included 183 acres of prime real estate that would become the Howard Hughes Center.

His appetite still unsated, he snapped up the Castaways, the Silver Slipper, the Frontier, and the Landmark, a badly listing shipwreck of a hotel off the Strip. All told, Hughes spent more than $167,000 a day during his Vegas spree.

The Barbarian hordes apparently had been vanquished. Instead of carpet joints run by mob-sters with dubious ethics—whose idea of cus-tomer service was to break your kneecaps if you failed to pay your gambling markers—the Strip hotels would be run by a benevolent dictator who had only the best interests of his subjects at heart.

To ease any qualms that this regime was anything but benign, a call was placed to the governor's mansion in Carson City, and Governor Laxalt, a handsome native Nevadan of Basque ancestry, had what he described as

race of the people on the receiving end of this beneficence. After taking over the Desert Inn, Hughes canceled the annual Easter Egg hunt. "I am not eager to have a repetition, in the Desert Inn, of what happened at Juvenile Hall when the ever-lovin' little darlings tore the place apart," he wrote in a memo to Maheu.

His racial views were even less enlightened. He declined to buy ABC after he watched an episode of *The Dating Game* featuring interracial contestants. The idea of hiring more African Americans in his hotels was anathema to Hughes, who wrote, "I feel that Negroes have already made enough progress to last the next two hundred years, and there is such a thing as overdoing it." Just as he feared his impeccable lawns being overrun by rampaging children, he also obsessed about an invasion of "hordes of Negroes" when he discovered that African American tennis superstar Arthur Ashe was playing in the Davis Cup tournament being held at the resort. Hughes demanded that the tournament be cancelled, but Maheu managed to dissuade his boss, and the match took place.

Hughes' megalomania refused to countenance any but his own ambitions. Thus, when he learned that investor Kirk Kerkorian was planning to open what was being touted as

ABOVE: *Sign welcoming Howard Hughes to Las Vegas, 1972.*
RIGHT: *A portrait of Hughes.*

"one of the most interesting conversations of my life." In this call, Hughes reiterated his promise to transform Las Vegas into "a really super environmental 'city of the future'—no smog, no contamination, efficient local government, where the taxpayers pay as little as possible, and get something for their money." Laxalt eagerly drank down the Kool-Aid. "Anything this man does, from the gaming industry all the way down the line, will be good for Nevada," the governor pronounced.

That would depend, in part, on the age and

the biggest and best resort in Vegas, Hughes poured millions into the Landmark, a thirty-one-story cylinder that was the Vegas version of the Seattle Space Needle. Kerkorian's International was scheduled to open in summer 1969, and Hughes worried that if it opened after his hotel, it would make the Landmark opening look like small potatoes by comparison. Refusing to set an actual date, Hughes obsessed over the guest list and menu. He finally approved July 1 for the opening, but with mere hours to go, he had approved only forty-four names on the guest list; two hours before the event, he finally gave a frantic Maheu the green light to order the food.

Mafia element had been purged from Vegas—that, as Laxalt stated, Hughes' investment had given the city the "Good Housekeeping Seal of Approval"—proved largely an illusion.

During his tenure on the top floor of the Desert Inn, Hughes purchased CBS affiliate KLAS-TV from *Las Vegas Sun* publisher Hank Greenspun. Hughes ordered the station to broadcast his favorite movies on the late show, which he watched, sequestered, in a codeine-induced haze.

In an eerie parallel, Hughes departed Las Vegas four years to the day that he arrived. His wasted form was carried down the back stairs of the Desert Inn on a stretcher, put in a van,

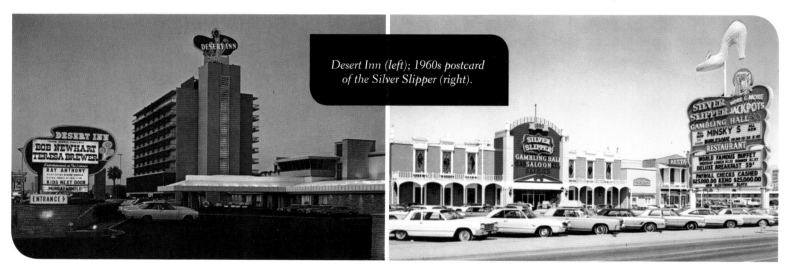

Desert Inn (left); 1960s postcard of the Silver Slipper (right).

The Landmark opening provided a final burst of euphoria over Hughes, but when the hotel proved to be a dud and his other hotels were losing millions of dollars, even his most ardent supporters began to discover that the emperor had no clothes—literally. His grandiose promises about creating some sort of desert utopia never materialized; indeed, Hughes failed to build a single hotel on his own. Plans for a $150 million "super Sands" failed to make it off the drawing board. Instead, he sequestered himself in his quarters at the Desert Inn, naked and unkempt, surrounded by piles of newspapers and old copies of *TV Guide*. Moreover, the notion that the

and transported to Nellis Air Force Base, where a private jet whisked him away to the Bahamas. In what came to be known as the "Thanksgiving Day Massacre," Laxalt informed Maheu at 3:00 a.m. that he had been fired. Hughes died six years later, leaving behind a vast fortune but little in the way of substantive influence.

In a fitting coda to Hughes' Las Vegas legacy, the ill-fated Landmark Hotel was imploded in 1995 to make room for a parking lot for the convention center. As a Joni Mitchell impersonator playing a Vegas lounge might put it: "pave Paradise Road, put up a parking lot . . ."

The Lion of Las Vegas

Kirk Kerkorian drove Howard Hughes crazy—well, crazier. Himself a former pilot who had flown Bugsy Siegel, among others, in his Cessna charter, Kerkorian made a tidy profit selling the land across from the Flamingo to Jay Sarno. With that money, he purchased an eighty-two-acre parcel on Paradise Road, next to the convention center, where he constructed the International. With 1,500 rooms and a 30,000-square-foot casino, the Y-shaped hotel was the largest in the country.

On opening night, Barbra Streisand was playing in one showroom, the rock musical *Hair* in the other, and for good measure, Ike and Tina Turner were strutting their stuff in the lounge.

Later, Elvis, who had declined the offer to open, became a fixture at the hotel, performing two shows a night in his sequined jumpsuit and pompadour.

Kerkorian sold the International, along with the Flamingo, to the Hilton Corporation in 1970 and doubled back to the Strip, where he broke ground for the MGM Grand in 1972. Thanks to a fast-track construction schedule, the hotel opened in December 1973 at a cost of $104 million.

Located on a piece of prime real estate kitty-corner from Caesars Palace, the MGM truly was the lion of the Strip, the biggest, gaudiest cat in this jungle of hotels. It had 2,100 rooms, eclipsing the Hilton (formerly the International) as the largest hotel in the country. In addition to the casino and showroom, the hotel had a shopping arcade,

Postcard of the International, 1969.

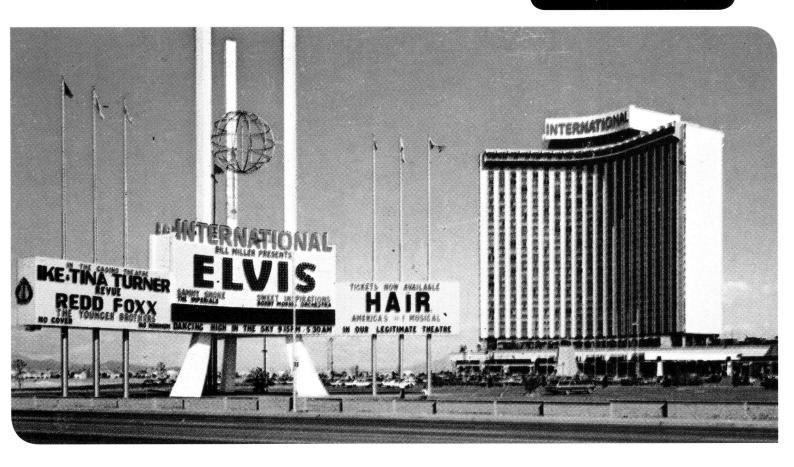

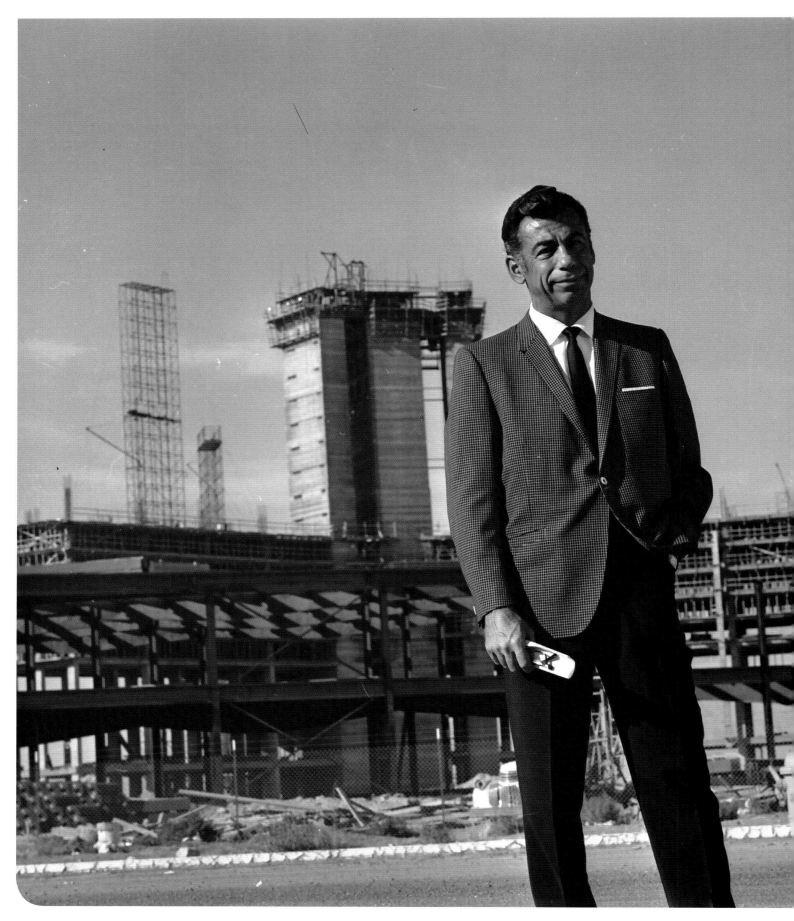

a jai-alai fronton, and a movie theater that showed classic MGM films while patrons reclined on couches, sipping on cocktails brought to them by leggy waitresses.

But there was a dragon lying in wait, a fire-breathing beast that unleashed flames that swept through the hotel in December 1980. Ignited by electrical wiring that had not been properly grounded, the fire swept through the hotel in a matter of minutes. Recalled one eyewitness, there was "screaming, yelling and flames every-where." In the casino, charred bodies were propped in their death positions in front of slot machines. Still, the casino manager had the presence of mind to retrieve the money from the safe. The worst disaster in Vegas history, the fire killed eighty-seven people and injured hundreds of others.

There was talk of simply closing the hotel for good—surely no one would want to stay there given what had happened—but Kerkorian was determined to rebuild. "How could I walk away while that whole team was out there, taking the brunt from everybody?" he said. "I had to be a part of it, I couldn't walk away, I just couldn't." Eight months later, the hotel reopened.

In the interim, eight people died in a fire at the Las Vegas Hilton. This spate of bad luck visited upon Vegas hotels had people in California joking about "Singed City."

FACING: Kirk Kerkorian built the MGM Grand and other Strip hotels. BELOW: Postcard of the MGM Grand, 1980s

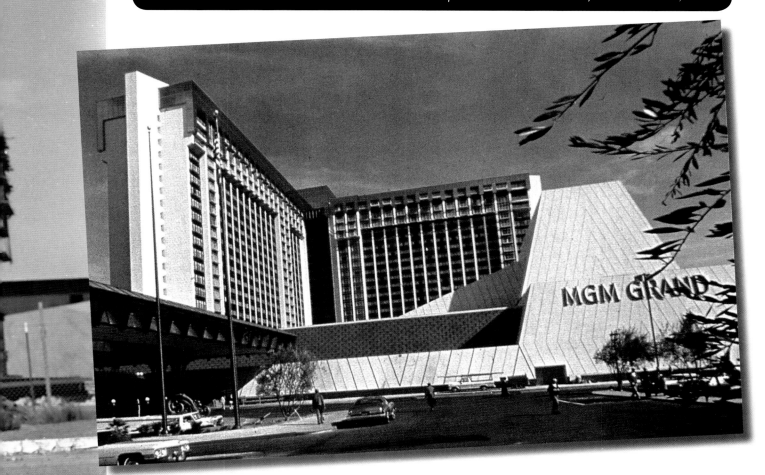

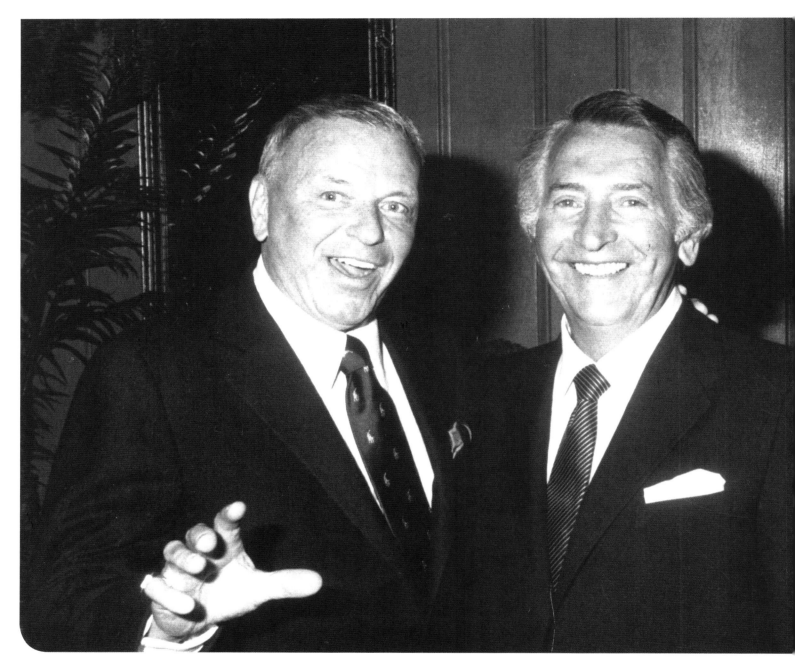

Either the Lord was wreaking vengeance upon this Sodom and Gomorrah on the Mojave, or Vegas was self-immolating, consumed in its own self-destructive heat.

Wynn, Lose, or Draw

Vegas had seen the Golden Age and the Age of Bread and Circus Circuses. Would this city-state of dreams and false hopes crumble into dust, a ghost town of faded old hotels and has-been entertainers?

What was needed to rescue Vegas from oblivion were two things: one was money, and the other, money. Steve Wynn did not have enough money, but he knew where to get it.

Wynn had learned the gambling business at his father's knee. The elder Wynn ran a bingo parlor above the Silver Slipper, and his ten-year-old son took in the pit bosses and cocktail

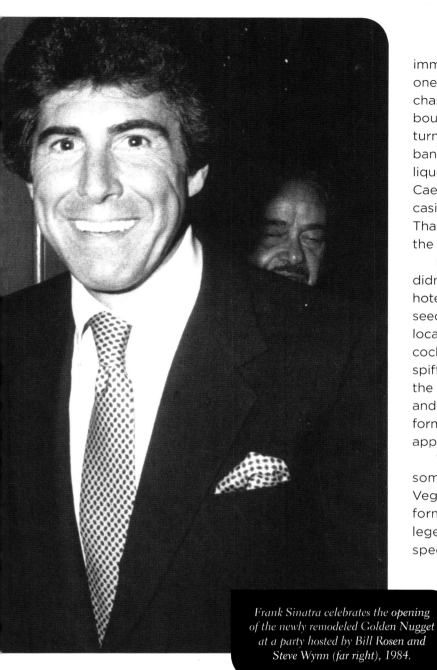

immediately began wheeling and dealing, always one step ahead of the competition. First, he purchased 3 percent of the Frontier. Howard Hughes bought the hotel three months later, and Wynn turned to E. Parry Thomas, the friendly Mormon banker, for a loan that he used to buy a wholesale liquor distributorship and a sliver of land next to Caesars Palace. To prevent him from building a casino there, Caesars offered him $2.25 million. That money secured him a controlling interest in the Golden Nugget on Fremont Street.

Old Vegas hands scoffed—clearly the kid didn't know what he was doing, building a new hotel in Glitter Gulch. Fremont Street had become seedy and down at the heels, drawing mostly locals who came for the ninety-nine-cent shrimp cocktails and penny slots. Undeterred, Wynn spiffed up the casino, cleaned out the riffraff from the staff, drew up plans for a new high-rise tower, and signed Frank Sinatra—*Sinatra!*—to forty performances. He even convinced Ol' Blue Eyes to appear in a national ad campaign for the Nugget.

Wynn wanted more. He wanted to build something so extravagant, so outside the old Vegas paradigm, that the city would be transformed forever. As it happened, his cousin's college roommate was Michael Milken, a junk bond specialist who immediately took to the idea of investing in gaming. Here, Wynn argued to money managers and pension funds, was a business built on the laws of probability and statistics. The argument proved persuasive: he procured $160 million in highly leveraged bonds for a new Golden Nugget in Atlantic City. With $100 million from the sale of that highly profitable venture, plus another $535 million in junk bonds, Wynn built the Mirage, three million square feet of grandiose, dazzling spectacle. In front was a fifty-four-foot volcano that erupted every half hour, spewing steam and flames into the Vegas night. Inside was a nine-story atrium with a tropical rain forest, and, lounging in a glass enclosure, a

Frank Sinatra celebrates the opening of the newly remodeled Golden Nugget at a party hosted by Bill Rosen and Steve Wynn (far right), 1984.

waitresses and all that money, and he was hooked. That the bingo parlor went bust in six weeks, and that his father gambled the rest of their money away and they had to leave town, did not deter him. Wynn had absorbed a valuable lesson: the best way to make money in a casino is to own it.

When his father died in 1967, Wynn took $45,000 from the bingo operation and

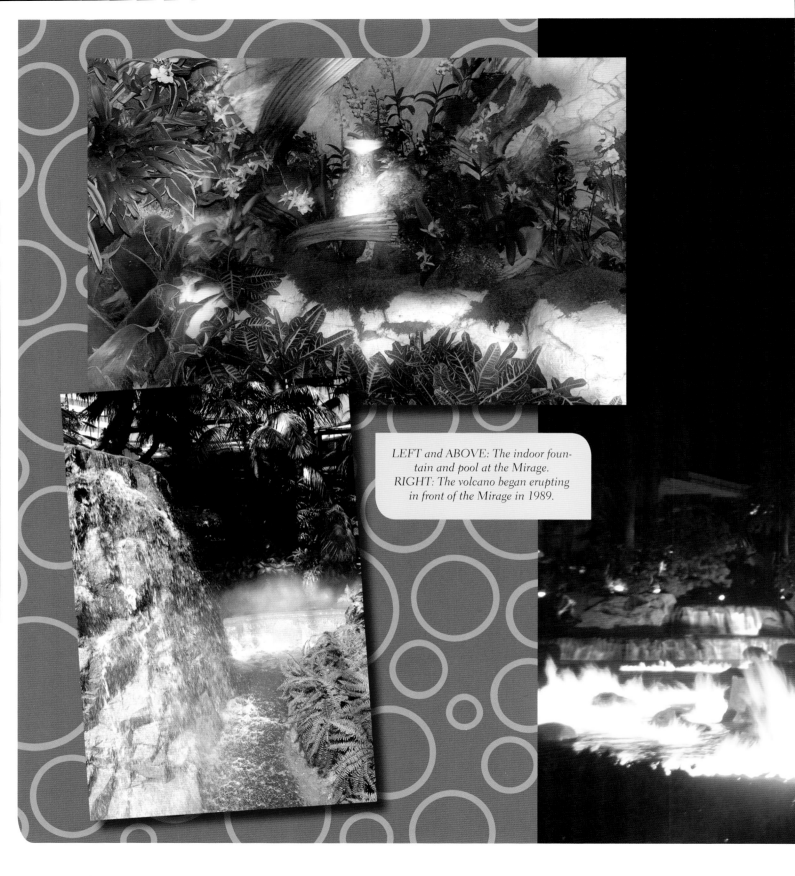

LEFT and ABOVE: The indoor fountain and pool at the Mirage.
RIGHT: The volcano began erupting in front of the Mirage in 1989.

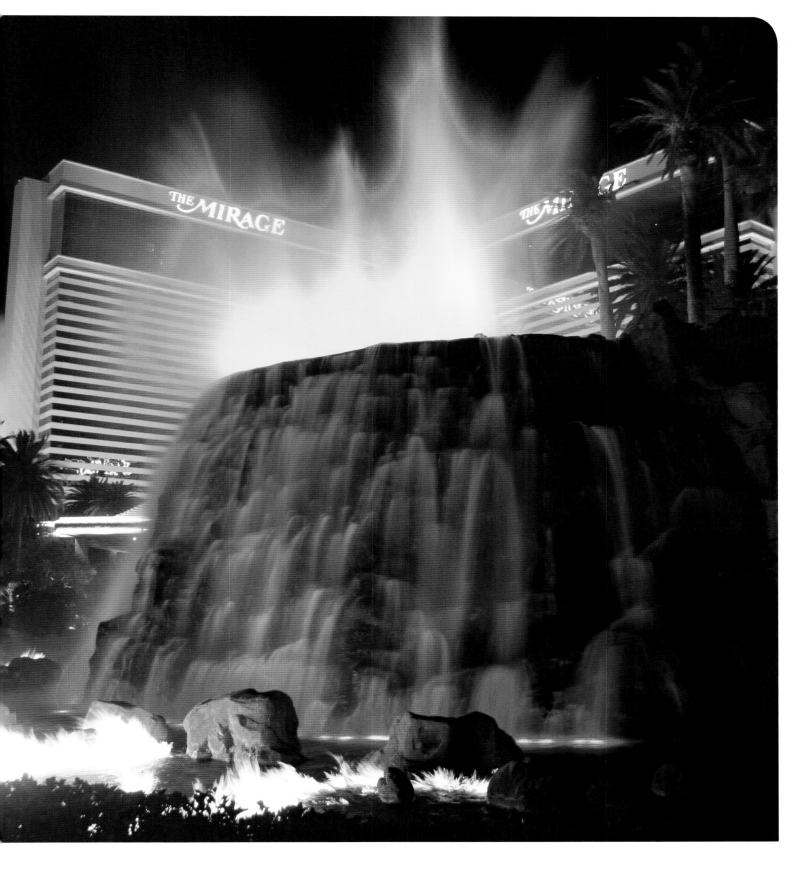

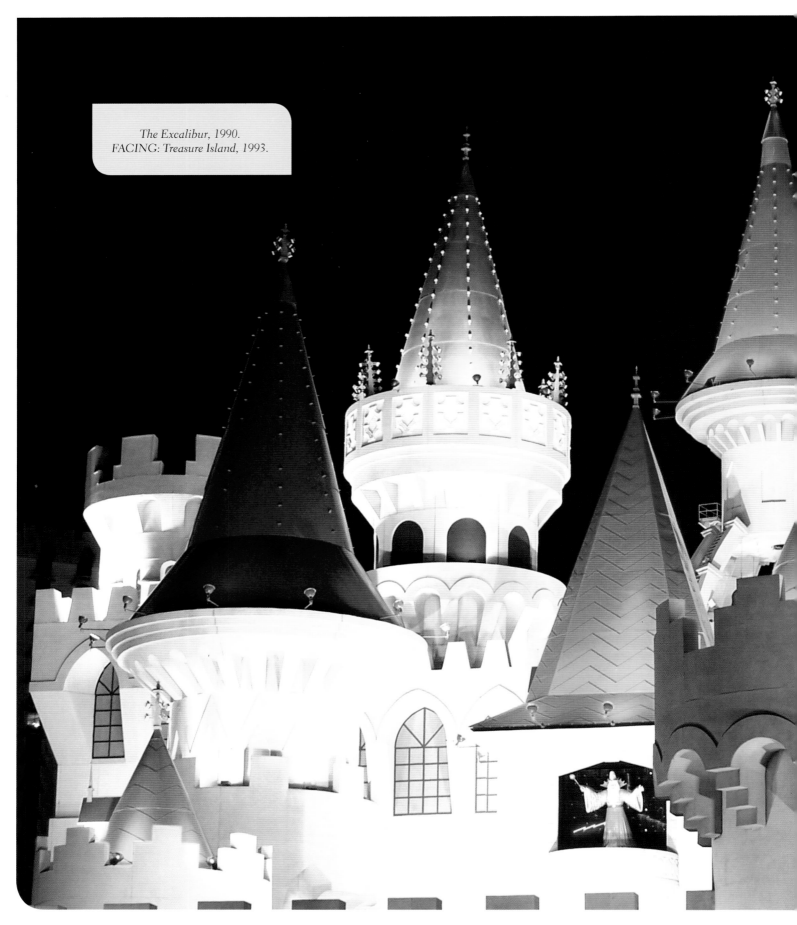

The Excalibur, 1990.
FACING: *Treasure Island, 1993.*

pair of white tigers that performed onstage twice nightly with two German trainers in white jumpsuits named Siegfried and Roy.

Measured in Vegas time, the new incarnation of Sin City was built in even less than a day, a hyperkinetic eruption of new hotels that threw caution, planning, and good taste into the desert wind. What emerged was a kind of theme park of pyramids, medieval castles, treasure islands, replicas of world cities—the "Disneylandization" of Vegas. The Luxor, the Excalibur, Treasure Island, Paris, New York New York (say it twice and it sings) were not so much hotels or even casinos as elaborate childhood fantasies, the false promise of instant wealth joined with another illusion: eternal youth.

Like feudal lords, the owners fought for supremacy, each wanting to proclaim himself emperor of this vast and lucrative domain. Kirk Kerkorian built a new MGM Grand that far exceeded anything dreamt of in heaven or hell: a $1 billion, 5,005-room megaresort that catered both to the high rollers and the penny-slots players. It was Vegas within Vegas, vast and self-contained, a windowless labyrinth in which one could easily become hopelessly disoriented.

Vegas marketed itself as a family town, a place where parents and children could enjoy a weekend

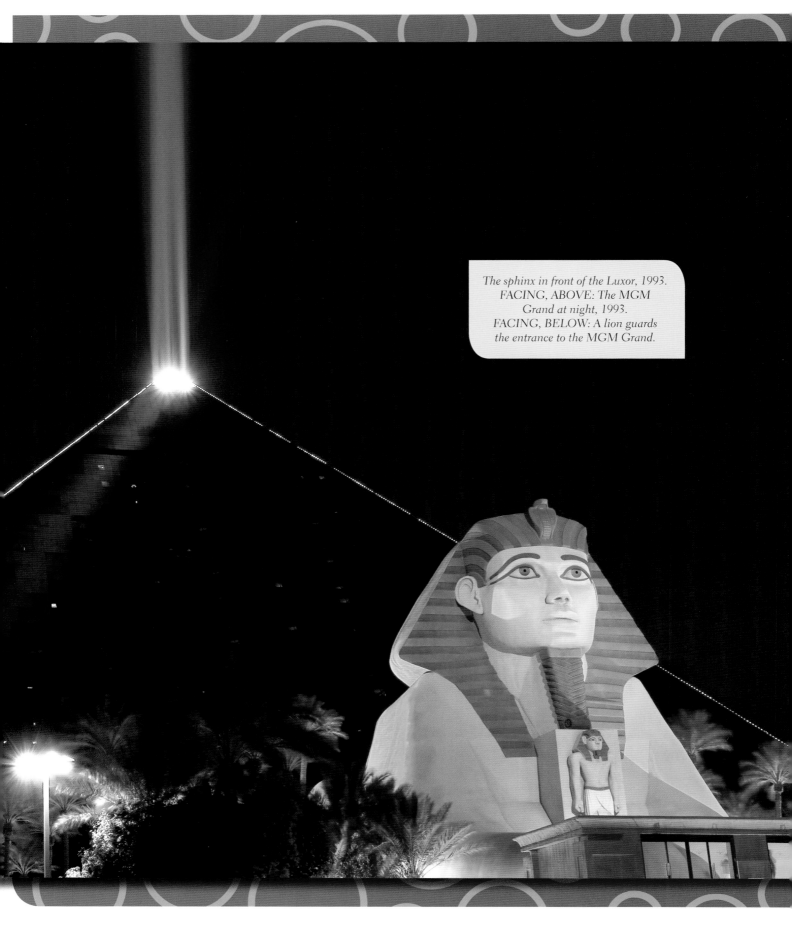

The sphinx in front of the Luxor, 1993.
FACING, ABOVE: *The MGM Grand at night, 1993.*
FACING, BELOW: *A lion guards the entrance to the MGM Grand.*

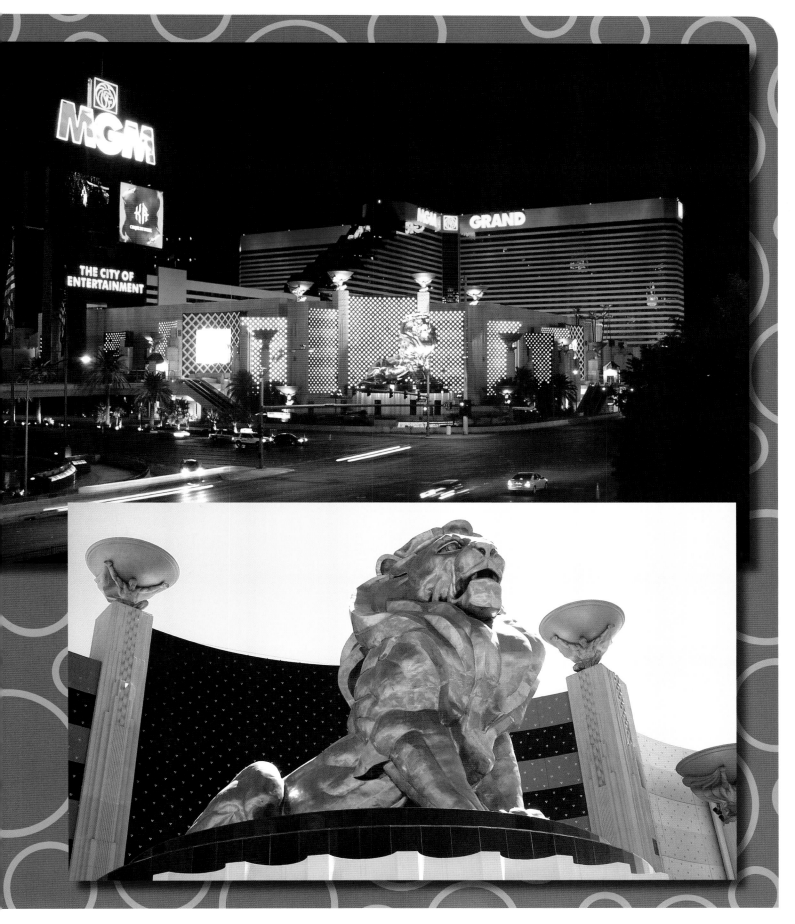

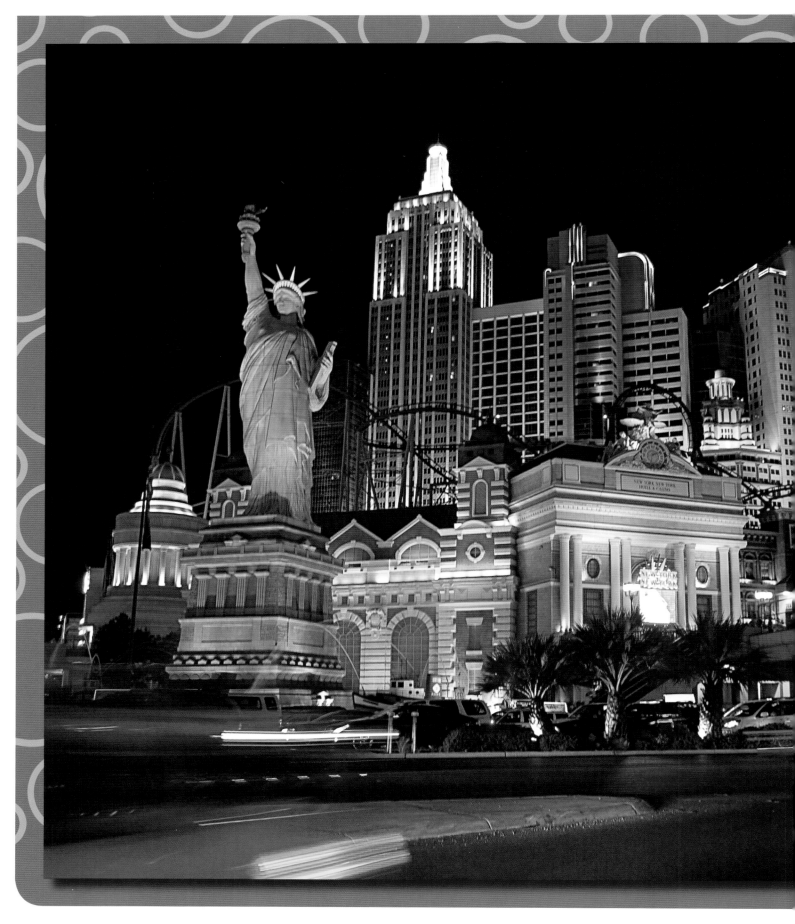

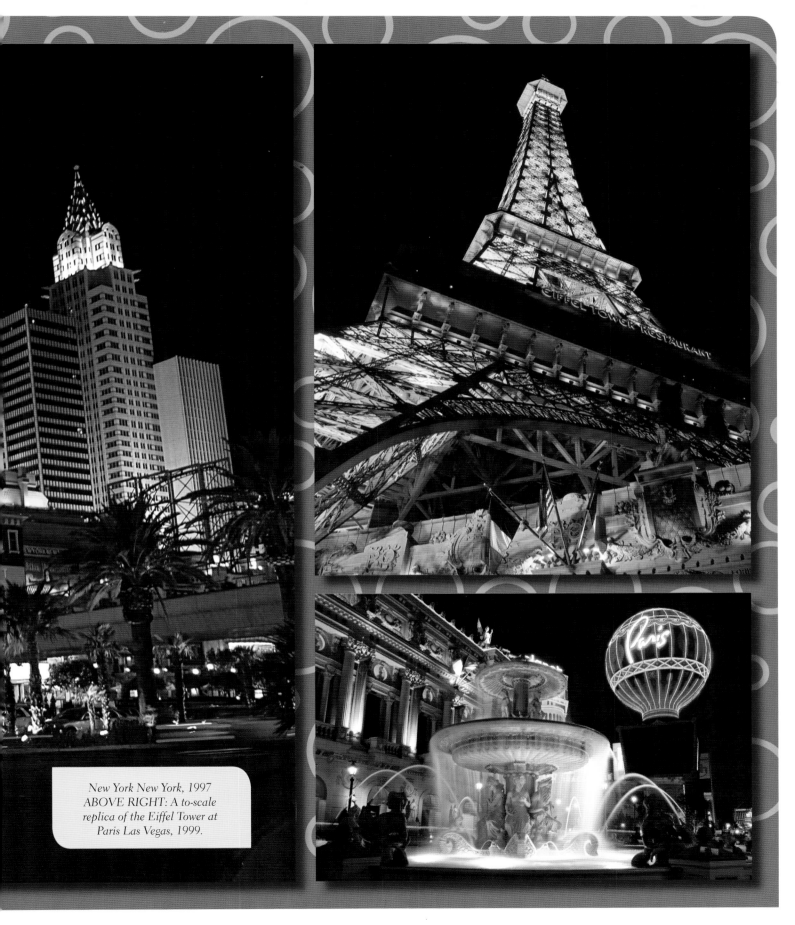

*New York New York, 1997
ABOVE RIGHT: A to-scale
replica of the Eiffel Tower at
Paris Las Vegas, 1999.*

of wholesome fun. (The insidious notion that children represented the future customer base—the people sitting hunched around a blackjack table or pouring dollar bills into the slots—did not escape the hotel owners.) The town had metamorphosed from a "cut-rate Babylon" on the desert into an adult theme park—Disneyland with a dark side. The cognitive dissonance between this idea of good clean family fun and the actual Vegas, a place predicated on vice, eventually produced a shocking crime: the murder of a three-year-old girl whose father left her to play in an arcade while he went to the casino to gamble. The crime took place not in Vegas, but in a place called Primm, Nevada, across the border from California. But the shock waves reverberated in Sin City. The notion that a gambling town was an appropriate venue to bring young children was quietly retired. The unspeakable had happened, and Vegas could ill afford to be unspeakable.

Upward and Outward

Vegas entered the new millennium with a seemingly infinite capacity for building even more lavish resorts. In 2004, Kerkorian's MGM Grand merged with Mirage Resorts, leaving Wynn a windfall, which he used to build the eponymous Wynn Las Vegas and the mirror-image Encore. In 2008, Sheldon Andelson's $1.9 billion Palazzo, a luxury all-suites resort, made its debut with a coterie of celebrity chefs and designer retail.

The notion that Vegas had reached saturation did not deter the developers of CityCenter,

The Wynn bears the name of the man who transformed the face of the strip.

The pool at the Palazzo puts other Vegas pools to shame.

an $8 billion "vertical city" in the heart of the Strip. Flanked by high-rise luxury condos and residential hotels, including the nonsmoking, nongaming Vdara, is ARIA Resort & Casino. Featuring soaring open spaces and generous use of wood and stone, it pumps natural light into its casino and guest rooms in an effort to evoke a sense of spaciousness and freedom—precious commodities indeed on the Las Vegas Strip of the twenty-first century.

To compete for the tourism dollar, the Strip hotels have upped the ante in entertainment as well. Though there is no Sinatra or Elvis to pack the showrooms, the marquees are lit up with superstar performers such as Elton John, Bette Midler, Celine Dion, and Cher. Magicians such as Penn & Teller and Lance Burton work their magic nightly. Aging floor shows such as the Folies may have flung their last feather boa, but in their stead are Broadway musicals and sophisticated, high-energy productions from those masters of surrealism, Cirque du Soliel.

Now that the Strip hotels have consumed every square inch of land, there is in fact no place to go but out. To the west is George Maloof's Palms Resort, with its happening club

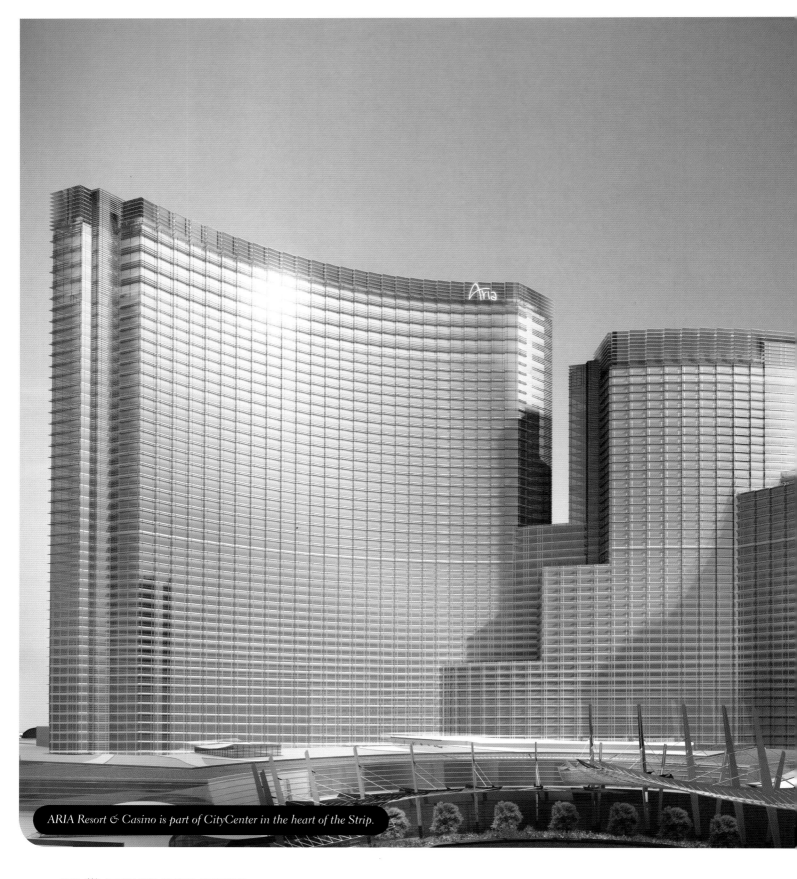

ARIA Resort & Casino is part of CityCenter in the heart of the Strip.

scene and tattoo parlor; to the south, the ultrahip Hard Rock Hotel, with its nonstop beach-party pool scene. Further out on the periphery is the Green Valley Ranch Resort in Henderson, with the Whiskey Blue bar by Rande Gerber. Seeking a peaceful alternative to the 24/7 din of the Strip, Lake Las Vegas has created a faux-Tuscan setting for resorts, golf courses, and residences. The discreet signage of the Ritz-Carlton and the smoke-free lobby of Loews Lake Las Vegas suggest a world far removed from the tawdry Strip with its gambling and nudity—so loud, so vulgar. On the opposite end of the valley, adjacent to Summerlin, is the ultrasleek Red Rock Resort, which has, in its gleaming curvature, sightlines of Red Rock Canyon.

Not everyone is enamored of this trend, viewing it as a hindrance to Vegas achieving greatness. Jon Ralston, columnist for the *Las Vegas Sun,* wrote, "As beautiful as you may think the Green Valley Ranch or Red Rock might be as resort complexes, they are gaming establishments. And some people—myself among them—have argued for decades that once casinos were allowed to migrate beyond downtown and Las Vegas Boulevard South, any chance that Las Vegas could become a great, soulful city instead of a caricatured, soulless one vanished."

Lake Las Vegas provides a serene oasis from the Strip.

O THE ZUMANITY!

"We love the tigers. We would never hurt the tigers." Siegfried and Roy, two tall Germans in white jumpsuits, are reassuring visitors of their good intentions from a video in the lobby of the Mirage. Directly across from their masters, two white tigers laze in a glass enclosure, seemingly oblivious to the crowds and to their masters' voices. The big cats are sleeping, biding their time, with the patience of their species.

White tigers are only part of the menagerie that populates the casino-cum-zoo-cum-aquarium that is the Mirage. Siegfried and Roy's Secret Garden Dolphin Habitat is home to a strange consortium of white tigers, white lions, and other chromosomal oddities. The dozen bottle-nosed Atlantic dolphins, who were born in Vegas, earn their keep like any good Sin City citizen by jumping, diving, and cavorting for the entertainment of human onlookers. The dolphin habitat is intended as a form of "eco-tainment" that has become popular. In reality, the dolphins are a loss leader, a sideshow to attract customers to the casino.

Mandalay Bay put some teeth into the concept of eco-tainment with Shark Reef, a 1.6 million-gallon saltwater habitat for a hundred different species of underwater creatures, including fifteen types of sharks, which can be observed from a glass tunnel that passes under their ocean-in-miniature. Their job is to provide that little frisson of fear, the sort created by the movie *Jaws* that gives one a titillating sense of terror without being exposed to actual danger. There are also tropical fish, moray eels, stingrays, a rare komodo dragon, and jellyfish—to William L. Fox, looking at these "genuinely alien and mysterious" creatures is like "watching Chihuly's glass ceiling at Bellagio come alive."

Siegfried and Roy's act, with its human interaction with large, dangerous, man-eating beasts, created that same voyeuristic thrill, tempered by the pleasant illusion that these big cats were harmless, domesticated, no more a threat than your tabby cat at home.

Siegfried and Roy had been a popular fixture in Vegas since their arrival in 1967, with a cheetah and a flamingo in tow. They got a gig with the Folies Bergère at the Tropicana, and then moved on to the Lido at the Stardust, ending up with their own full-length show at the Frontier in 1982. They acquired three white tiger cubs and began breeding them at a $10 million compound on Vegas Drive, north of the Strip, called the Jungle Palace.

"When we came to Las Vegas we heard no sound of birds and we saw no greenery," they proclaimed in their national media preview. "We decided to create our environment, a place which would represent the natural habitat of the animals, and a place where we could commune with nature."

The goings-on in the Jungle Palace approached the bizarre. The house was decorated as a sort of gay hunter's fantasy pad, with Oriental rugs, a hand-carved Buddha and 450-pound jade bull, fourteen-foot ivory tusks, and, in Roy's bedroom, a giant elephant head.

The breeding program produced such anomalies as the "lepjag"—a cross between a leopard and a jaguar. The tiger cubs got big, and bigger still, reaching upward of six hundred pounds. During a playful romp in the compound, Roy was pinned by one of the cats. He bit it on the nose and it reeled back—lesson learned, dominance asserted. However, an employee was not so fortunate. He was attacked in 1985 and ended up paralyzed.

Siegfried and Roy had a well-honed philosophy when it came to training the tigers to perform. "You can't treat animals like props," Roy said. "They must want to perform for you. They thrive on praise. Just like children, they want to be taught and disciplined."

With the kind of hubris that only men in sequined jumpsuits can summon, Siegfried and Roy put the big cats through their paces in a nightly extravaganza at the Mirage, where they performed night after night to sold-out crowds. They even performed tricks backstage for Muhammad Ali.

One night, Roy brought out Montecore, a seven-year-old white tiger, on his leash for the signature disappearing act. After informing the audience (disingenuously) that this was the cat's first night on stage, he ordered it to lie down. But for some reason—he wasn't in the mood, he had had enough of this jumpsuited blond with his tan and his gleaming white teeth, or maybe something spooked him—the big cat did not sit down. Roy pulled at the leash, and suddenly the cat grabbed him by the forearm. Roy thumped him on the head with the microphone, Siegfried shouting, "No, no!" But this time the reprimand did not work. Roy toppled to the ground, and the cat grabbed him by the throat and hauled him offstage. The horrified audience could hear Roy screaming behind the curtain. The cat was out of the bag; the act, apparently, was over.

Backstage, Montecore was doused with a fire extinguisher and reluctantly released his mauled captive. The bite had just missed the carotid artery. Roy was rushed to the hospital and stabilized, then transferred to Los Angeles for treatment. In addition to extensive muscular

and nerve damage, he suffered from swelling of the brain, which resulted in a stroke. The Mirage canceled the show, laying off the 267 employees who handled the production.

Still suffering from partial paralysis on his left side, Roy reunited with Siegfried in 2009 for a benefit at the Bellagio to raise money for the Lou Ruvo Brain Institute, a new research facility in Union Park. With members of PETA protesting outside, the duo came onstage with Montecore the tiger, who had been absolved of all blame for the attack. Steve Wynn, who praised the pair for creating an act that you didn't have to be over 21 to view, stated, "It's clear that Montecore did not attack Horn," likening the tiger's actions to picking up a cub and carrying it off in its mouth. With Siegfried's help, Roy came onstage and climbed into a cage; in a sleight of hand, he disappeared, and in his place was the big cat. This appearance was likely the last for both Roy, who lives with Siegfried at a compound called Little Bavaria, and Montecore, who retired to live out his last days at the Secret Garden.

How to Eat Like a Vegan

N: VAY'-GUN: CITIZEN OF LAS VEGAS, AKA SIN CITY; ALSO, ONE WHO ESCHEWS HEALTHY FOOD IN ANY FORM.

To eat like a Vegan is to embrace food in the same way that one is encouraged to embrace gaming—wholeheartedly, without discrimination or question. Not for the faint of heart or the arterially impaired, Vegan food is heavily predicated on starch and meat from the hoof. There is protein, rendered in huge platters of bacon and eggs over easy, T-bone steaks lopping over the sides of their plates, jumbo shrimp cocktails, and pastrami piled high between slices of Jewish rye. There are even vegetables—that is, if a wedge of lettuce heavily laden with Thousand Island dressing, or the tomato in the sauce accompanying a shrimp cocktail, can be considered vegetables.

Running through the clogged veins of the Vegan diet is a simple stratagem: provide an abundance of cheap food, even if you have to take a loss, in order to entice customers into the casinos.

Even at $1.99, shrimp cocktail is still a bargain in Vegas.

Ranchinn restaurant, bar, casino, and coffee shop, 1952.

There is also a basic psychological principle at work: maybe you lost $300 playing blackjack, but by God, you're going to consume everything in sight at the ninety-nine-cent breakfast buffet.

Before there was Glitter Gulch or the Strip, there was the Colorado Restaurant out on the Boulder Highway. Proprietress Mattie Jones operated it out of her home, serving chicken and biscuits and bootleg whiskey to the workers building Hoover Dam in the early 1930s.

The restaurant moved across the street into a Union Pacific Railroad barracks, which was hauled down Fremont Street by a tractor, and became a Las Vegas institution—the Green Shack. Popular among lawyers, politicians, and families, it served chicken in a basket and the proprietors handed out candy to the children as they left. The Green Shack survived into the 1990s, when it was listed on the National Register of Historic Places. John Curtas of KNPR radio saw the Green Shack as "a glimpse of days gone by, before beltways and Bellagios defined the Vegas way of life." But this historic slice of Sin City did not survive; in 1999, Jim and Barbara

The Green Shack was a Vegas institution, starting in the 1930s.

McCormick closed its doors. In 2005, the new owners razed the original building, which had succumbed to mold and deterioration. Only the sign was salvaged—COCKTAILS, STEAK, CHICKEN—and became a piece of Vegas nostalgia enshrined at the Neon Museum.

Early on, the hotels grasped the essence of the Vegan diet—dangle cheap food before the patrons, and they will descend upon your casino like seven-year locusts. In particular, the all-you-can-eat buffet seemed to embody the very heart and soul of Vegas. The El Rancho Vegas pioneered this concept in the late 1940s with its Buckaroo Chuck Wagon Buffet. For the princely sum of $1, you could eat as much as you liked, morning, noon, or night—even from the haunch of beef at the carving station. Other casinos followed suit, and the buffet became an enduring staple of the Vegas dining scene.

It wasn't always about sheer quantity. Sometimes it was about a certain food that people regarded as a delicacy. Borrowing the idea from Fisherman's Wharf in San Francisco, the Golden Gate Hotel and Casino began serving cold-water shrimp served with cocktail sauce made from a secret recipe and presented in a tulip sundae glass. The price of fifty cents was, even in 1959, a bargain, and people bought them up by the dozens and took them home to store in their freezers. In 1999, co-owner Mark Brandenburg discovered that the hotel was losing $300,000 a year on shrimp cocktails and raised the price to ninety-nine cents, still a bargain and a favorite among locals. In 2008, the price doubled to $1.99, though Players Club members were still given the old price. To mollify patrons, the hotel began using bigger shrimp—advertised as the "Best Tail in Town."

Across the street, at Benny Binion's Horseshoe Club, the signature dish was chili.

Allegedly made from a jailhouse recipe acquired by Binion during his incarceration for tax evasion in Texas, the chili was spiced with stories by the former bootlegger, who held forth from a booth in the hotel's Sombrero Room.

There's nothing like a bowl of red to fortify you for a night of gambling.

This coarse Western fare was not for the swank new Fremont Hotel, which opened in 1956. Presiding in the hotel's gourmet dining room was Chef Shilig, who had once slung hash for the Ritz in Paris and The Savoy in London. Noted chef Billy Gwon was imported from New York to supervise the Chinese restaurant. In the Vegas of forty-nine-cent breakfasts and fifty-cent shrimp cocktails, it seemed almost counterintuitive to offer gourmet cuisine, but the Fremont was attempting to lure customers

who otherwise might end up on the Strip, offering them a more refined alternative to Benny Binion's chili or tarted-up shrimp cocktails.

While the Strip was well endowed with low-price buffets and prime rib dinners for $4.99, some of the hotels made a play for the more sophisticated palate. Breaking with its Moroccan theme, the Sahara opened the House of Lords, a grandly baroque restaurant that tried to elevate the Vegas dining experience. The Tropicana brought in Martin Appelt from the Waldorf Astoria to create sumptuous dishes for its patrons. Restaurateur Alexander Perino opened a branch of his Los Angeles restaurant to appeal to the Hollywood set.

Celebrities and show-girls patronized some of the nearby local restaurants. The Golden Steer—a dark, clubby steak house on West Sahara—was frequented by Sinatra and the other members of the Rat Pack. Nat King Cole and Joe DiMaggio also ate there, as did mobster-about-town Tony "the Ant" Spilotro. Elvis was a regular at the Villa d'Este, where he regularly consumed heaping plates of spaghetti and meatballs. Foxy's, a deli with a big grinning fox face on the sign, was a favorite of showgirls desperately in need of sustenance after the second show. Foxy's was among the restaurants that refused service to the black entertainers in the 1950s. Like the other establishments in town, it bowed to pressure to integrate in 1960, and Nat King Cole, Sammy Davis Jr., and others joined the patrons for pastrami sandwiches, cole slaw, and dill pickles.

Strip hotel entertainers such as Jack Benny and politicians such as Senator Alan Bible got their Chinese food fix at Fong's Garden on East Charleston. The Fong family's first restaurant, the Silver Café, was located downtown at First and Fremont. Wing Fong, the nephew of the owner, found the new location and traveled to major cities throughout the West to bring back ideas for decorating the restaurant. Fong's Garden opened to a standing-room-only crowd on Labor Day in 1955. The pagoda framing the entrance was made of oxidized copper; inside, the restaurant was decorated with murals, lanterns, vases, and tapestries imported from Hong Kong. The food was Cantonese—egg rolls, fried rice, chop suey, chow mein, sweet 'n' sour pork. The drinks came with little umbrellas, even the Shirley Temples. The restaurant was a huge success, and Wing Fong became a pillar of the community, a staunch supporter of education and local charities, and a renowned champion of civil rights.

Restaurants that hired nonunion workers incurred the wrath of the Culinary Workers Union, the largest union in the state. Year after year, the union picketed in front of the Alpine Village, a German restaurant on Paradise Road, while inside, waiters in leiderhosen and waitresses in dirndl dresses served weinerschnitzel and strudel to the customers (here were those who would brave the picket line just for the seasoned cottage cheese alone—*see recipe above*). On the Strip, the stakes were higher and more visible. In 1995, the union put five thousand picketers in front of Kirk Kerkorian's MGM Grand for the megaresort's grand opening. Not wishing to appear antiunion, many of the state's prominent politicians refused to cross the picket lines, and Kerkorian was forced to capitulate to the union's demands.

SEASONED COTTAGE CHEESE

2 pounds cottage cheese
1/2 teaspoon caraway seeds
1–12 teaspoons sugar
1 teaspoon Accent
1/2 teaspoon white pepper
1 tablespoon dried chives
1/2 teaspoon celery salt

In the 1990s, the Vegan diet underwent a radical transformation. In the new era of dining as theater, gourmands were accustomed to more sophisticated fare than shrimp cocktail and steak with all the trimmings. Celebrity chefs descended on Vegas, sitting down at the table for a game of high-stakes culinary poker: "I'll see your foie gras and raise you a duck confit."

Wolfgang Puck, who was the toast of LA with his Spago restaurant, opened another Spago in Caesars Palace in 1992. Feigning a general indifference to coming to Sin City, Puck told the *New York Times,* "I love boxing, so I told the developer that the only way I'm ever going to open in Las Vegas is if I can get to every fight with free ringside tickets. And he said yes."

This version, while accurate as far as it goes, is a tad disingenuous. Puck, a shrewd businessman, did not stake his Vegas venture solely on the basis of ringside seats. He correctly intuited that Vegas would be fertile ground to spread his gospel of "LIVE LOVE EAT." His loyal following was undoubtedly appalled at the idea that their exclusive Beverly Hills enclave would suddenly become a franchise, and in tacky Las Vegas, no less. But the faithful did not abandon their beloved "Wolfie," and the Vegas version of Spago, located in the exclusive Forum Shops,

Bam! Succulent shellfish at Emeril Lagasse's New Orleans Fish House at the MGM Grand.

The drinks are on Emeril!

The wine rests easy at Emeril Lagasse's.

provided diners with the exotic harmonies of spring rolls with ponzu sauce.

The vapors from Wolfie's weinerschitnzel carried east on the jet stream, and soon every big-name chef worth his coarsely ground sea salt had to have a restaurant in Vegas. Even before gaining national prominence as a TV chef, Emeril Lagasse had garnered a big following among foodies, and reservations at Emeril, his restaurant in New Orleans' Warehouse District, were highly coveted. Like Puck, Lagasse saw the potential in Vegas and opened Emeril's New Orleans Fish House at the MGM Grand. Mark Miller, with his Coyote Cafe, also opened in the MGM Grand. Jean-Louis Palladin re-created Napa in the Rio Casino and Hotel.

French cuisine seemed a bit precious for Vegas, but that didn't deter the leading French chefs from setting up shop. Joël Robuchon, France's Chef of the Century, came out of retirement to open Robuchon and L'Atelier del Joël at the MGM Grand, both grandly extravagant dining experiences. Marc Poidevin, chef de cuisine at Le Cirque 2000, headed west with his box of recipes to set up an outpost of this food-lover's fantasia at the Bellagio. Daniel Boulard Brasserie at the Wynn, while not up to the standards of the New York original, is an evening of richly

FACING: The grand entrance to Joël Robuchon at the MGM Grand.

ABOVE: The private dining room affords an intimate dining experience.

RIGHT: Presentation is all part of the floor show with dishes such as Le Thon.

orchestrated, deftly prepared dishes. Michael Mina mimicked his success in San Francisco with two restaurants at the Bellagio and another at the MGM Grand.

The Bay Area, incubator of California cuisine, also contributed to the French revolution in Vegas. San Francisco epicurean superstar Hubert Keller performed a variation on his Fleur de Lys at Mandalay Bay. Thomas Keller, who created a stir with his French Laundry in Napa, brought his refined take on French bistro fare to Bouchon in the Venetian.

For sheer artistry, one can dine at Picasso at the Bellagio, where the artist's original masterpieces line the walls and chef Julian Serrano's cuisine is museum-worthy. The prices are appropriately steep—a prix fixe dinner might not set you back as much as an original Picasso, but you'd better hope that the tables in the casino return your three-figure investment. David Burke's restaurant at the Venetian is the kind of whimsical dining experience that might appeal to Salvador Dali, with such dishes as Crisp & Angry Lobster and David Burke's Cheesecake Lollipop.

In response to that existential question, "Where's the beef?" Puck opened a steakhouse at the Palazzo called, eloquently, Cut. Chefs Jean-Georges Vongerichten of Jean Georges, Vong, and Jo Jo opened Prime, a steakhouse,

in the Bellagio. Tom Collicchio, who coaches culinary aspirants on Bravo's *Iron Chef*, plies his craft at Craftsteak at Mandalay Bay. Gone are the bite-sized portions of nouvelle cuisine—diners at Brian Massie's BRAND Steakhouse at the Monte Carlo can tuck into a 120-ounce porterhouse for six.

Perhaps no one has come closer to achieving that Byzantine combination of haute cuisine, celebrity, and showmanship than Charlie Palmer of Aureole. Designed by Adam Tihany, Aureole in the Mandalay Bay Hotel is equal parts culinary performance art and Vegas–style theatrics. Soaring forty-two feet over the bar is a wine tower—four stories of stainless steel, glass, and plexiglass—in which some nine thousand bottles of wine are prominently displayed. To retrieve a bottle of champagne or Cabernet, a comely "wine goddess" climbs into a harness that is hooked onto hoists on the sides of the tower and is swiftly transported up to retrieve the desired vintage. This high-wire act, which takes all of ten seconds, is all part of the over-the-top approach to dining that entices guests to drop a few hundred dollars for a dinner.

Diners had better hope they do well at the gaming tables after they see the check brought to their dinner table—dinner at Alex at the Wynn and Restaurant Guy Savoy readily exceeds $300 for two—but then, in Vegas, excess is all part of

FACING, FROM FAR LEFT: The ceiling at Le Cirque at the Bellagio evokes a circus tent; Rich doesn't begin to describe dishes such as La Pintade Fermiére and Les Legumes at Joël Robuchon.

RIGHT: L'Atelier de Joël Robuchon.

the experience. So much for the long-standing Vegas axiom that food is a loss leader, that you have to give it away in order to bring people into the casinos. Hotel owners have added both cachet and cash to their lavish enterprises by importing celebrity chefs and upping the ante for restaurants on the Strip. Even in 2008, with the world economy going into the tank, restaurants continued to open with the haughty assurance of blue-chip stocks, confident that because of their name and reputation, they would be recession-proof.

Should the appetite for the rarefied cuisine of Puck, Emeril et al. prove to be finite, there are always those Vegas staples—the all-you-can-eat buffet, the club sandwich up in the room at 4:00 a.m. after a night of gambling; and even at $1.99, the shrimp cocktail is still a bargain. But perhaps the consummate Vegas dining experience is to be found at Cathouse Restaurant at the Luxor.

Roasted Langoustines grace the menu at Le Cirque.

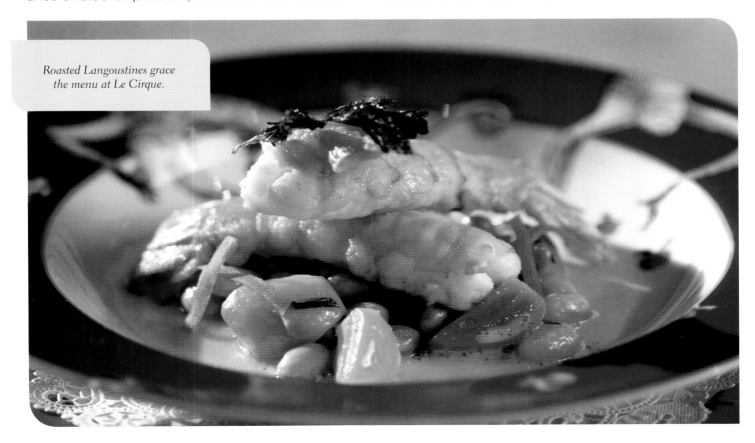

Tom Colicchio's
Craftsteak restaurant
at the MGM Grand.

Picasso paints a
nice dining room
at the Bellagio.

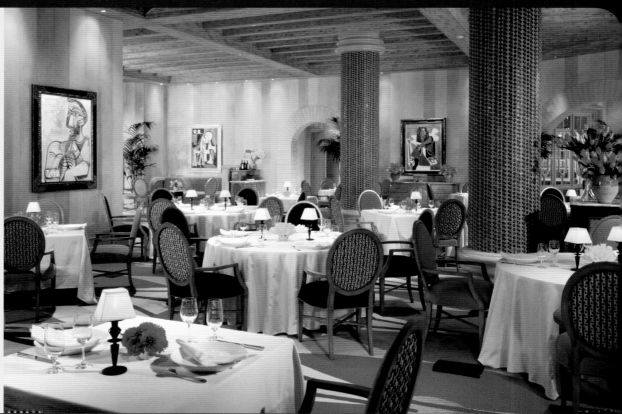

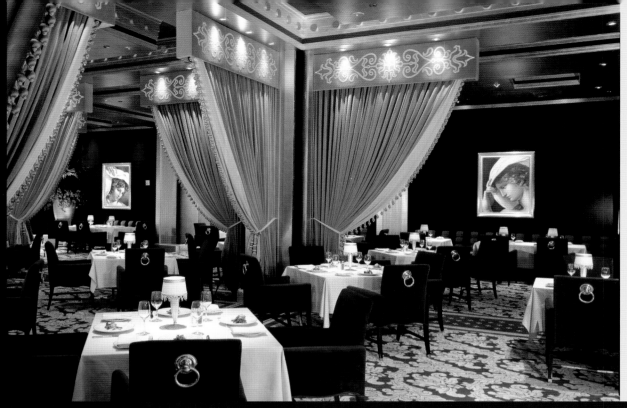

Prime is a steak-lover's dream at the Bellagio.

Michael Mina mimics his success at the Bellagio.

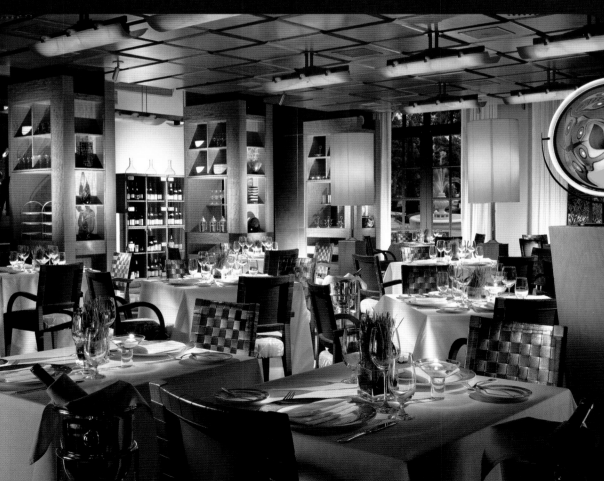

Chef Kerry Simon, of *Iron Chef* fame, created what *Condé Nast Traveler* called "the best fusion of upscale cuisine and Vegas-style erotic spectacle to come along since the early days of Caesars Palace's legendary Baccanal." While guests dine on filet mignon or lamb curry with Israeli cous cous, they can voyeuristically watch a Cathouse Coquette primping for the evening behind a one-way mirror. *Me-ow.*

RIGHT: A wine angel prepares to ascend the wine tower at Aureole at Mandalay Bay. FACING: Full view of the wine tower.

Zeus himself needs reservations at this sumptuous Caesars Palace restaurant.

The Shock of the New: Art in Las Vegas

One day in 2006, hotelier Steve Wynn, an avid art collector, was showing off a prized acquisition, Picasso's *Le Rêve,* to a group of admiring friends in his office. He raised his arm to gesture at the Cubist masterpiece and his right elbow hit the painting, causing a ripping sound. The Picasso now sported a hole about the size of a pinkie finger. Wynn uttered an expletive, and then said, "Thank God it was me."

Writer Nora Ephron, among those with a ringside seat for this catastrophe, was horrified. "I felt that I was in a room where something very private had happened that I had no right to be at," she later wrote. "I felt absolutely terrible." Wynn dismissed the incident, assuring everyone (including himself) that the damage was reparable. "It's a picture," he said that night at dinner. "It took Picasso five hours to paint it." After the painting was restored, he decided to keep it, at his wife Elaine's insistence.

The Swarovski crystal dazzles like a Vegas marquee.

The fountains in front of the Bellagio.
.

But other works from his collection he happily shared with the public, leasing priceless paintings to Vegas hotels, as though to declare to the world, "I am not a vulgarian."

By spreading his artistic largesse on the Strip, Wynn was poking a stick in the eye of those such as art critic Robert Hughes who would write off Vegas as a cultural wasteland. In his book *The Shock of the New,* Hughes declared that "one cannot imagine 'public art,' let alone a museum, on the Vegas Strip." Art, he declared, "would have nothing to do except look high-minded and insignificant." Indeed, he

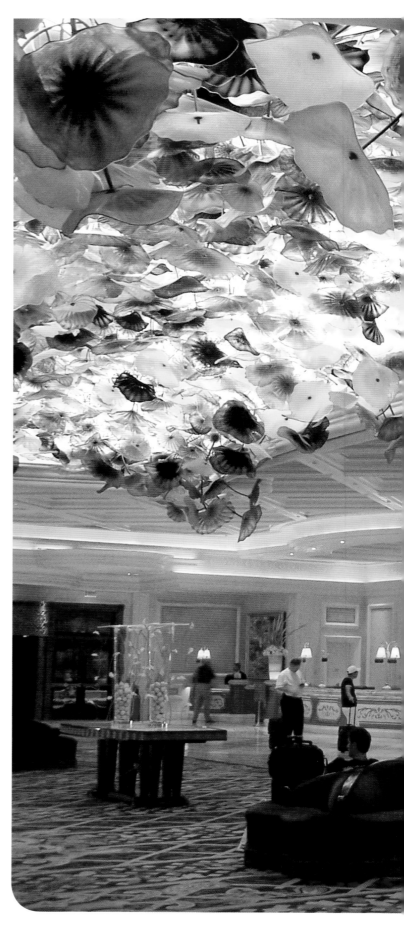

suggested, the only way you're going to find art in this city is on the name tag of the guy running you over in the town car to Caesars Palace. Better to stick to what you know: the 115,999-carat, 50-pound rhinestone at the Liberace Museum, for example, or the neon signs illuminating the desert night.

Wynn and fellow hotelier Sheldon Adelson gambled that Hughes was wrong, that the great unwashed who flock to Vegas casinos could be induced to appreciate fine art.

Thus legions of visitors to the Bellagio, a $1.6 billion creation, were treated to a series of encounters with art, both high and kitsch. In front of the hotel is a man-made lake that, every fifteen minutes, shoots jets of water 240 feet in

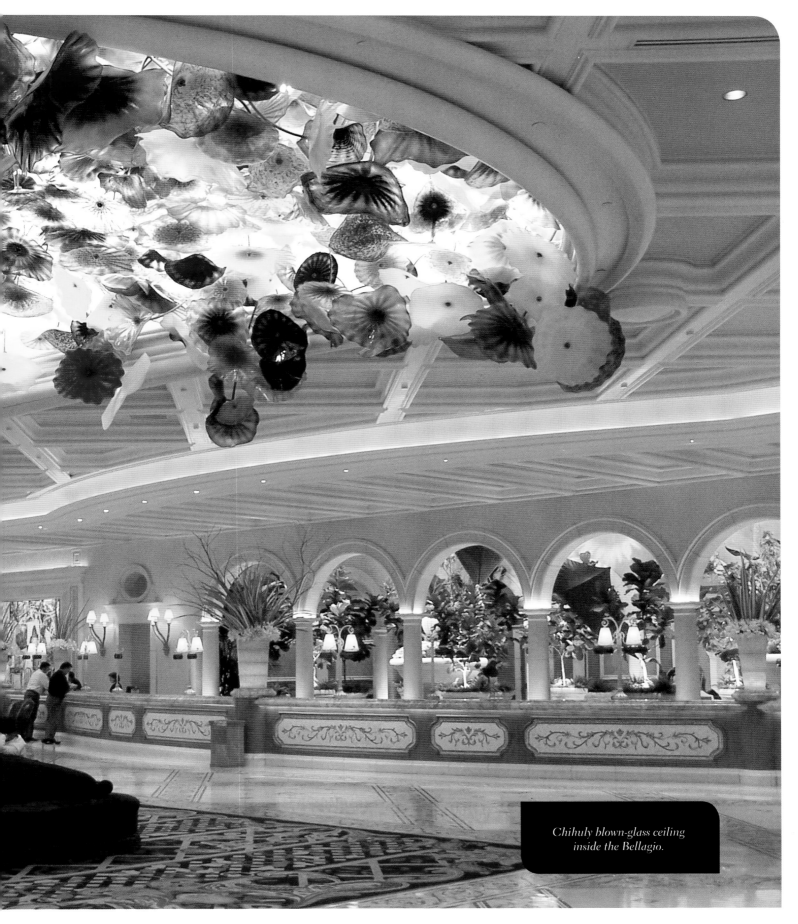

Chihuly blown-glass ceiling
inside the Bellagio.

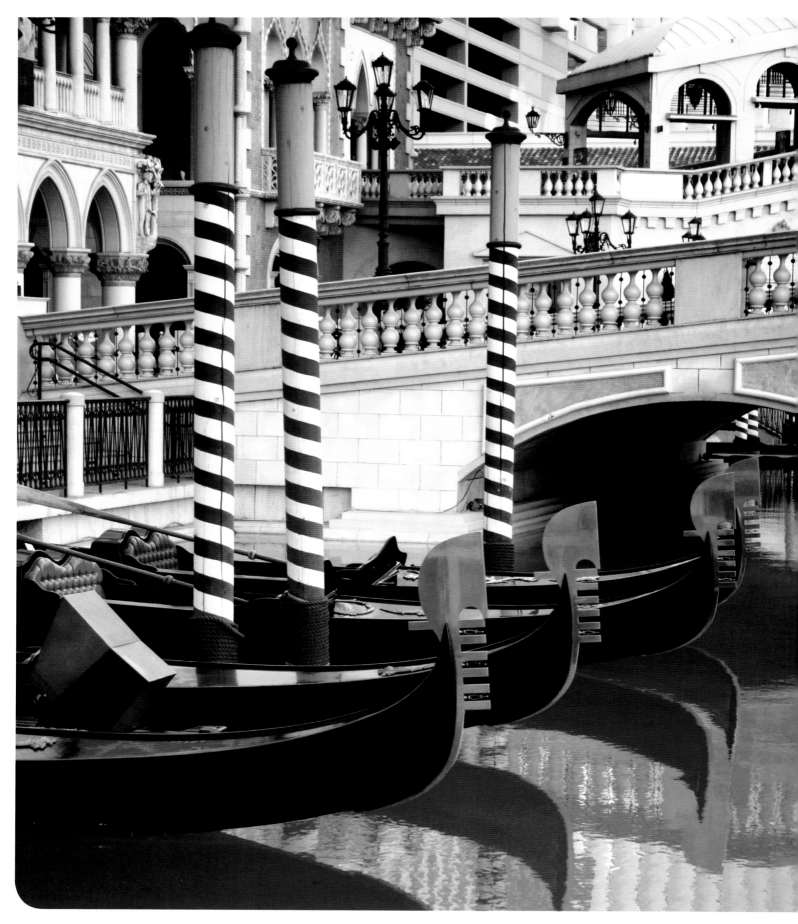

the air, an intricately choreographed water ballet set to classical music. At eye level, this profligate display stops people in their tracks; viewed from above, it resembles a routine by the June Taylor dancers. How could anyone resist entering the hotel proper, holding out promises of even greater treasures?

Art critic Dave Hickey, then a professor at UNLV, strolled through the lobby of the Bellagio with artist Robert Rauschenberg, where both stared up at the ceiling: a massive hand-blown glass sculpture by Dale Chihuly. It took five tons of steel to mount the twenty-ton extravaganza, which set Wynn back a cool $10 mil. As sheer spectacle, it "translates into visitors' being visually stunned, in this case not by an imitation of art but by an original artwork," William L. Fox observed in *In the Desert of Desire.*

Those willing to make the trek across the casino (and not yield to the clarion call of the gaming tables) will be rewarded by an art gallery that once housed thirty-six of the world's greatest masterpieces, culled from Wynn's personal collection—Rubens, Van Gogh, Matisse, Pissarro. The gallery, which was curated by Hickey's wife, Libby Lumpkin, opened in 1998. It stood as a challenge to the paradigm: would people who line up for the $1.99 all-you-can-eat buffet pay $15 a head to view this *amuse-bouche* of Western art? It seemed akin to splitting tens, but it paid off: the gallery drew in 630,000 visitors in the first nineteen months, people in shorts and T-shirts lining up for hours for a glimpse of a real Van Gogh before repairing to the casino to perform in that tableau of triumph and loss.

When Kirk Kerkorian acquired the hotel in 2000, the art collection reverted to Wynn's private collection and the gallery was converted into a temporary exhibition space. First up: a collection of Andy Warhol images based on publicity stills of celebrities such as James Dean and Marilyn Monroe. Warhol's pop art sensibility and obsession with the theme of celebrity proved to be the perfect fit for Vegas—a city, as William L. Fox noted, that is "constantly erecting ever more elaborate facades that asymptomatically approach the genuine."

Post-Warhol, the gallery exhibited twenty-eighty works, mostly contemporary American, on loan from the private collection of actor and author Steve Martin, himself a knowledgeable art collector. PaperBall, a subsidiary of a New York art dealer, took over the management of the gallery, debuting with a show of Alexander Calder's sculptures. However, it was the exhibit of Fabergé from the Kremlin that lured a staggering 140,000 visitors to view those exquisitely wrought eggs, a dazzling spectacle in miniature.

Just across the Strip, Sheldon Adelson constructed a grandiloquent, $1.5 billion homage to Renaissance Venice on the site of the former Sands. A rococo combination of High Renaissance culture and Low Vegas kitsch, the Venetian features a miniature replica of the Grand Canal in Venice. Under a ceiling that creates the permanent illusion of twilight, guests can drift along the canal in a gondola. On the ground floor, at Madame Tussaud's Wax Museum, living statues of presidents and celebrities

FACING *and* NEXT SPREAD: *Gondolas await passengers on the canals at the Venetian.* ABOVE: *The exterior of the Venetian at night.*

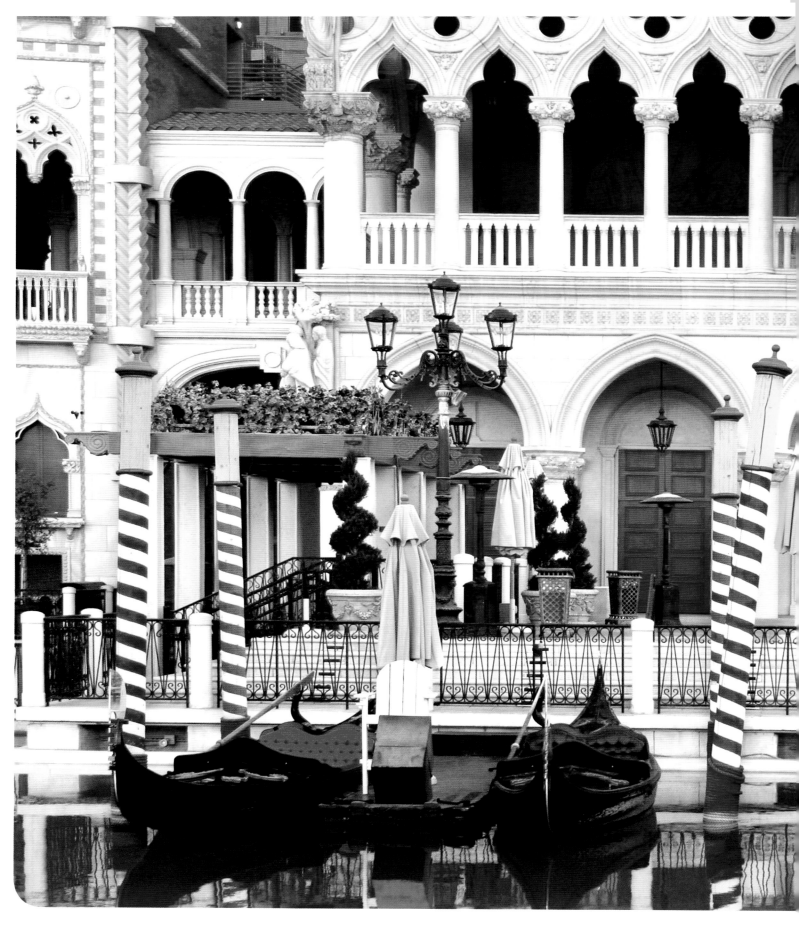

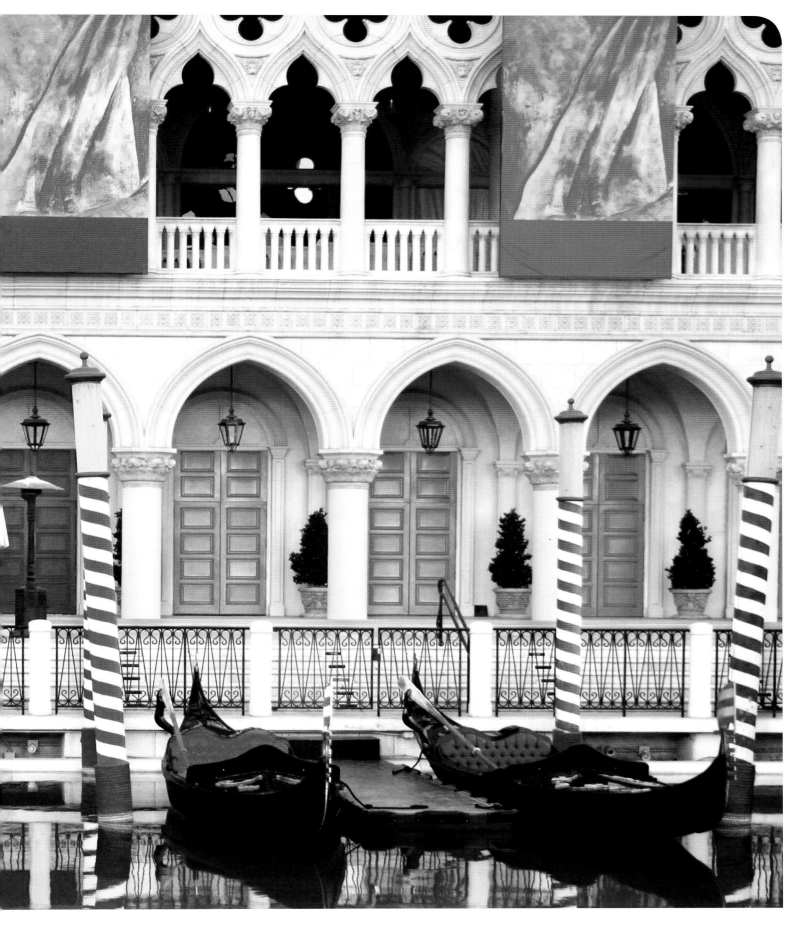

mingle—JFK and Frank Sinatra, two old pals, are permanently reunited in wax. The walls in the public spaces are hung with reproductions of frescoes by Titian and other Italian masters.

Then came the stunning announcement that the Guggenheim Museum in New York would open not one, but two museums at the resort. Designed by Rem Koolhaas, the renowned Danish architect, the Guggenheim Las Vegas was a two-story facility that accommodated, among other examples of unique American art forms, an exhibit on the motorcycle. The smaller museum would house forty-five paintings from the permanent collections at the Guggenheim and the Hermitage in St. Petersburg, Russia.

Apparently, Adelson overestimated the public's appetite for art, whether highbrow or popular—the larger museum suffered a downturn in attendance after the attacks of September 11, 2001, and closed its doors. The second, smaller museum continued its parade of the Greatest Hits of Western Art, drawing modest audiences, including locals who came in on Tuesdays to take advantage of the "free-after-five" program and maybe, after viewing

"The Art of the Motorcycle" exhibit at the Guggenheim Las Vegas enjoyed a fifteen-month run.

the art, sign up for the players card. Eventually, the novelty wore off, and Vegas reverted to type: the art in this town is rendered primarily in neon and green felt, not canvas and oils. The museum had a decent run—less than Wayne Newton but longer than Elvis—but it finally closed its doors in 2008. *Adiós,* Picasso. Catch you later, Kandinsky. Vegas, it seemed, had had its fill of fine art.

Gajin Fujita, Ride or Die, *2005. From "Las Vegas Diaspora" at the Las Vegas Art Museum.*

Las Vegas Diaspora

When Dave Hickey and his wife Libby Lumpkin moved to Las Vegas, they left behind the vibrant cultural scene of New York, where just knowing that the Met was there was comforting. Now they found themselves in Las Vegas, where Lumpkin experienced surreal art writ large upon the desert: on the one hand, Vegas was "a wonderful visual spectacle"; on the other hand, it was "like being on Mars." (Actually, Mars is probably cooler in summer, and likely has about as much water.) Now it was for the two of them to discover if art could flourish in this culturally arid climate.

Dave Hickey, a noted art critic, joined the art department at UNLV in 1991, the same year that Jerry Tarkanian coached the Runnin' Rebels to an NCAA title. Like Tarkanian, Hickey recruited his "players," not from the white, middle-class suburbs, but from the streets—graffiti taggers from East LA, offspring of British DJs and Polish workers, slackers from Dallas, cops' kids from Simi Valley. Excluded or quickly eliminated were "tree huggers, religious nuts and communitarian do-gooders." The result was a volatile mix

of personalities and talents. It was combustible stuff, and Hickey, rather than imposing the usual art-program tropes such as the lugubrious "group crit," in which students sit around and comment on each other's work, turned them loose, and it paid off.

One painter proved that a Vegas birth certificate is not an automatic disqualification from the cultural scene. Tommy Burke, a native Las Vegan, "stood there with his skateboard under his arm and showed me his exquisite 'woozy geometry' paintings," recalled Hickey in his essay "One Neon Decade." "They were so good, I was tempted to bonk him for being talented."

After gallery exhibitions, Hickey and the students repaired to the Fireside Lounge, a dimly lit joint on the Strip once favored by mobster Tony "the Ant" Spilatro. The time was well spent—it produced a series of glow-in the-dark paintings and loungy *objets d'art.*

Among the students in Hickey's program was Gajin Fujita. A graduate of the Otis Institute in Los Angeles, Fujita came to UNLV to work

with Hickey and find his artistic voice. Friends and relatives were incredulous that he had chosen Vegas, the antithesis of an artistic city, as a place to come of age as an artist. For Fujita, attending UNLV meant a scholarship and a chance to work with Hickey. Vegas was only a four-hour drive from his native Los Angeles, yet this landlocked place in the middle of the desert induced an immediate homesickness. He would look out the window of his second-floor apartment and watch the sunset and discover natural colors that, as much as the neon lights, came to inform his work. Ironically, the lesson that he took from this experience was the ethic of hard work: he and his fellow students, banished to this artistic outpost, had to work doubly hard to prove themselves, to seek vindication. He viewed Vegas as a working town, and this, more than the neon or glitz, shaped his artistic development.

Fujita was among the twenty-six artists from the UNLV program featured in "Las Vegas Diaspora: The Emergence of Contemporary Art from the New Homeland," curated by Hickey and held at the Las Vegas Art Museum. (Robert Hughes, eat your Picasso.) The program proved that art could flourish in the rarefied air of Vegas. Fujita's *Burn* featured a fusion of Japanese imagery with East LA graffiti that's like "finding an Edo-period painting on a barrio wall," as UNLV art professor Kirsten Swenson noted in *Art in America.*

Tim Bavington, one of Hickey's Brits, was also featured in the show. His *Step (In) Out*, a vertical-striped composition, was placed against a projecting wall painted lime green, a Vegas-style sensory overload. Phil Argent, another Brit, had been worried about a painting called *Hot Oil Treatment* that he had been working on, and asked Hickey to look at it. "No wonder you're worried," Hickey told him. "This is good!"

Proving that what happens in Vegas doesn't always stay in Vegas, the exhibit traveled to the highly regarded Laguna Arts Museum in 2008, transforming these works, and their creators, into a true diaspora. Fujita left after graduation, exhibiting his work at the Fourth International

Tim Bavington, Step (In) Out, *2007. From "Las Vegas Diaspora" at the Las Vegas Art Museum.*

James Hough, How Is My Baby So Far Away? *2007. From "Las Vegas Diaspora" at the Las Vegas Art Museum.*

Biennial, curated by Dave Hickey in Santa Fe. His work has been featured at the Pacific Asia Museum, the Los Angeles County Museum of Art, and other museums and galleries around the country. Others artists, like Tim Bavington, stayed on in Vegas, creating a place for themselves in what is still a relatively free, wide-open arts scene, a kind of artistic meritocracy.

Libby Lumpkin, director of the Las Vegas Art Museum, credited the Diaspora exhibit with initiating "the cultural development of Las Vegas that is in full swing today" and proving "that Las Vegas can be a fertile incubator for the most sophisticated and innovative forms of creative expression." Lumpkin had hoped to build an internationally recognized permanent collection of contemporary art that belonged to Las Vegas as a cultural asset. The very notion provoked howls of laughter among the cognoscenti. During a museum fund-raiser, one New York collector made this martini-induced utterance: "The Las Vegas Art Museum? You have got to be kidding!" In February 2009, faced with a budgetary shortfall, the museum closed its doors. However, museum board president Patrick Duffy is not ready to throw in the brush. "The arts aren't dead in Las Vegas," he declared. Maybe he can ask Lance Burton, Master Magician, to pull money out of a hat.

What Lies Beneath

REDRUM. This word—*murder* spelled backward—crawled on the wall of one of the labyrinths of underground tunnels found beneath the streets of Las Vegas. On another wall, a tagger waxed philosophical:

> TAKE ONLY PICTURES, LEAVE ONLY
> FOOTPRINTS, KILL ONLY TIME

Built to handle the runoff from flash flooding, the tunnels are populated by an assortment of drug addicts and psychotics, the broken and disenfranchised. This subterranean world was discovered by writer Matthew O'Brien, who made numerous trips over a period of several years and recounted his adventures in *Beneath the Neon: Life and Death in the Tunnels of Las Vegas.* He found, among the wet and debris and crackheads and makeshift meth labs, "a reality I wish all America could see." In the graffiti artists' exuberant wall renderings, he discovered "some poetry and really profound things."

Brian Paco Alvarez, former curator of the Liberace Museum and vice president of the Contemporary Arts Collective, accompanied O'Brien into the tunnels and was astounded by what he saw. Inspired by the visit to the tunnels, the native-born Alvarez decided to mount an exhibit at the Arts Factory, a bright orange building in downtown Las Vegas that houses a grassroots group of artists' studios and galleries.

To re-create the grittiness of the underground world, Alvarez brought in gravel and debris and water; he also blocked out the windows to street light. The graffiti artists' renderings were replicated on the exhibit walls, a running commentary on the detritus and citizens of this underground, carelessly cast off by society. Comparing the tunnels to the sewers of Paris or the catacombs of Rome, Alvarez said, "This shows Vegas as a true city."

Sin City Rising

Accustomed to creating illusions of cities, Las Vegas developers summoned an impressive cast of leading architects, designers, and artists to create a "cultural and lifestyle revival of city living in the heart of the Strip." The result was CityCenter, an $8 billion mixed-use development touted by developers as "one of the great urban places of the world."

CityCenter is a kind of architectural tribute band: Pelli, Jahn & Liebeskind, together for one glorious bash. The distinctive Pelli touch is evident in the ARIA Resort's dual curvilinear

glass towers, designed by Pelli Clarke Pelli Architect. The soaring open spaces allow a generous infusion of natural light, which was once anathema to a Vegas casino. Nature is evoked in liberal use of foliage, wood, and stone. Daniel Liebeskind, who designed the Freedom Tower for Ground Zero in New York City, brought his lofty aesthetic to the Crystals at CityCenter, a high-end retail and dining venue. The interior design by David Rockwell and the Rockwell Group reflects the hipper-than-thou sensibility the firm brought to the W Hotels. Like twins separated at birth, the two residential Veer Towers veer in opposite directions—five degrees from center—an oddly disconcerting *pas de deux* created by Helmut Jahn.

The public spaces were to be adorned, not with white tigers or floating craps games, but with works of art, works that would transform CityCenter into a "living, breathing museum of iconic works of art." Who better to lend an air of legitimacy to this project than Maya Lin? A newcomer to the Vegas scene, Lin chose, for her thematic material, not gaming but nature: the Colorado River. Using reclaimed silver, she fashioned a 133-foot cast of the river, which is suspended high above the reception area in ARIA, CityCenter's sixty-one-story resort-casino.

A rendering of the CityCenter development at night.

Lin's intention was to induce the visitor to think about the river, its life and flow.

Languidly reclining among the craps tables and slot machines at the ARIA is Henry Moore's *Reclining Connected Forms, 1969–1974,* an abstract sculpture of a baby wrapped in a mother's embrace. *Suffer the little children to come unto me.*

Downtown, at the foot of Fremont Street, is the old Union Pacific Railroad yard, a brownfield that Mayor Oscar Goodman called "the most worthless piece of real estate imaginable." The

city took possession of this piece of urban blight to create its own "city within a city": Union Park. To kick things off, Larry Ruvo, the Vegas wine and spirits distributor whose father died of Alzheimer's, put up $50 million to build the Lou Ruvo Brain Institute. To fuse this serious, purposeful building with the *je ne c'est quoi* spirit of Vegas, the city needed the architectural equivalent of Frank Sinatra, so they went out and hired Frank Gehry.

architectural style: part Frank Lloyd Wright, part faux Renaissance, and generously endowed with Vegas Kitsch. Convinced of the public import of the project, he finally relented.

Mayor Goodman visited Gehry in his studio in 2006 to review the progress on the designs for the new building. Though he did not have veto power, the mayor gave the designs his stamp of approval, telling Gehry, "It's Vegas, you're a genius." The plans had the look of

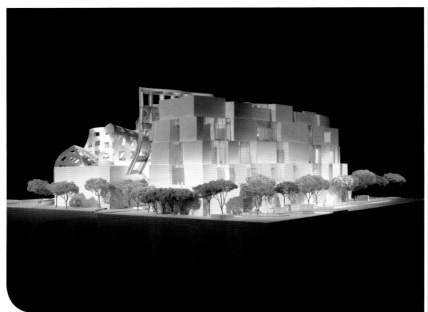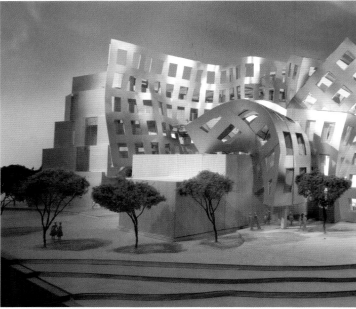

Lou Ruvo's Brain Institute in Union Park bears the signature imprint of renowned architect Frank Gehry.

Gehry, purportedly averse to all things gambling, at first resisted the city's entreaties, proclaiming that he would never build in Las Vegas. But Ruvo saw in Gehry an intuitive showmanship that made him ideally suited to design a building in Vegas. His ability to artfully transpose architecture's formalism into a popular idiom is revealed in such works as the Museum at Bilbao and the Disney Concert Hall in Los Angeles, which have become tourist attractions unto themselves. He also worked on the motorcycle exhibit at the Venetian's Guggenheim Museum, which exposed him to the Vegas

crumpled-up paper—in fact, the original inspiration *was* crumpled-up paper. The plans were organized into an exhibit at the Las Vegas Art Museum, offering the public the opportunity to witness, as Libby Lumpkin termed it, "the unfolding of the conceptual stages of a Frank Gehry building—all starts and stops."

If Gehry's design mirrored the razzle-dazzle of Vegas, the $50 million Smith Center for the Performing Arts was an exercise in sobriety and restraint. Architect David Schwarz drew inspiration from another local architectural wonder: Hoover Dam. Made of earth-red metaquartzite,

the three-building complex harkens back to the 1930s art deco era, with a carillon tower rising from the main building—a traditional approach that some worried would clash with Gehry's more atonal design.

The critics took aim at the project's lofty aspirations. KNPR commentator Jeff Burbank referred to Union Park as an "out-of-context, hodgepodge approach," a graphic demonstration as to "just how confused they [the city planners]

which will be housed in Gehry's building, said, "The thought that you have to look like your neighbor just doesn't speak to the DNA of Las Vegas. It's a different breed of cat here. We celebrate being different." Robert Zarmegin, developer of the sixty-story World Jewelry Center, sees Union Park as metamorphosing into a mini-Manhattan, and Mayor Goodman prophesized that it will become "a tourist destination for people with intellect." And if this in itself is not a

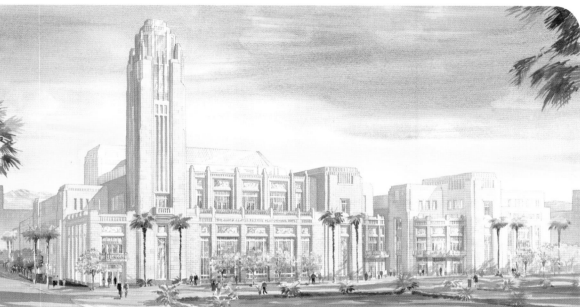

A rendering of the Smith Center for the Performing Arts in Union Park.

are about what this still-evolving town should reveal to the world, and about itself." Dave Hickey offered the following dire prediction to the *New York Times*: "The idea is that they're going to put in these public buildings and this is going to make a respectful downtown for Las Vegas without all the glitz and glamour, I guess, but I think it'll be a ghost town," adding ominously that "those open spaces that landscape architects so love are not really conducive to the desert climate."

The project's supporters dismissed these critics with a flick of the wrist. Maureen Peckman, COO of the Keep Memory Alive organization,

sufficient draw, there are always the $1.99 shrimp cocktail and the penny slots. These, the basic components of Glitter Gulch, have outlasted the brothels and the railroads, and they are likely to outlast these Gehry-come-latelys as well.

If you find all this art suffocating, if you yearn for a touch of the old Vegas, fear not—Cirque du Soleil and its partners created a permanent production at CityCenter's ARIA featuring live musicians, singers, dancers, and state-of-the-art sound and lighting to celebrate the timeless musical legacy of Elvis.

Thank you. Thank you very much.

Epilogue

Is Vegas the City of the Future?

In May 2005, Las Vegas marked its centennial with a sixty-five-ton cake. Delivered on seven flatbed trucks, assembled in an airplane hanger, and iced by a legion of volunteers, this towering confection was a fitting tribute to a city that, for the past fifty years, has reveled in excess and over-the-top spectacle.

If size matters, then Las Vegas had much to celebrate. In 2005, it was the fastest-growing metropolitan area in the United States, with more than a thousand new residents moving to town each week. Tourism was at an all-time high, and new, even more lavish hotels were being built at a frenzied pace.

Las Vegas is, as UNLV historian Hal Rothman noted, "a hard town that will make you pay for your inability to restrain your desires." Vegas ranks near the top of American cities in rates of alcoholism, drug addiction, bankruptcies, teen pregnancy, and suicide. Gambling addiction is the city's dirty little secret—the Problem Gambling Center, which opened in 1986, is treating a growing number of compulsive gamblers, including women.

In a sense, the entire city has been playing with fire for a hundred years. It has been on a continual betting jag, fed by its own ravenous need to reach new levels of excess. In its glorification of spectacle, its constant, almost pathological need to top itself, it keeps building and spending and growing, squandering precious natural resources, ignoring the mounting social problems. Even when the *Las Vegas Sun* broke a story about

hotel construction sites violating OSHA safety codes and putting workers at risk—a gritty piece of reporting that earned a Pulitzer Prize in 2009—the hotels kept going up, up, up. Nothing, it seemed, could stop this juggernaut.

Not given over much to introspection, Vegas did not pause, at its centennial mark, to examine whether, in the pursuit of money and pleasure, it had sacrificed its soul. Under the glitz and kitsch and excess, are there the stirrings of a soul, the semblance of a conscience?

There are a few encouraging signs that the city may indeed be developing such a con-science. UNLV launched an Urban Sustainability Initiative, a grassroots effort to find solutions to the problems facing Las Vegas—water supply, air quality, land use, traffic and congestion, and economic growth. The university is attempt-ing to lead by example by reducing its water use by 25 percent, expanding its use of solar energy, retrofitting buildings to use power more efficiently, and more. CityCenter, the privately financed $8 million "vertical city" in the heart of the Strip, set itself the lofty goal of being "one of the world's largest environmentally sustainable urban communities." Toward that end, this venture is incorporating such envi-ronmentally responsible practices as the use of reclaimed water, onsite power generation, and extensive use of natural light. So confident

were the owners in this "green" approach that they applied for the US Green Building Council's Leadership in Energy and Environmental Design (LEED) certification.

With celebrity architects joining the parade of celebrity chefs streaming into town, the city may end up with haute design along with its haute cuisine. That Frank Gehry is designing not a hotel, but a center for research on Alzheimer's and other neurological disorders, suggests that maybe Vegas has finally grown out of its pro-longed adolescence and is ready to take itself seriously—and be taken seriously by the rest of the world.

Vegas is a city of the here-and-now and the immediate future. (What's the next card going to be?) Anything from the past is relegated to the scrap heap of history. But even in a city that with great regularity implodes yet another hotel, one finds a growing nostalgia for the past. Vintage signage has been rescued and put into a Neon Museum. There is a move afoot to rebuild a resort on the site of the former Moulin Rouge, that great experiment in integra-tion. Such venerated pedagogical edifices as Fifth Street School and Las Vegas High have been preserved. Red Rock Canyon has been cordoned off as a state recreation area. And the site where water was first discovered in the valley is now Springs Preserve, a 180-acre

botanical garden and historic attraction listed on the National Register of Historic Places.

Vegas has passed through the Golden Age and the Age of Bread and Circus Circuses and the Age of Faux Internationalism. It has survived the machinations of the mob and the crazy, imploding self-destructiveness of Howard Hughes. Now, in this new century, it finds itself at a crossroads, uncertain whom to follow: there is the man who put his elbow through a Picasso, and others who are trying to become the next Picasso; a mayor who was a former mob attorney, and a former hooker trying to end this crime against women. Then there is the Recession (with a capital R). A city long thought to be immune from the vagaries of the economy found itself hard-hit by the recession of 2008–09. Hotel occupancy and casino revenue—the lifeblood of Vegas—fell precipitously, and the city that was once everyman's dream suffered from the nation's highest foreclosure rate.

Smelling blood in the water, the critics took aim at the imperiled city and its many obvious failings. Urban critic James Howard Kunstler visibly shudders at the thought of Vegas as the city of the future: "If Las Vegas truly is our city of the future, then we might as well all cut our own throats tomorrow." Some say Vegas has become bland now that the corporations with their suits and long-range business plans have

taken over. Where are the Bugsy Siegels and the Benny Binions? Where is that smell of nuclear fallout in the morning? Where have all the hookers gone, long-time passin'? At least there is still Wayne Newton.

At its heart, Vegas will always be Vegas. Its essential Vegas-ness is hard-wired right into its DNA, its survival indelibly linked to that peculiar institution of gambling. Vegas is still a place where, when you go there, they have to take you for all you've got. It makes no distinction between the down-on-his-luck loser and a would-be president. Indeed, it is the wise politician who doesn't touch Vegas with a ten-foot pole. While campaigning for president in 2008, then-Senator Barack Obama attended the Democratic caucuses at the Bellagio. Said Obama, "The only problem with me is when I come to Las Vegas, I'm not allowed to have fun. Everybody knows me. If I start playing blackjack, I'll get in trouble."

Vegas remains, defiantly, unapologetically itself. At day's end, when that huge disk of Nevada sun slips behind the mountains, the lights of the Strip illuminate the black desert sky, the showgirls come out onstage, and the gamblers hunker down at the tables, we are reaffirmed yet again by the one thing we can't seem to get through our heads: the house *always* wins.

Notes

The Two Faces of Vegas

7: "The damn state was broke": Michelle Ferrari with Stephen Ives, *Las Vegas: An Unconventional History* (New York: Bulfinch, 2005).

8: "a disease, a nightmare": Sally Denton and Roger Morris, *The Money and the Power: The Making of Las Vegas and Its Hold on America* (New York: Vintage, 2001).

8: "everyman's cut-rate Babylon": Alistair Cooke, *Alistair Cooke's America* (New York: Knopf, 1973).

8: "deliciously deranged": Denton and Morris, *The Money and the Power.*

8: "It was as though there were two Vegases": Ibid.

Creating a Cut-Rate Babylon

10: "If you want to get rich": Denton and Morris, *The Money and the Power.*

12: "Hell, had I known that": Ibid.

12: "the goddamn biggest fanciest gaming casino": Ibid.

14: "a lonely giant": A. D. Hopkins, "Benny Binion: The Cowboy Who Crushed the Limit," The First 100, Part III: A City in Full, www.1st100.com.

14: "We don't run for office": Denton and Morris, *The Money and the Power.*

14: "Utah corporation": Ibid.

17: "good food, good whiskey cheap": Hopkins, "Benny Binion."

18: "cut-rate Babylon": Cooke, *Alistair Cooke's America.*

24: "they tower, they revolve, they oscillate": Tom Wolfe, "Las Vegas (What?) Las Vegas (Can't hear you! Too noisy) Las Vegas!!!!" from *Literary Las Vegas*, ed. Mike Tronnes (New York: Holt, 1995).

27: "This poker game here": Hopkins, "Benny Binion."

27: "I would almost certainly be a gambler again": Ibid.

Why Vegas Loved the Bomb

32: "Every leader of the world": Interview with Troy Wade, "The Las Vegas I Remember," KNPR Radio, January 14, 1998.

32: "This is Walter Cronkite": "Las Vegas: An Unconventional History," American RadioWorks, produced by American Public Media, 2005.

35: "Every precaution will be taken": Denton and Morris, *The Money and the Power.*

35: "Stop. Situation serious": Ibid.

38: "sang like they were on the *Queen Mary*": Ibid.

38: "On numerous occasions": Daniel Lang, "Our Far-Flung Correspondents: Blackjack and Flashes," *New Yorker*, September 20, 1952.

38: "To Nevadans": A. Constandina Titus, *The Bomb in the Backyard: Atomic Testing and American Politics*, 2nd ed. (Reno: University of Nevada, 2001).

38: "I saw the big guy this morning": John Cahlan, *Las Vegas Review-Journal*, February 5, 1951.

38: "We have glorified gambling": Hank Greenspun, "Where I Stand," *Las Vegas Sun*, August 14, 1963.

39: "Up until that point": "Las Vegas: An Unconventional History."

40: "The 1,350 square miles at the Nevada site": Interview with Troy Wade, "The Las Vegas I Remember."

40: "The light and the heat": Ibid.

44: "When I was test controller": Ibid.

44: "out to the distance where fallout was expected": Philip W. Allen, *Memories of Weather Service for Nuclear Energy*, 2002.

44: "such intense light": Ibid.

44: "so fascinated by the spectacle": Ibid.

44: "could knock one's hat off": Ibid.

44: "They were probably radioactive": Ibid.

45: "I was beginning to get the idea": Interview with Hal Curtis, "The Las Vegas I Remember," n.d.

45: "the dangers of radiation pollution": Denton and Morris, *The Money and the Power.*

50: "ensure the safety of U.S. deterrent forces": United States Nuclear Tests—July 1945 through September 1992, 2nd ed., US Department of Energy, 1994.

50: "A nuclear waste dump": Geoff Schumacher, *Sun, Sin & Suburbia: An Essential History of Modern Las Vegas* (Las Vegas: Stephens Press, 2004).

"NO ONE'S SISTER LIVES IN LAS VEGAS"

52: "I never want anybody to be ashamed": Hank Greenspun, Interview for Oral History Collection, 1998, UNLV Special Collections.

52: "Let's go": Author interview with Philip and Jean Allen, March 2008.

55: "Huh. Mormons": Tony Kushner, *Angels in America. Part One: Millennium Approaches* (New York: Theatre Communications Group, 1993).

61: "good solid family people": Zelvin D. Lowman, *A Voice in the Desert: A History of First Presbyterian Church, Las Vegas, Nevada* (Franklin, TN: Providence House, 1992).

63: "I came here one day": "Las Vegas: An Unconventional History."

BLACK, WHITE, AND GREEN

66: "The men who run Las Vegas": Denton and Morris, *The Money and the Power.*

69: "You're in Nevada now": Sammy Davis Jr. and Burt Boyar, *Yes I Can: The Story of Sammy Davis Jr.* (New York: Noonday Press, 1965).

69: "Then why don't you go live": Ibid.

69: "more racial barriers": James Goodrich, "Negroes Can't Win in Las Vegas," *Ebony*, March 1954.

70: "many are illiterates": Ibid.

70: "For months, the whole town talked": Trish Geran, *Beyond the Glimmering Lights: The Pride and Perseverance of African Americans in Las Vegas* (Las Vegas: Stephens Press, 2006).

71: "I felt strange and alone": Ibid.

71: "Sorry, Debbie": From recollections by Alice Key, Moulin Rouge file, UNLV Special Collections.

73: "You know I've played Las Vegas": Ibid.

73: "I don't know how to swim anyway": Ibid.

74: "There was a tremendous amount of excitement": Ibid.

74: "I didn't know anything": Ibid.

75: "Of course, [the black stars] couldn't get into the casino areas": Interview with William H. Bailey, "The Las Vegas I Remember," KNPR Radio, n.d.

76: "Give them a drink": Interview with Dr. James McMillan, "The Las Vegas I Remember," KNPR Radio, n.d.

77: "I don't know anything about gambling": Ibid.

77: "the son of a bitch signed": Hank Greenspun, Interview for Oral History Collection.

78: "It was said on the street": Response by Nevada Resort Association to complaint filed by Las Vegas branch of the NAACP with Commission on Equal Rights of Citizens, State of Nevada, 1964, from archives of UNLV Special Collections.

78: "It was said on the street": Interview with Dr. Charles Kellar, "The Las Vegas I Remember," KNPR Radio, n.d.

78: "Some of these folks": Ibid.

78: "progress is being made": Response by Nevada Resort Association to complaint filed by Las Vegas branch of the NAACP with Commission on Equal Rights of Citizens, State of Nevada, 1964.

78: "There are twenty-five million Negroes": Kellar, "The Las Vegas I Remember."

79: "all hell would break loose": Ibid.

79: "I know you are": McMillan, "The Las Vegas I Remember."

79: "The Moulin Rouge is intriguing": John L. Smith, column in *Las Vegas Review-Journal,* December 15, 1995.

79: "We didn't realize the importance": From recollections by Alice Key.

79: "Maybe that's on my conscience": McMillan, "The Las Vegas I Remember."

FAST TIMES AT VEGAS HIGH

80: "I felt like I was one of them": Lily Fong, Interview for Oral History Collection, UNLV Special Collections.

82: "Coming to Las Vegas High School": www .lasvegas2005.org.

83: "She was hobbling out on crutches": Maude Frazier archives, UNLV Special Collections.

84: "Early on, we concluded": www.agassi prep.org.

85: "I think a huge impact": "Las Vegas: An Unconventional History."

87: "getting a little tired": A. D. Hopkins, "Jerry Tarkanian: Tark the Shark," The First 100, Part III: A City in Full, www.1st100.com.

87: "That reputation": Ibid.

87: "Prior to 1977": Ibid.

87: "Rising Star in American Education": Don Yaeger, *Shark Attack: Jerry Tarkanian and His Battle with the NCAA and UNLV* (New York: Harper Collins, 1993).

88: "I could forgive him": Ibid.

88: "You can help a kid": Ibid.

89: "writing that looks out from America": www.unlv.edu.

WHAT'S A GIRL LIKE YOU DOING IN A PLACE LIKE THIS?

90: "Showgirls are so dumb": Showgirl archives, UNLV Special Collections.

90: "This is what you call freedom": William Taubman, *Khrushchev: The Man and His Era* (New York: Norton, 2003).

92: "We like big boobies": Showgirl archives, UNLV Special Collections.

92: "one of the most difficult challenges": Libby Lumpkin, "The Showgirl," *Deep Design: Nine Little Art Histories* (Los Angeles: Art Issues Press, 1999).

93: "They were really all Cecil B. DeMilles": Showgirl archives, UNLV Special Collections.

94: "I want two more years": Ashley Powers, "They Bid Adieu to a Sexy Old Showgirl," *Los Angeles Times*, March 19, 2009.

94: "There was a great sense of openness": Interview with Tracy Heberling, "The Las Vegas I Remember," KNPR Radio, n.d.

94: "I wouldn't tell anybody": Showgirl archives, UNLV Special Collections.

95: "It's like being sisters": Ibid.

95: "It's wonderful": Heberling, "The Las Vegas I Remember."

97: "a better risk": Beverly Harrel, "House Organ," Cottontail Ranch Club Vol. 1, No. 1, from Prostitution archives, UNLV Special Collections.

97: "I think Nevada's brothels": Ibid.

98: "Yeah, they cut us off": Ibid.

99: "These two blondes": Alan Richman, "Lost Vegas," from *Literary Las Vegas.*

99: "If the girl is slick enough": Lynette Curtis, "Outlaw Industry, Ex-Prostitutes Say," *Las Vegas Review-Journal*, September 6, 2007.

99: "I left that business": Ibid.

101: "With a lot of these kids": Lynette Curtis, "Judge Touts Safe House for Kids Ensnared in Prostitution," *Las Vegas Review-Journal*, May 15, 2008.

101: "We've basically giving a green light": Curtis, "Outlaw Industry."

101: "No, not even close": Ibid.

101: "Vegas is already a paradise": *Bob Herbert*, "City as Predator," *New York Times*, September 4, 2007.

102: "They would call you": Pete Earley, *Super Casino: Inside the "New" Las Vegas* (New York: Bantam, 2001).

103: "I was one of the girls": Phyllis Barber, *How I Got Cultured: A Nevada Memoir* (Reno: University of Nevada, 1994).

103: "Your judgment was swift": Ibid.

SEX, POLITICS, AND OTHER CRIMES AND MISDEMEANORS

104: "What's so bad about gambling": Denton and Morris, *The Money and the Power.*

104: "Gambling produces nothing": Ferrari, *Las Vegas: An Unconventional History.*

106: "They fled subpoenas": Ibid.

106: "has not resulted in excluding the undesir-ables": Denton and Morris, *The Money and the Power.*

108: "He made me": Ferrari, *Las Vegas: An Unconventional History.*

108: "ex-convict": Hank Greenspun with Alex Pelle, *Where I Stand: The Record of a Reckless Man* (Los Angeles: David McKay, 1966).

108: "the most immoral": Ibid.

108: "the chances are": Ibid.

108: "sadistic pervert": Ibid.

111: "just for the hell of it": Truman Capote, *In Cold Blood* (New York: Vintage, 1965).

111: "Don't look much like a lynch mob": Ibid.

114: "You find a stockbroker or trader": Ben Mezrich, *21: Bringing Down the House* (New York: Free Press, 2002).

114: "You fuck with the cardinal rule": Ibid.

115: "Beyond Las Vegas' reputation": Thomas H. Kean and Lee H. Hamilton, *The 9/11 Report* (New York: St. Martin's, 2004).

115: "The pro-Western ideologies": Alan Maimon and Margaret Ann Mile, "Increased Vigilance Arises from Knowing Las Vegas Has Inviting Terrorism Targets," *Las Vegas Review-Journal*, September 10, 2006.

BRINGING DOWN THE HOUSE

118: "Dahling, we're simply the best-paid shills": Denton and Morris, *The Money and the Power.*

120: "Never again": Ibid.

120: "I ain't belongin' to nothing": Davis, *Yes I Can.*

122: "Every swinger and do-da-diddy guy": "Las Vegas: An Unconventional History."

125: "Swing a little": Kitty Kelly, *His Way: The Unauthorized Biography of Frank Sinatra* (New York: Bantam, 1986).

125: "As I was to learn": Ibid.

125: "We're on our way": Ibid.

125: "several comely prostitutes": Denton and Morris, *The Money and the Power.*

125: "You're wondering": The Sands archives, UNLV Special Collections.

125: "I built this hotel": Ibid.

125: "Frank who?" Ibid.

126: "He gets away with too much": Kelly, *His Way.*

126: "those fly-by-night entertainers": The Beatles archives, UNLV Special Collections.

126: "How do you work this telly": Ibid.

126: "Then all of a sudden": Interview with Don English, "The Las Vegas I Remember."

128: "We've had a pretty hard time": Elvis Presley archives, Frontier Hotel folder, UNLV Special Collections.

128: "We will not open": Ibid.

128: "He was comfortable": Ibid.

128: "Listen, I would like all of you": English, "The Las Vegas I Remember."

129: "I feel it is a rip-off": Wayne Newton archives, Las Vegas Hilton folder, UNLV Special Collections.

130: "more like James Dean": Burton Bernstein and Barbara B. Haws, *Leonard Bernstein: American Original* (New York: Collins, 2008).

130: "the knack of a teacher": Ibid.

130: "I dig absolutely": Tom Wolfe, *Radical Chic & Mau-Mauing the Flak Catchers*, (New York: Farrar, Straus and Giroux, 1970).

130: "pool-to-pool vacation": Letter from Leonard Bernstein to Shirley Bernstein, September 1960, from the Leonard Bernstein Collection, Library of Congress.

130: "In Las Vegas": Murray Schumach, "Bernstein Links Audiences to TV," *New York Times*, September 2, 1960.

131: "Let's show them": Barber, *How I Got Cultured*.

BREAD AND CIRCUS CIRCUSES

134: "would pawn his clothes": K. J. Evans, "Jay Sarno: Dream Weaver," The First 100, Part II: Resort Rising, www.1st100.com.

134: "It took right off": Ibid.

136: "what the whole hep world": Hunter S. Thompson, *Fear and Loathing in Las Vegas* (New York: Random House, 1971).

136: "About that time": Evans, "Dream Weaver."

136: "To tell the truth": Ibid.

137: "When we did learn": Ibid.

138: "It's where I grew up": Ibid.

140: "Let's buy 'em all": Denton and Morris, *The Money and the Power.*

140: "some demonic demigod": Ibid.

140: "one of the most interesting conversations": Ibid.

140: "a really super 'environmental city'": Ibid.

140: "Anything this man does": Ibid.

141: "I am not eager": Schumacher, *Sun, Sin & Suburbia.*

141: "I feel that Negroes": Ibid.

142: "Good Housekeeping Seal of Approval": Denton and Morris, *The Money and the Power.*

145: "screaming, yelling and flames": Earley, *Super Casino.*

145: "I had to be a part of it": K. J. Evans, "Kirk Kerkorian: The Quiet Lion," The First 100, Part III: A City in Full, www.1st100.com.

159: "As beautiful as you may think": Jon Ralston, "Jon Ralston Wonders Whether Rampant Gambling, Prostitution Should Be Part of Image That Las Vegans Want to Create," *Las Vegas Sun*, September 9, 2007.

160: "genuinely alien and mysterious": William L. Fox, *In the Desert of Desire: Las Vegas and the Culture of Spectacle* (Reno: University of Nevada, 2005).

160: "We decided to create our environment": Siegfried & Roy, "A World Beyond Belief," National Media Preview, Siegfried & Roy Archives, UNLV Special Collections.

161: "They must want to perform": Ibid

161: "It's clear that Montecore": "Siegfried and Roy: Five Years After the Tiger Injuries," ABC News, *20/20*, March 5, 2009.

HOW TO EAT LIKE A VEGAN

164: "a glimpse of days gone by": "Green Shack," Food for Thought with John Curtas, KNPR Radio, December 3, 1998.

167: "I love boxing": Nadine Brozan, "Chronicle," *New York Times*, February 19, 1993.

176: "the best fusion of upscale cuisine": Cathouse Restaurant press release, November 18, 2008.

THE SHOCK OF THE NEW: ART IN LAS VEGAS

178: "It's kind of nice": Steve Friess, "In the Land of Glitter and Gambling, Plans for an Oasis of Art," *New York Times*, May 19, 2009.

178: "Thank God it was me": Norm Clarke, "Wynn Accidentally Damages Picasso," *Las Vegas Review-Journal*, October 16, 2006.

178: "I felt absolutely terrible": Nora Ephron, "My Weekend in Vegas," www.huffingtonpost.com/nora-ephron/my-weekend-in-vegas_b_31800.htm.

178: "It took Picasso five hours": Nick Paumgarten, "The $40 Million Elbow," *New Yorker*, October 23, 2006.

180: "Art would have nothing to do": Robert Hughes, *The Shock of the New: The 100-Year History of Modern Art. Its Rise, Its Dazzling Achievement, Its Fall* (New York: McGraw-Hill, 1990).

183: "translates into visitors' being visually stunned": Fox, *The Desert of Desire.*

183: "constantly erecting": Ibid.

187: "like being on Mars": Author interview with Libby Lumpkin, March 2008.

187: "tree huggers": David Hickey, "One Neon Decade," from *Las Vegas Diaspora: The Emergence of Contemporary Art from the Neon Homeland* (Las Vegas Art Museum, 2007).

187: "They were so good": Ibid.

188: "finding an Edo-period painting": Kirsten Swenson, "Sin City Slickers," *Art in America*, February 2008.

188: "This is good": Hickey, "One Neon Decade."

189: "Las Vegas can be a cultural incubator": Libby Lumpkin, Acknowledgments, *Las Vegas Diaspora.*

189: "The Las Vegas Art Museum": Ibid.

189: "The arts aren't dead": Kristen Peterson, "Strapped Las Vegas Art Museum Plans to Shutter," *Las Vegas Sun,* February 21, 2009.

189: "a reality I wish all America could see": Steve Bornfeld, "Tunnel Visions: 'Beneath the Neon' Shines Light on Subterranean Life," *Las Vegas Review-Journal*, June 27, 2008.

190: "This shows Vegas as a true city": Ibid.

190: "cultural and lifestyle revival": "CityCenter Offers Opportunity to Live the Las Vegas Strip Experience," www.citycenter.com.

190: "one of the great urban places": Ibid.

190: "living, breathing museum": Ibid.

191: "the most worthless piece of real estate": Friess, "In the Land of Glitter and Gambling, Plans for an Oasis of Art."

192: "It's Vegas, you're a genius": Alan Choate, "Downtown Rebound on Center Stage," *Las Vegas Review-Journal*, April 25, 2008.

192: "the unfolding of the conceptual stages": Sam Skolnik, "In Varied Vegas, Two Buildings Spark Architectural Debate," *Las Vegas Sun*, May 25, 2008.

193: "just how confused": Ibid.

193: "those open spaces": Steve Friess, "Up With the New: A Second Center City for Las Vegas," *New York Times*, April 23, 2008.

193: "The thought that you have to look": Skolnik, "In Varied Vegas."

193: "a tourist destination": Ibid.

EPILOGUE: IS VEGAS THE CITY OF THE FUTURE

194: "a hard town": Schumacher, *Sun, Sin & Suburbia.*

196: "one of the world's largest": "Las Vegas: An Unconventional History."

197: "If Las Vegas truly is our city": "CityCenter Offers Opportunity to Live the Las Vegas Strip Experience."

197: "The only problem with me": Don Frederick, "Lessons at the Kitchen Table," *Los Angeles Times*, May 25, 2008.

Bibliography

Books

Barber, Phyllis. *How I Got Cultured: A Nevada Memoir.* Reno: University of Nevada Press, 1994.

Bernstein, Burton, and Barbara B. Haws. *Leonard Bernstein: American Original.* New York: Collins, 2008.

Capote, Truman. *In Cold Blood.* New York: Vintage, 1965.

Cooke, Alistair. *Alistair Cooke's America.* New York: Knopf, 1973.

Davis, Sammy, Jr., and Burt Boyar. *Yes I Can: The Story of Sammy Davis, Jr.* New York: Noonday Press, 1965.

Denton, Sally, and Roger Morris. *The Money and the Power: The Making of Las Vegas and Its Hold on America.* New York: Vintage, 2001.

Earley, Pete. *Super Casino: Inside the "New" Las Vegas.* New York: Bantam, 2001.

Ferrari, Michelle, with Stephen Ives. *Las Vegas: An Unconventional History.* New York: Bulfinch, 2005.

Fox, William L. *In the Desert of Desire: Las Vegas and the Culture of Spectacle.* Reno: University of Nevada, 2005.

Geran, Trish. *Beyond The Glimmering Lights: The Pride and Perseverance of African Americans in Las Vegas.* Las Vegas: Stephens Press, 2006.

Greenspun, Hank, with Alex Pelle. *Where I Stand: The Record of a Reckless Man.* Los Angeles: David McKay, 1966.

Hickey, David. "One Neon Decade." From *Las Vegas Diaspora: The Emergence of Contemporary Art from the Neon Homeland.* Las Vegas Art Museum, 2007.

Hughes, Robert. *The Shock of the New: The 100-Year History of Modern Art. Its Rise, Its Dazzling Achievement, Its Fall.* New York: McGraw-Hill, 1990.

Kean, Thomas H., and Lee H. Hamilton. *The 9/11 Report.* New York: St. Martin's, 2004.

Kelly, Kitty. *His Way: The Unauthorized Biography of Frank Sinatra.* New York: Bantam, 1986.

Kushner, Tony. *Angels in America, Part One: Millennium Approaches.* New York: Theatre Communications Group, 1993.

Lowman, Zelvin D. *A Voice in the Desert: A History of First Presbyterian Church, Las Vegas, Nevada.* Franklin, TN: Providence House, 1992.

Mezrich, Ben. *21: Bringing Down the House.* New York: Free Press, 2002.

Moehring, Eugene P. *Resort City in the Sunbelt: Las Vegas, 1930–2000.* 2nd ed. Reno: University of Nevada Press, 2000.

O'Brien, Matthew. *Beneath the Neon: Life and Death in the Tunnels of Las Vegas.* Las Vegas: Huntington Press, 2007.

Schumacher, Geoff. *Sun, Sin & Suburbia: An Essential History of Modern Las Vegas.* Las Vegas: Stephens Press, 2004.

Taubman, William. *Khrushchev: The Man and His Era.* New York: Norton, 2003.

Thompson, Hunter S. *Fear and Loathing in Las Vegas.* New York: Random House, 1971.

Titus, A. Constandina. *The Bomb in the Backyard: Atomic Testing and American Politics.* 2nd ed. Reno: University of Nevada, 2001.

Tronnes, Mike, ed. *Literary Las Vegas: The Best Writing About America's Most Fabulous City.* New York: Holt, 1995.

Ward, Kenric. *Saints in Babylon: Mormons and Las Vegas.* Bloomington, IN: 1st Books Library, 2002.

Wolfe, Tom. *Radical Chic & Mau-Mauing the Flak Catchers.* New York: Farrar, Straus and Giroux, 1970.

Yaeger, Don. *Shark Attack: Jerry Tarkanian and His Battle with the NCAA and UNLV.* New York: Harper Collins, 1993.

Periodicals

Bornfeld, Steve. "Tunnel Visions: 'Beneath the Neon' Shines Light on Subterranean Life." *Las Vegas Review-Journal,* June 27, 2008.

Brozan, Nadine. "Chronicle." *New York Times,* February 19, 1993.

Cahlan, John. Column in *Las Vegas Review-Journal,* February 5, 1951.

Choate, Alan. "Downtown Rebound on Center Stage." *Las Vegas Review-Journal,* April 25, 2008.

Clarke, Norm. "Wynn Accidentally Damages Picasso." *Las Vegas Review-Journal,* October 17, 2006.

Curtis, Lynette. "Outlaw Industry, Ex-Prostitutes Say." *Las Vegas Review-Journal,* September 6, 2007.

——. "Judge Touts Safe House for Kids Ensnared in Prostitution." *Las Vegas Review-Journal,* May 15, 2008.

Frederick, Don. "Lessons at the Kitchen Table." *Los Angeles Times,* May 25, 2008.

Friess, Steve. "In the Land of Glitter and Gambling, Plans for an Oasis of Art." *New York Times,* May 19, 2008.

——. "Up with the New: A Second Center City for Las Vegas." *New York Times,* April 23, 2008.

Goodrich, James. "Negroes Can't Win in Las Vegas." *Ebony,* March 1954.

Greenspun, Hank. "Where I Stand." *Las Vegas Sun,* August 14, 1963.

Harrel, Beverly. "House Organ." Cottontail Ranch Club. Vol. 1, No. 1. From Prostitution archives, UNLV Special Collections.

Herbert, Bob. "City as Predator." *New York Times,* September 4, 2007.

Jones, Jay. "Card Counters versus the Casinos." *Los Angeles Times,* March 23, 2008.

Lang, Daniel. "Our Far-Flung Correspondents: Blackjack and Flashes." *New Yorker,* September 20, 1952.

Lumpkin, Libby. "The Showgirl." *Deep Design: Nine Little Art Histories.* Los Angeles: Art Issues Press, 1999.

Maimon, Alan, and Margaret Ann Mile. "Increased Vigilance Arises from Knowing Las Vegas Has Inviting Terrorist Targets." *Las Vegas Review-Journal,* September 10, 2006.

Paumgarten, Nick. "The $40-Million Elbow." *New Yorker,* October 23, 2006.

Peterson, Kristen. "Strapped Las Vegas Art Museum Plans to Shutter." *Las Vegas Sun,* February 21, 2009.

Ralston, Jon. "Jon Ralston Wonders Whether Rampant Gambling, Prostitution Should Be Part of Image That Las Vegans Want to Create." *Las Vegas Sun,* September 9, 2007.

Powers, Ashley. "They Bid Adieu to a Sexy Old Showgirl." *Los Angeles Times*, March 19, 2008.

Schumach, Murray. "Bernstein Links Audiences to TV." *New York Times,* September 2, 1960.

Skolnik, Sam. "In Varied Vegas, Two Buildings Spark Architectural Debate." *Las Vegas Sun,* May 25, 2008.

Smith, John L. Column in *Las Vegas Review-Journal,* December 15, 1995.

Swenson, Kirsten. "Sin City Slickers." *Art in America,* February 2008.

Time, March 12, 1951.

Vartabedian, Ralph. "U.S. Seeks the Go-ahead for Nevada Nuclear Dump." *Los Angeles Times,* June 4, 2008.

———. "Yucca Mountain Project Is 'Doomed,' Nuclear Firm Says." *Los Angeles Times,* June 6, 2008.

GOVERNMENT PUBLICATIONS

"The Historic Connection," Vol 9. No. 2. A Publication of the Historic Preservation Office, City of Las Vegas.

"Nevada Test Site." Energy Research and Development Administration, January 1976.

"NTS News & Views." Special Edition. US Department of Energy, April 1993.

"A Perspective on Atmospheric Nuclear Tests in Nevada: Fact Book." Prepared for the Underground Nuclear Testing Program: Environmental Statement. US Atomic Energy Commission, 1973.

"United States Nuclear Tests—July 1945 through September 1992". 2nd ed. US Department of Energy, 1994.

US Department of Energy, Nevada Operations Office by H.N. Frisen, Raytheon Services Nevada. 2nd Rev. August 1995.

INTERVIEWS, ORAL HISTORIES, RADIO BROADCASTS, AND TRANSCRIPTS

Archives from UNLV Special Collections.

Author interview with Libby Lumpkin, March 2008.

Author interview with Philip and Jean Allen, March 2008.

"Green Shack." Food for Thought with John Curtas. KNPR, December 3, 1998.

Interview with Dr. Charles Kellar. "The Las Vegas I Remember." KNPR Radio. [No date on transcript.]

Interview with Dr. James McMillan. "The Las Vegas I Remember." KNPR Radio. [No date on transcript.]

Interview with Don English. "The Las Vegas I Remember." [No date on transcript.]

Interview with Hal Curtis. "The Las Vegas I Remember." KNPR Radio. [No date on transcript.]

Interview with Tracy Heberling. "The Las Vegas I Remember." KNPR Radio. [No date on transcript.]

Interview with Troy Wade. "The Las Vegas I Remember." KNPR Radio, January 14, 1998.

Interview with William H. Bailey. "The Las Vegas I Remember." KNPR Radio. [No date on transcript.]

"Las Vegas: An Unconventional History." American RadioWorks, produced by American Public Media, 2005.

Oral History Collection. UNLV Special Collections.

"Siegfried and Roy: Five Years After the Tiger Injuries." ABC News, *20/20*, March 5, 2009.

NEWSLETTERS AND PRESS RELEASES

Cathouse Restaurant press release, November 18, 2008. Prostitution archives, UNLV Special Collections.

Response by Nevada Resort Association to complaint filed by Las Vegas branch of the NAACP with Commission on Equal Rights of Citizens, State of Nevada, 1968. From archives of UNLV Special Collections.

Siegfried & Roy, "A World Beyond Belief." National Media Preview. Siegfried & Roy archives, UNLV Special Collections.

LETTERS AND UNPUBLISHED RECOLLECTIONS

Allen, Philip W. *Memories of Weather Service for Nuclear Energy,* 2002.

Letter from Leonard Bernstein to Shirley Bernstein. September 1960. Leonard Bernstein Collection, Library of Congress.

WEB SITES

Andre Agassi College Preparatory Academy. www.agassiprep.org.

CityCenter Las Vegas. www.city center.com.

Ephron, Nora. "My Weekend in Vegas." www.huffingtonpost.com/ nora-ephron/my-weekend-in-vegas_b_31800.htm.

Evans, K. J. "Jay Sarno: Dream Weaver." The First 100, Part II: Resort Rising. www.1st100.com.

———. "Kirk Kerkorian: The Quiet Lion." The First 100, Part III: A City in Full. www.1st100.com.

"Frank Gehry Designs the Lou Ruvo Brain Institute." Las Vegas Art Museum Exhibits. www .lasvegasartmuseum.org/exhibitions /exhibitions_archive/gehry.

Hopkins, A. D. "Benny Binion: The Cowboy Who Crushed the Limit." The First 100, Part III: A City in Full. www.1st100.com.

———. "Jerry Tarkanian: Tark the Shark." The First 100, Part III: A City in Full. www.1st100.com.

www.citycenter.com.

www.klvx.org.

www.lasvegas.com.

www.lasvegas2005.org.

www.media.vegaspbs.org.

www.unlv.edu.

www.usbr.gov/lc/hooverdam.

Index

Photo Credits